The Art of Glen Loates

Paul Duval

The Art of Glen Loates

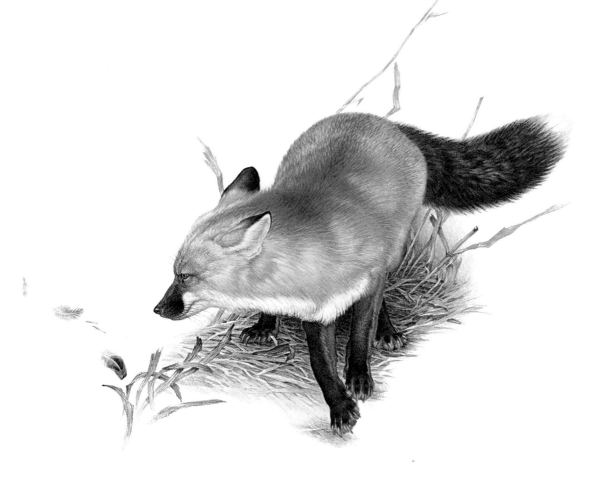

Cerebrus Publishing Company Limited,
Prentice-Hall of Canada, Ltd., Scarborough, Ontario.

I dedicate
this book
to my Parents
and my Brother
Bernard
who made it all
possible.

Glen Loates.

Contents

Foreword. *9*

Introduction. *11*

I. Early Beginnings. *15*

II. Transition. *49*

III. New Horizons. *73*

IV. A Wider Recognition. *93*

V. Interval. *139*

VI. Maturity. *159*

Artist's Statement. *187*

Index to the Works. *189*

ISBN 0-920016-05-7
Copyright © 1977 by Setaol Incorporated
Artwork copyright © 1977 throughout the world by the artist Glen Loates.
All rights reserved.
No part of the contents of this volume
may be reproduced without the written permission of Setaol Incorporated.
See notice on page 190.
Published by Cerebrus Publishing Company Limited/Prentice-Hall of Canada, Ltd.
Scarborough, Ontario, Canada.
First printing.

Foreword

he few "working" nature artists in North America could be counted on one's fingers eleven years ago, when I assumed the editorship of *Audubon.* Today, as advertisements for nature prints show, the field is a crowded one. Thus discrimination is essential. I have been asked many times what I look for in a nature painting. My answer is: Life! The technique, the medium, is not what is important. It may be an oil canvas with a minimum of detail, an interpretive sketch, or a very literal rendering. But the painting should convey the essence, the vitality, the place of the creature it portrays. Here is where so many artists, or would-be artists fail.

I also have been frequently asked to name the best nature artist. To do so, even were I willing, is patently impossible. For one thing, there are artists who specialize in birds, in plants, in fishes and other marine life. There are even artists who paint little else but charging elephants and stalking lions.

But there are very few nature artists capable of portraying *any* subject with great skill, imagination and accuracy, who can capture the being of a blue jay, cougar, salmon, lily, or moth with equal excellence. And there is none better in this elite category than Martin Glen Loates. The proof is in hand. Whether the painting be of a red squirrel confronting a pileated woodpecker at its nesting hole, a woodchuck nibbling a weed, a lynx pouncing on a grouse, a bat in pursuit of a moth, or an evening grosbeak fleeing a marten, what leaps from every page is the essence, the vitality, the place of the animal. Its *Life!*

The name of Martin Glen Loates is not as famous as it deserves to be. This volume will do much to remedy that situation. It is the most welcome addition to my personal library in many years.

Les Line, Editor
Audubon Magazine

Introduction

rom the very beginnings of man's activities as an artist, animal life has captured his imagination and recording spirit. The prehistoric cave paintings of Lascaux in France and Altamira in Spain reveal how vividly the earliest Europeans were moved by the bisons, boars and steeds which surrounded them so many thousands of years ago. Since then, succeeding generations of all cultures and nations have celebrated the forms and activities of birds and beasts in every pictorial media. The multitude of ancient styles utilized to render them varied from the suavely smooth cats and apes of Egypt to the tensely etched lions of Assyria and the contorted creatures of the Scythian and Han cultures.

In more recent centuries, many of the world's most revered masters have dedicated their skills to the portrayal of wildlife. Leonardo, Dürer, Pisanello, Rembrandt, Rubens, Delacroix, Degas, Monet and Picasso are but a few famed painters who created a virtually endless zoological procession ranging from rabbits, elephants, cats and roosters to goats, doves, tigers and their multitude of winged and footed brethren. Each of these artists brought to his wildlife portrayals a compelling creative power mixed with a real affection and admiration for his subjects. In fact, the variations of technique, style and media used in the literally millions of graphic renditions of animal life created since the caveman provide a complete history of art from its beginnings until now. These examples would also give a vivid lesson in the uniqueness of each truly creative artist's vision. What a visual contrast separates a portrayal of an elephant by a miniature painter of the Punjab or a carver from Nigeria from, say, a crayon drawing of the same mammal by Rembrandt. And what a world of attitude separates the haughty dignity of an Egyptian bronze cat from the playful 19th century impressionist renderings by Edouard Manet. Cultural attitudes, social purpose and creative personality have all combined to lend to each significant work of animal art its peculiar power, character and attraction.

Animal portrayals of the distant past were wrought mainly to evoke the totemic or

religious spirit of the species represented, as straightforward decoration or as a supplementary part of compositions built around the human figure. Only in the last few centuries have artists concerned themselves with the realistic rendering of wildlife for the sake of making a careful record of the physical detail and activity of a particular species. This has its beginnings with such pioneer antecedents as Pisanello's 15th century studies of herons and turtles, Leonardo's anatomical drawings of horses and Dürer's famed rendering of a recumbent hare. These were the forerunners of wildlife painting as we know it today, with its preoccupation with the exact proportion, natural textures, individual character, movement and posture of each creature represented. Remarkably, despite such apparent creative limitations imposed upon wildlife painting, artists of genuine and unique genius have emerged from its ranks.

In the Western world, during the past few hundred years, a vital tradition of wildlife art has evolved, led by such great figures as Charles Collins (1680-1744), Thomas Bewick (1753-1828), John James Audubon (1785-1851), John Gould (1804-1881), Richard Friese (1854-1918), Friedrich Karl Kuhnert (1865-1926), Louis Agassiz Fuertes (1874-1927), Archibald Thorburn (1860-1935) and Carl Clemens Rungius (1869-1959). These significant forerunners have been followed into the contemporary period by such noteworthy bird and animal painters as Roger Tory Peterson, Sir Peter Scott and J. Fenwick Lansdowne. All these artists, past and present, have been widely illustrated; their works have become familiar to those interested in wildlife art through major books and other publications.

This present publication is being issued to bring together and introduce the art of one of the world's most gifted wildlife painters: Martin Glen Loates. Although this young North American artist's main concern has been with the world of mammals, he has, during his relatively short career, also ventured into the fields of botany and ornithology. No excuse is made here for the inclusion of early, boyhood efforts, since this is a survey of a career in progress and to fully report it, both pictures and text survey the artist's creative explorations since their beginnings.

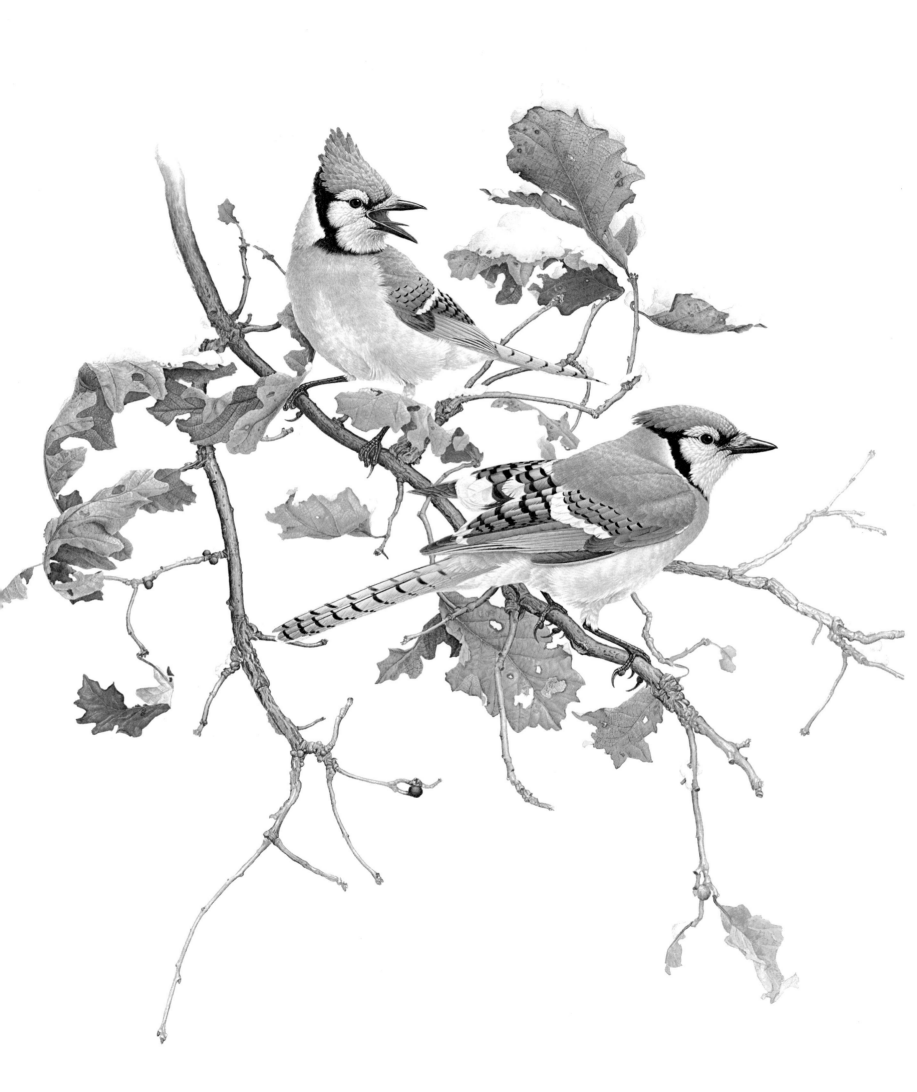

BLUE JAY, 1976
Transparent watercolor on paper, 26 x 30" (66.1 x 76.2 cm.)

13

I. Early Beginnings

ontemporary concern with the conservation of our natural heritage has brought with it an increased interest in wildlife art, past and present. It has been the good fortune of North American artist Martin Glen Loates to approach his maturity as an animal painter during this period. The current awareness of a beleagured nature has helped to bring his special talents to an international audience at an early stage in the artist's career.

Glen Loates was born on May 3rd, 1945, in Toronto General Hospital, three or four minutes before his twin brother, Bernard. That the twins should be involved in art seemed almost inevitable. Their father, Albert Arthur Loates, was a designer and talented amateur painter; their two older brothers, Walter and Jim, were to carve their career in architecture and commercial art.

The Loates' family circumstances were modest. Glen's father, like his son, was born in Toronto, and had begun his career during his early teens as an apprentice at his parents' butcher shop in the city's east end. In his spare time, Albert Loates painted traditional watercolors and decorated porcelain in oils, an activity he inherited from his English-born mother. When he was nineteen, Albert Loates' interest in art overcame his future as a butcher, and he left home to launch a slightly more

creative career as a painter of billboards. Glen's father soon left behind his ambitions as an artist in favor of a career as a display specialist, but his affection for portraying animals and birds no doubt had some impact upon his son's early decision to become a wildlife painter.

Some of Glen Loates' first memories are of the flat above a variety store on Toronto's Mt. Pleasant Road, where he spent the first six years of his life. Mt. Pleasant was a busy thoroughfare, and provided plenty of divertisement for the eyes of an already budding artist. He would sit at the front window, enthralled by the street's passing pageantry of clanking red trollies, horse-drawn ice carts, trucks, steam rollers and assorted pedestrians.

In the bunk bed he shared with his twin brother, Glen would draw up his observations in crayon on cheap paper pads. A few of these drawings, done between the ages of four and six, survive to give evidence of the acute observations of an already visually aware child.

Although these sketches show a surprising exactitude of hand and vision, the boy was never satisfied with them. It was when he asked his mother to correct them, and was directed to his father, that he received his first criticism and instruction, simultaneously becoming aware of a new side to his parent's talents. Realism concerned Glen from these earliest beginnings, and in his childhood pur-

PARROT, 1931
Watercolor by Albert Loates, the artist's father
Age, nineteen years

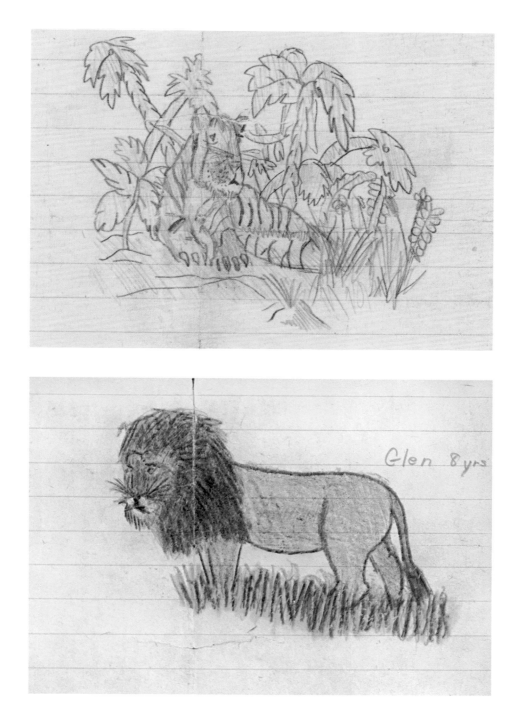

Top: TIGER, 1953
Pencil on paper. Age, eight years
Above: LION, 1953
Pencil on paper. Age, eight years

17

suit of it, he added plasticene sculptures to his repertoire, attempting to reproduce fruit and other objects, constantly frustrated that he couldn't make his replicas more "real."

Loates' childhood drawing activities did not detract from a busy, normal childhood, but complemented it. The neighborhood held a variety of challenging playgrounds for the very young. With their older brother, Jim, Glen and Bernard would go hiking, exploring and tobogganing. In the immediate vicinity of their home was the sprawling and beautiful Mt. Pleasant cemetery, which the boys readily converted into a vast playground for walks and games. Nearby, too, was a railway spur alongside a large coal and lumber depot, where Glen found trains and dumptrucks to draw, and endless structures to climb.

Jim, or their parents, would also take the twins to the local Riverdale Zoo where, at the age of seven, the artist drew his first portraits of birds and mammals. The local movie house set the seal on this concern for animals, when Glen saw his first Walt Disney films. For years after, he amused himself, from time to time, doing adaptations of Disney cartoon characters, and his affection for the great American animator has remained firm ever since. Today, Loates owns a large collection of Disney lore, covering everything from Mickey Mouse watches to penny-banks and virtually every related publication.

Glen Loates' interest in portraying the wildlife of his native country came early, and he was encouraged in his love of the land by the tales his mother used to tell about her parents and distant ancestors all of whom for generations hailed from Newfoundland.

His mother's maiden name was Frona Maria Rowe and her father, Walter Rowe, operated a lumbering business in St. John's. Today, Glen remains devoted to the facts of his long natural heritage, and that background has undoubtedly affected the direction of his career.

Strangely enough, Glen did not receive any encouragement during his earliest school years, spent at the nearby Hodgson Avenue Public School. He remembers no art instruction and a complete absence of paintings from the classroom walls. His teachers' only comments on his special talents were that he was concentrating too much upon art. He was not unhappy when the family left Mt. Pleasant Road to move to Homewood Avenue, located in the northern outskirts of the city. It was a district still studded by farms and possessed a markedly rural atmosphere. Here, for the first time, Glen's attention was attracted to nature. He wandered the local fields, and sketched horses in pencil and crayon at the farm of a school chum, Larry Passer. Though his teachers still seemed slow to encourage his talents in art, his fellow students collected

all the drawings they could acquire from the developing artist. This fan club did much to increase Glen's boyhood creative production.

It was at this time that Glen's mother took him and his twin brother to see the Walt Disney classic, *The Living Desert.* "It was a turning point in my career," Loates later recalled. "I remember being absolutely stunned by that film. The beauty of the photography and the drama of the animals overwhelmed me. I think my future direction was decided then and there. Certainly, I owe a tremendous debt to Disney for my becoming a wildlife artist."

This newly awakened interest in wildlife was accelerated when the family moved to Estelle Avenue in Willowdale, an area north of Toronto which was prolific with ravines, woods, streams and swamps.

"If Disney inspired me, Willowdale provided me with my first true nature subjects and backgrounds," says Loates.
He was now ten years old, and becoming an avid collector of butterflies, beetles, grasshoppers and other insects, all of which he drew. Those early boyhood drawings are full of surprising observation and technical finish. Glen was obviously already a wildlife prodigy.

Young Loates discovered Miss Fraser, a teacher at Cummer Avenue Public School who took an interest in his work. From time to time she would pin his efforts up in a place of honor on the classroom board, and called upon him to display his talents for his classmates and visiting inspectors. But Glen did not possess outstanding academic skills, and rarely received the gold and silver stars with which the teacher ornamented the better efforts. To compensate, Glen would forge his own stars upon his doubtful exercises.

Not far away from Cummer Avenue School flowed the winding Don River, a perfect refuge for boyhood hikes and assorted birds and mammals. The Don River had been a favorite painting place for generations of celebrated artists and was the first artistic home of the famed Canadian-American naturalist, Ernest Thompson Seton, who based many of his early nature stories on the banks of that river. The Don was also to be the site of Glen Loates' first considerable efforts in wildlife art. While his brother Bernard searched for fossils, Glen sketched flowers, moths and beetles. On their bicycles, the twins were able to explore miles of the river at will.

The Loates' family activities were sometimes an almost accidental influence in abetting the artist's career. During weekends in the summer months, Glen's parents would often take their children to Lake Simcoe, a large lake fifty miles north of Toronto. On trips in an outboard up some of the streams feeding the lake, Glen and Bernard would

pursue and observe snapping turtles, bull frogs, and myriad small fish amidst the water-lilies which grew in abundance in the quiet backwaters. Occasionally, they would sight a groundhog, fox or raccoon. What might later seem tame stuff, then composed a series of exciting discoveries.

Back in the city, there awaited another new source of wildlife lore. Glen's grand-mother Loates had noticed him sketching flowers in her backyard during family visits. She suggested to his parents that he and his brother would benefit from a visit to the Royal Ontario Museum, and volunteered to take them there.

In his strongest imaginings, Glen had never suspected the existence of the wildlife riches he found on display at the museum. "I was awe-inspired by the sheer amount of animal life to be seen, and by the presence of species which no longer existed, like the pas-senger pigeon."

Glen was specially excited by the museum's thousands of insect specimens that he discovered under black protective blinds. One after another, he would lift the light-proof covers to find the endless colors and shapes which mark the insect world. Their vivid and iridescent patterns compelled him back to the museum again and again during the next few years, always with sketch book in hand. Glen and Bernard, who were almost inseparable,

would make the long trip together downtown every few months to exercise their fascination, Glen in the zoological area and his brother in the geological. Many of Loates' most success-ful drawings of his pre-teen years resulted from those early visits to the Royal Ontario Museum, which was later to provide him with some of the most fruitful associations of his career.

Glen Loates' parents were their son's constant enthusiasts during those early, forma-tive years. His father established a small studio for him in the basement of their home, com-plete with artboard, filing cabinet and a peg board to pin up pictures. He helped Glen build up a collection of animal illustrations for his files, and was always ready with information about techniques and media from his wide experience as a designer. Glen was provided with a microscope, books on insects and, at the age of eleven, a volume of the paintings of John James Audubon. Thus, in all ways, the wildlife artist's future was being lovingly launched at home.

In 1955, at the age of ten, Glen met two men who were to have a deep influence on his life: Gary C. Benson, who was to be his school teacher for the next three years and Fred Brigden, a noted Canadian painter.

Benson recognized the youngster's natural creative talents, and became his first patron. Noting his student's academic limita-

tions, he urged him to use his special gifts to enhance his studies. As a result, Loates produced notebooks that were visually compelling, and were preserved by his teacher. These notebook studies are graphically detailed notes, mostly of natural science themes, and in them Loates reveals for the first time his love of realism and his ability to record fact in an exact, dramatic way. And it is just that balance between fidelity and action which was to typify the artist's mature wildlife art.

Benson's classroom was the first in which Loates found any sign of fine art. The walls were decorated with reproductions of paintings by leading Canadian painters and illustrators. Benson would not hesitate to introduce works of art into his general teaching if it would enlarge upon or illuminate an academic idea. The classroom book shelves were lined with *National Geographics* and other publications relating to natural history, all of which were eagerly perused by young Loates. Glen spent three years under Benson's tutelage, repeating grade six twice. The teacher's greatest compliment to his young student artist was to commission him in 1958 to paint a mural for the Benson home's recreation room. It was the boy's first major creative undertaking, and he spent the entire summer of 1958 executing the wall design. The fact that the subject was a Paris street

scene did little to curb the enthusiasm of the nature artist.

In the spring of 1955, Cummer Avenue Public School invited veteran landscape painter, Fred Brigden (1871-1956) to exhibit his art and speak in the schools' auditorium. Brigden, who had achieved the status of a "grand old man" of Canadian art, lived only a few blocks away from the school. Like Loates, Brigden, who had come to Canada from England as an infant, did many of his earliest boyhood sketches along the banks of the Don River. He had gone on to become a pioneer painter of Canada's northland during the first decade of the century. He enjoyed a diverse career, as co-founder of one of the country's major commercial art houses, illustrator and landscape painter. His most successful works were in watercolor, and in 1926 he was the founding president of the Canadian Society of Painters in Watercolor. When Glen Loates heard him talk in the schools' auditorium, Brigden, although by now in his early eighties and retired to his Newtonbrook home overlooking a large orchard and the expanses of the Don Valley, was still a vital and energetic presence.

Glen was excited about seeing and hearing his first "professional" painter, but not so much that he abstained from hurrying up to his classroom immediately after Brigden's talk to show his own efforts to the veteran

artist. Brigden studied the student's work with interest, and invited him to visit his studio. The following weekend, loaded down with every example of his drawings he could find, Glen rode his bicycle to Brigden's studio home. "It must have been the most exciting day of my life up till then," he later admitted.

Before looking at Loates' work, Brigden took him on a tour of his studio, chatting about art in general, and showing the boy examples of finished landscapes and pictures in progress. He explained the differences between watercolor and oil, and let his young visitor examine the various items of materials and equipment. All of this time, although delighted by the privileged tour he was taking into the wonderland of art, Glen was anxiously awaiting a chance to show his famous host the samples he had brought with him. Finally, the opportunity came, and he took from a brown paper wrapper his large pile of drawings.

Brigden sorted these out into two groups, one of cartoons, mostly copies after Disney, and the original studies Glen had made from insects he had collected.

"Forget these," the mentor told the boy, pointing to the heap of cartoons. Then indicating the nature drawings, he added, "This is where you should be going. That butterfly—it is beautiful because it is from your personal experience and your own feelings about it. Feeling is as important in art as fact, but it must be your own." Brigden also suggested that Glen should try landscape painting, but only if he felt he wanted to do so.

Fred Brigden invited Loates to revisit him whenever he had new works to show. He wanted to watch the progress of his new protegé. Thus developed a close, if brief, relationship between the two, born generations apart, but sharing the same creative background of their beloved Don River. Glen went back again and again, for instruction and encouragement, during the following year before Brigden died. He was allowed to watch the older artist at work, an experience for which he later gave credit for helping him understand the watercolor medium. Brigden also steered Loates away from the fugitive colored pencils he had been using. He taught him about permanent color, and the importance of keeping his watercolor washes "clean." He gave him sheets of watercolor paper and other materials. Always, after the first few visits, he insisted that his young visitor call him "Fred."

"It is impossible for me to measure the importance of that brief year's encounter with Fred Brigden," says Loates today. "He was the only true art teacher I ever had. He was endless in his generosity and technical advice."

Loates took Brigden's expert counsel to heart. He stopped using colored pencils and

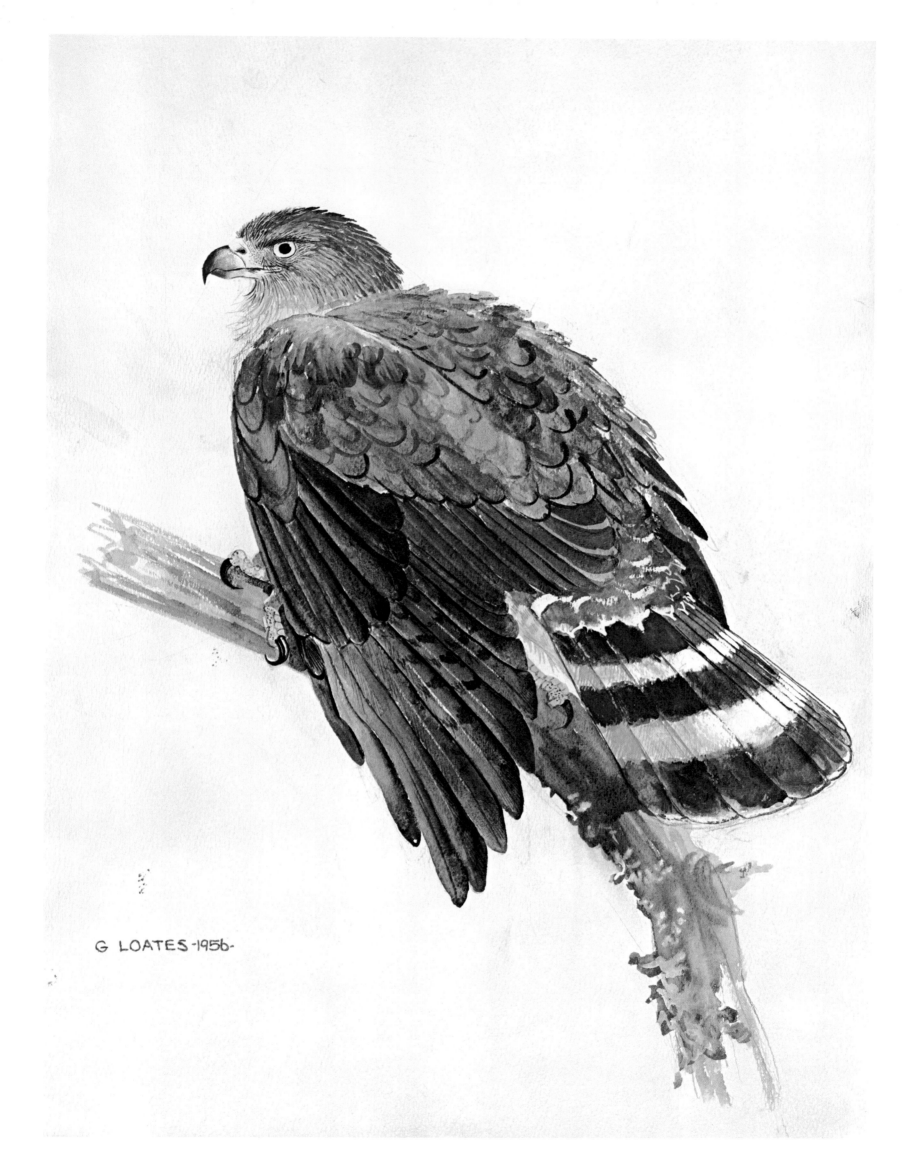

G LOATES -1956-

HAWK, 1956
Opaque watercolor on paper, 18 x 12" (46 x 30.5 cm.)

23

began painting in watercolors, from a box which his parents bought for him. At first, the new medium confounded him, but with Brigden's assistance he was soon using it with surprising ease, the beginning of that perfection of watercolor technique which led to the subtle major works of later years. Those earliest watercolors were mostly of creatures he kept in his small basement aquarium— crayfish, tadpoles and snails—and of a growing collection of mounted insects which he obtained from the Don Valley and nearby parks.

Between the years 1960 and 1961, Glen Loates attended Northmount Junior High School. That period was very enriching. For a student who was not markedly drawn to academic scholarship, Glen was increasingly fortunate in some of the tutors he encountered. Following several years in the classroom of the sympathetic Gary Benson, he found himself in the science class of Stewart Calvert at Northmount High for two years. Calvert was a natural history buff and was attracted by his artistically gifted student's preoccupation with wildlife. Like Benson, he encouraged Loates to use his creative talents to buttress his science studies. As a result, science was the only academic subject in which he excelled. It was Calvert who relaxed Glen's depression about his lack of high scholastic marks, and urged him to seriously consider art as his

profession when he left high school.

"It may be hard to believe that one teacher could affect the direction of my life so deeply," recalls Loates. "But Stewart Calvert's urgings and insight were an immeasurable support during those early 'teen years. I emerged from his classroom more determined than ever to become a professional wildlife artist."

It was during those early high school years that Glen first visited a public art institution, the Art Gallery of Toronto (now the Art Gallery of Ontario). His initial reaction to the work of past painters was mixed. For whatever reason, his response to the canvases of Rembrandt, Hals, Rubens and other old masters was negative. But he instinctively reacted warmly to the northern wilderness landscapes by such Canadians as Tom Thomson, Arthur Lismer and A. Y. Jackson. No doubt he sensed in their interpretations of beaver ponds, backwater swamps and dense forest, the isolated environment that could harbor the animal life which now so deeply engrossed him.

By the time Glen Loates entered high school at the age of fourteen, he was already doing some surprisingly competent wildlife studies. Daily he would inform himself about the subjects he wished to paint, by observation, reading and collecting specimens, alive and dead. By the late 1950's, his work was

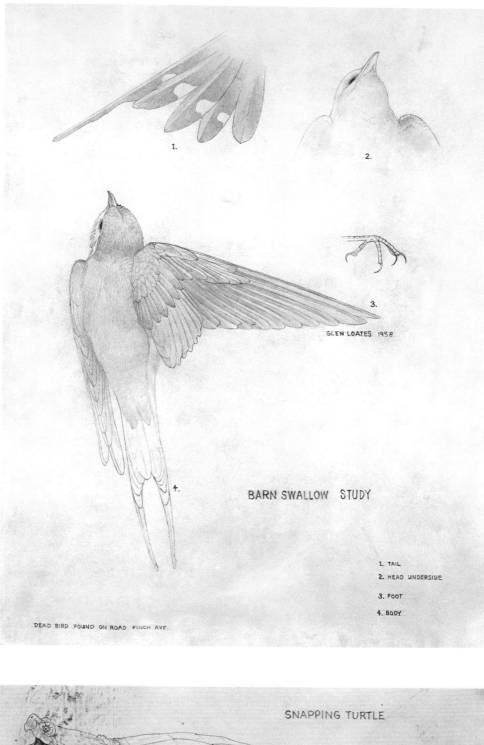

BARN SWALLOW STUDY

GLEN·LOATES 1958

1. TAIL
2. HEAD UNDERSIDE
3. FOOT
4. BODY

DEAD BIRD FOUND ON ROAD FINCH AVE.

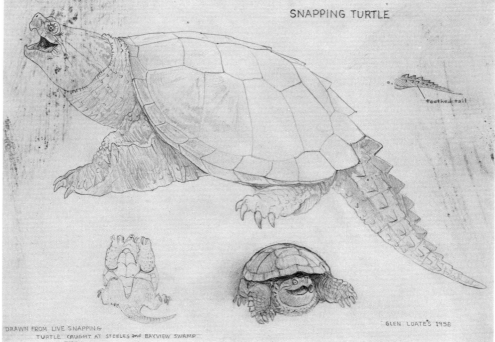

SNAPPING TURTLE

feathed tail

DRAWN FROM LIVE SNAPPING
TURTLE CAUGHT AT STEELES and BAYVIEW SWAMP

GLEN·LOATES 1958

Top: BARN SWALLOW, 1958
Pencil on paper. Age thirteen years
Above: SNAPPING TURTLE, 1958
Pencil on paper. Age thirteen years

beginning to reveal an air of maturity.

Most of the drawings done during 1958 were executed in the demanding medium of lead pencil, which leaves no room for the slick effects and lack of precision obtainable with more flexible media. Pencil demands discipline of the hand and certain accuracy of observation. It is rarely willingly chosen by a very young artist because of its stern character and lack of instant effect. In a good pencil drawing, every stroke must be meaningful. Young Loates chose pencil because, even at the age of thirteen, he was aware that if he was to succeed as a wildlife painter, intimate observation and exact rendering must underlie every bird or animal portrayal. There could be no room for cheating in such a marriage of science and art.

The formative drawings from the late 1950's reproduced in this volume give some notion of Loates' earliest serious attempts at wildlife art. Typical of his many 1958 studies is the "Snapping Turtle," captured by himself and Bernard at a swamp near their home. In a cardboard box, which served as an enclosed model stand, Glen was able to observe his potentially vicious subject at leisure. This early drawing is not only effective as description, but possesses an easy vigor of execution for so young an artist. No less well achieved is the "Barn Swallows" study of the same year, based on a specimen found in the gutter on neigh-boring Finch Avenue. There is a surprising grace and surety in this teenage drawing. Not all of Loates' earliest drawings were limited to wildlife: his sketch of a rail fence from 1958 was drawn partly in response to Fred Brigden's earlier urgings to look at nature and landscape in all its aspects. In most of these boyhood drawings there is a remarkable lack of that stiffness and awkwardness normally found in the work of artists still in their early 'teens.

Two large pencil drawings of 1959 suggest that Loates already had a sure instinct for composition. "Sparrow Hawk" and "Common Crow" are placed upon the paper with an eye to both abstract design and dramatic impact. The easy sense of pictorial balance they reveal offers a hint of his mastery of design to be seen in such later outstanding works as "Raccoon Family" (1976) and "Red Fox and Ring-necked Pheasant" (1975). The large study of the "Common Crow" possesses a dramatic presence that sets it aside from most of the drawings of Loates' fourteenth year, as well as an admirable vigor and com-pleteness in its realization.

While Glen concentrated upon wildlife, his twin brother acquired a youthful passion for geology. Bernard became an avid "rock hound," and his search for samples would take him frequently northward to the geologically rich area of Bancroft. Glen would join him on these trips, dividing his time between assisting

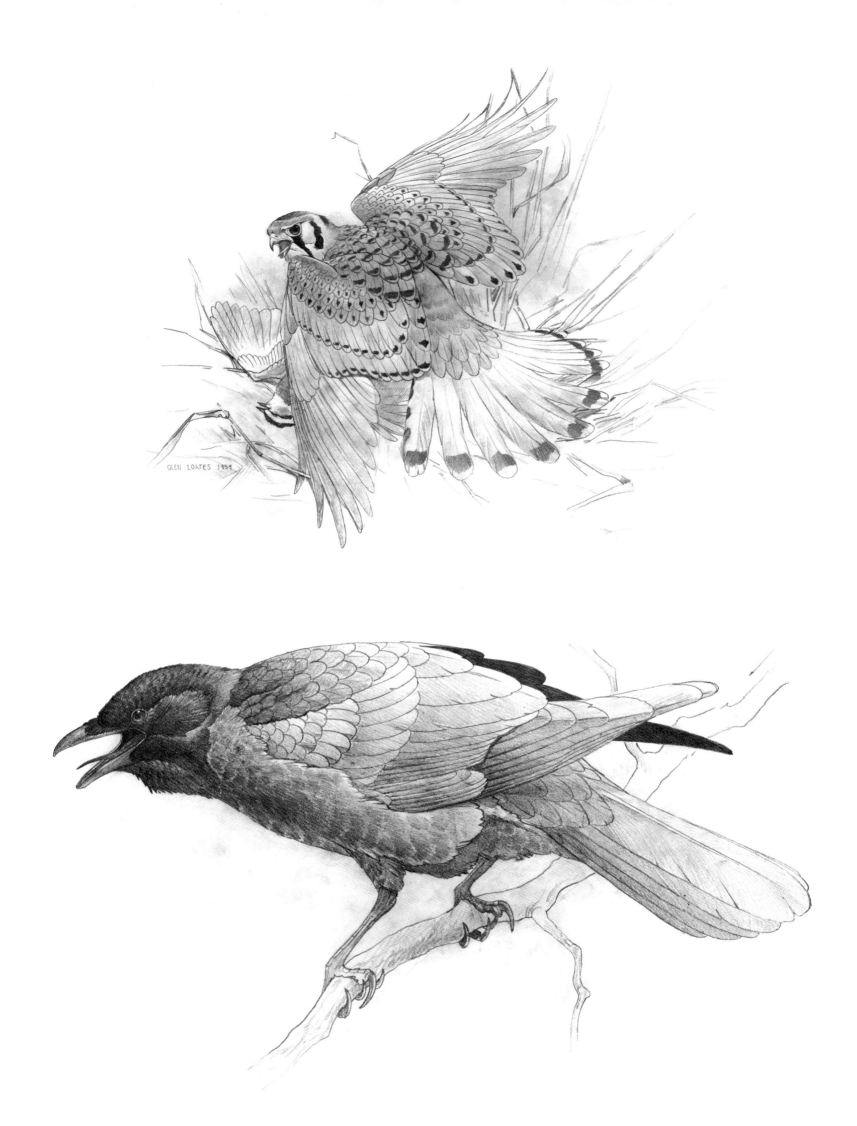

Top: SPARROW HAWK, 1959
Pencil on paper. Age fourteen years
Above: COMMON CROW, 1959
Pencil on paper. Age fourteen years

27

his brother's treasure hunt and sketching. On their earliest Bancroft sojourns, they were driven by the father of a friend, but as soon as Bernard reached sixteen he obtained a driving licence, and the two boys travelled at will throughout the northland for six or seven years in one of the now-prospering family's cars. It was just one more instance of the interdependence which had marked the twins' relationship since infancy. Much of Loates' feeling and knowledge for northern mammals came from those early drives to Bancroft, Timmins, Huntsville and other areas.

Many of Loates' earliest nature drawings are of insects and spiders, his first loves among wildlife themes. These include several portraits of tarantulas, which show the experimental range of his maturing black and white drawing techniques. A 1959 tarantula study is an ominous silhouette rendered in broad, almost brusque, ink strokes, while another the following year is almost delicate in its style. The subject of these two drawings was purchased in New York on one of the Loates family's return trips from a Florida vacation. For many years, during his 'teens, these annual visits to Florida gave Glen an opportunity to sketch southern flora and fauna. Much as he enjoyed the material in Florida, however, he looked forward to the family's brief stops in New York en route home.

There, he would make long visits to the city's Museum of Natural History, sketching as many specimens as time would allow. One of the resulting drawings is the "Squid" reproduced in this volume. The basic pencil drawing was done at the museum, and later developed in India ink when he arrived back in Toronto. The stippling technique used in its rendering is characteristic of the careful pen and ink studies he was concerned with in 1960. Glen's preoccupation with this technique was short-lived, though it supplied a very valuable contribution to the artist's technical discipline.

Occasionally, Loates would revert back to drawing insect studies, particularly for his school science notebooks. A remarkable 1960 example of this is the study of "Mosquito." This reveals the intense desire in the young artist to elicit the maximum of acute observation and executive skill in his graphic work. It may appear stiff in rendering compared to the easier fluidity of his later achievements, but it is a remarkable accomplishement for a boy still in his fifteenth year. A related 1960 painting on tinted paper, of the "Common Housefly," is hardly less impressive in its fastidious presentation of *minutae.*

During his two years at Northmount Junior High School, the quality of Loates' painting abilities improved rapidly. His technical skills with paint were quickly catching up with his talent as a draftsman. He had learned

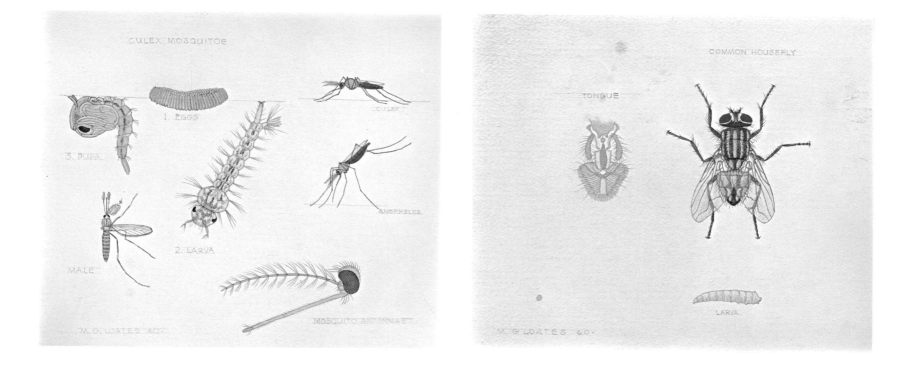

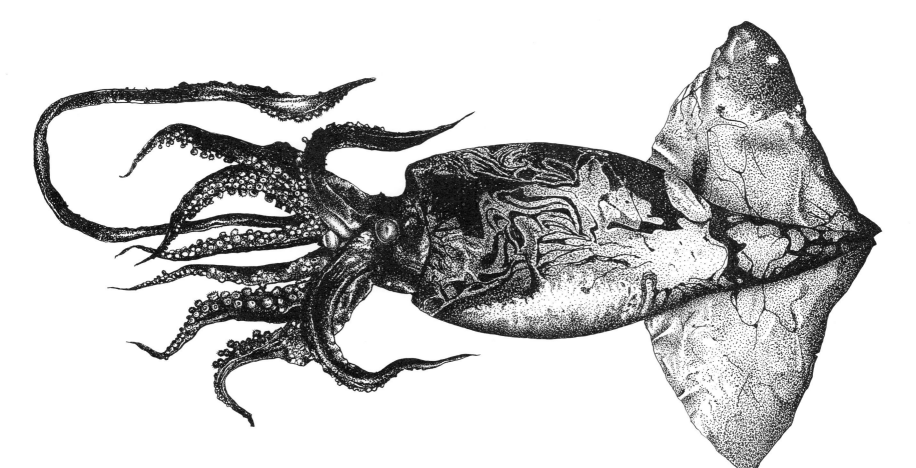

Top left: MOSQUITO, 1960
Opaque watercolor on tinted paper. Age fifteen years
Top right: COMMON HOUSEFLY, 1960
Opaque watercolor on tinted paper. Age fifteen years
Above: SQUID, 1960
Ink on board. Age fifteen years

Fred Brigden's lessons about clean color and crisp brush handling well, and his efforts in both opaque body color and transparent wash were approaching a mature style. The 1959 study of the head and other details of a Baltimore Oriole is typical of these early attempts. Like most of his painting between 1959 and 1963, it is executed with body color on a sheet of tinted paper. By 1962, at the age of seventeen, Loates was ready to attempt finished paintings of complete birds, such as the Blue Jay of that year. Though its body handling has neither the sharp fidelity, delicacy nor chromatic sparkle of his mature works in transparent watercolors, the young artist was pleased with this painting at the time, and it encouraged him to pursue his early interest in birds, a theme which was later to give way to increasing concern with mammals. In the meantime, his bird compositions were to grow in surety and subtlety, as witnessed by his two 1962 pencil studies, "Swamp Sparrows" and "Northern Shrikes." He was beginning to bring together his ornithological subjects derived from on-the-spot study and preserved skins, and his botanical field sketches, such as the jack-in-the pulpit in the "Swamp Sparrows," and the hawsberry bush in "Northern Shrikes."

Most of Loates' early bird studies were inspired, in part, by the example of two wildlife artists he admires most, John James Audubon and his contemporary, Fenwick Lansdowne.

He had owned his volume of Audubon's work for several years, and was introduced to Lansdowne's brilliant bird studies through reproductions in magazines and folios.

Many of Loates' youthful botanical paintings are complete, if modest, achievements in their own right. His obvious affection for floral life and his increasingly deft technique combined to create delightful momentoes of his woodland researches. Occasionally, these paintings were done on-the-spot, but more often were drawn from specimens dug up in the field and transported to the artist's studio. Invariably, however, careful pencil notes of the subject would be made before it was removed.

An excellent example of Loates' on-the-spot floral watercolors is the "Herb-Robert" of 1962, with the pale green fern "fiddleheads" in the foreground. Such sketches would take him the better part of a day, the young artist seated on a sketching-stool with a canvas seat, a jar of water and his paint-box beside him. The portrait "Wild Ginger" of 1963, and the "Woodland Violet" of 1964 are typical of the floral studies done from transplanted specimens. In all cases, Loates' floral studies of the early 1960's were painted in body color on tinted Fabriano papers.

From the time of his earliest trips to Florida with his family, Glen Loates was fascinated by underwater life. The submarine world, with its fantastic shapes, dramatic light

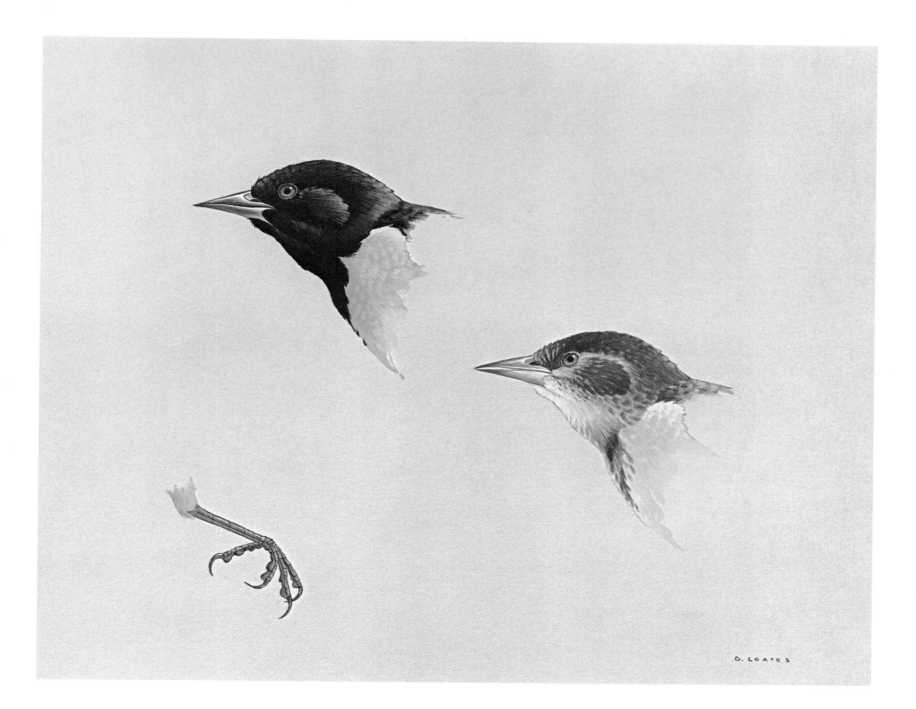

BALTIMORE ORIOLE STUDY, 1959
Opaque watercolor on tinted paper, 8½ x 11″ (21.6 x 28 cm.)
Private collection
31

and extraordinary color, fed his desire to portray aspects of it in paint. As early as 1958, at the age of thirteen, he was busy collecting and drawing marine specimens. An example of that year is the painting of a small octopus caught by Glen near a Florida wharf.

By 1964, the young artist's interest in marine subjects led him to paint what was unquestionably his finest and most ambitious painting to date. Titled "Sperm Whale and Giant Squid," it was the result of an overwhelming fascination for the mysterious Giant Squid, which he had first encountered at New York's American Museum of Natural History. This is a terrifying portrayal of one of nature's most gargantuan conflicts. The action is captured with a vivid actuality. The shadowless grey-green ground upon which the life and death drama takes place suggests the most impenetrable depths of the ocean. It is these very depths of its normal habitat that have kept the giant squid from being studied as closely as marine biologists would like. The sperm whale's power to dive offers the squid perhaps its greatest threat. In Loates' imagination, the struggle between the two ocean monsters is captured at its peak, the whale having just bitten through the squid's tentacles, attracting a school of sharks swimming nearby. The entire picture is in muted greens and blue greys, except for the dark carmine flowing from the Sperm Whale's torn flesh.

"Whale and Squid" illustrates the consummate care that Loates took in researching his material while still in his 'teens. He first read all the available texts he could find dealing with the giant squid. He then checked on the physical and natural history details with two authorities at Toronto's Royal Ontario Museum, David Barr, in the Museum's Department of Entimology and Invertebrate Zoology, and Dr. Randolph Peterson, the chief of Mammology, who advised on the Sperm Whale. In the resulting painting, Loates turned this expert information into an exciting confrontation in nature. It was to be one of the many compositions in which he brings together face-to-face competing species. The majority of wildlife painters restrict themselves to depicting one species at a time, but Glen, from some of his earliest works, has carved a special position for himself as a portrayer of rivalry, or the pursuit of one animal by another. This has added a unique note of drama to his most characteristic painting.

Though "Whale and Squid" is unquestionably Loates' most complex early marine study, his teenage ventures into the field ranged from fresh water algae to dolphins, all of them portrayed from life. His "Pond Leeches Feeding on Frogs-Eggs" and "Fresh Water Clams" of 1963 originated from

specimens gathered at Lake Simcoe and transferred to his own studio aquarium. More exotic themes such as "Dolphins" and "Clown Fish With Sea Anemones" of 1964 originated from trips to Florida. The first color notes for the Dolphins were made in a deep-sea boat, since the brilliant hues of that sea-going mammal rapidly disappear when exposed to air. The sketches for the Clown Fish were made from specimens viewed in captivity at a marineland.

Glen Loates' formal schooling ended in the winter of 1961, in the middle of his sixteenth year. Along with it, terminated his years of trial and error as a part-time amateur wildlife painter. For, though he had already shown remarkable accomplishments during his early 'teens, he had no opportunity to allow his talents that time and concentration required to hone them to the edge of professional perfection. The events of 1961 pointed him in that direction.

His divided allegiance between painting and school studies was causing Loates serious difficulties in the classroom. Despite his encouragement and sympathy for the young artist's special creative gifts, even Glen's favorite science master, Stewart Calvert, could see the necessity for a decision regarding the boy's future. He recommended to Glen's parents that Glen should leave his formal high school studies and enroll in a specialized art school. So, in December of his ninth-grade year, Glen left the structured confines of Northmount Junior High, hopefully to launch a career in art. This was not to be as simple as he may have hoped.

Loates first visited the Ontario College of Art, with hopes of enrollment. The College President, Sydney Watson, examined the boy's portfolio of nature studies, but rejected his application to study for two reasons. The first – and official – reason was Glen's lack of sufficient academic credits. The second – and sympathetic – explanation put forth by Watson was that the young applicant, with his ambition to be a wildlife painter, would hardly benefit from the usual courses taught in an art school. He admired Loates' obvious and already remarkably advanced gifts in his special field, and recommended that he pursue what was a rare and special talent.

Loates met a similar response when he searched for work among Toronto's many commercial art houses. He possessed no accredited diploma from an art school and his samples bore no direct relationship to the requirements of design or engraving establishments. Unlike the Art College experience, these commercial rejections disappointed and thwarted the ambitions of the youthful artist, who was prepared to do any kind of art work to launch his career. Little did he then realize that these rejections were to prove a vital part

of his future success. If he had obtained employment on the creative assembly line of a large commercial art house, he very well might have lost the impetus toward a career as a wildlife painter.

In the summer of 1963, a year and a half after leaving high school, Loates finally did manage to obtain work with the small Dickinson Commercial Art Studios, located on the third floor of an ancient building at the corner of Queen and Bay Streets, in the heart of downtown Toronto. The company had a staff which varied between three or four, headed by Marjorie Dickinson. Loates was hired as an apprentice, at thirty-five dollars per week. His earliest chores were to help keep the studio tidy, wash out pots and run errands. Dickinson specialized in mail order-catalogue work, and after a brief period, the new apprentice's technical skills were put to work re-touching photographs, accenting highlights, removing blemishes and generally gilding the retail lilies. His deft touch for detail was also used to render fine details on label designs. Loates remained at Dickinson two years. By the time he left, he was earning eighty dollars per week.

One important experience came out of Loates' stay at Dickinson. His employer, recognizing his special talent for wildlife art, attempted to find a commercial outlet for it. After a few months, she was able to direct him to Charles Matthews, of the printing house of Sampson Matthews, who was searching for an artist to portray wild flowers for a 1964 Toronto-Dominion Bank calendar. Through this, the work of Glen Loates first reached reproduction in color although, ironically, he was not allowed to use his signature. The fact that his special creative ambitions had been acknowledged and illustrated for thousands to see was exhilarating enough, despite the fact his name was omitted.

While at Dickinson, Loates continued to paint wildlife at home, and it was during this period that he executed such works as "Giant Squid." It was also then that he met a number of people who were to play decisive roles in the advancement of his career. Early in 1963, he had been introduced by Stewart Calvert, his former science teacher, to Mrs. Ottelyn Addison, who contributed articles to the *Ontario Naturalist Magazine.* Mrs. Addison was enthusiastic about the young artist's talents, and invited him to illustrate her writings on nature subjects. He received only five dollars for each of these pen and ink drawings, but the exposure and contacts resulting from the experience were inestimable.

One of the most rewarding contacts was Mrs. Addison's own son, Bill, who became one of Loates' leading fans. He introduced him to a number of distinguished naturalists, including the late Jim Baillie, one of Canada's

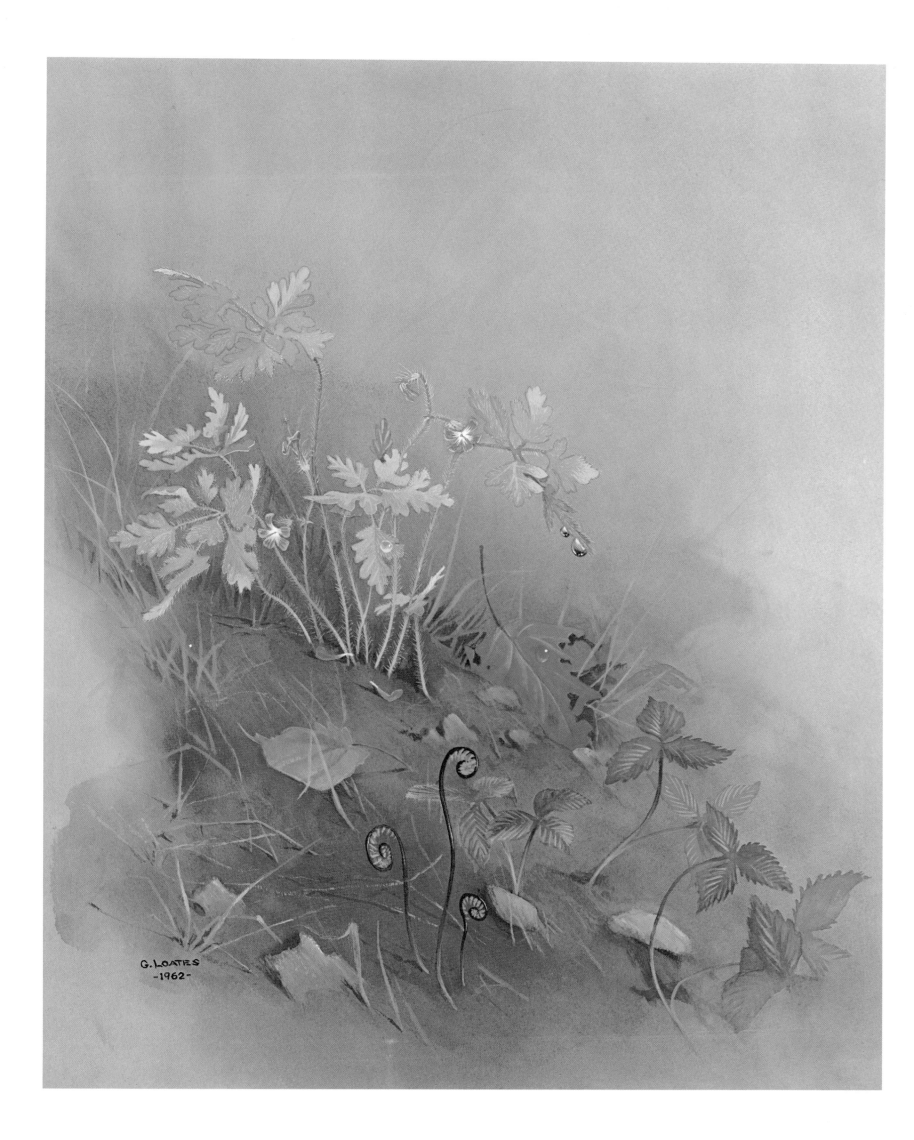

HERB-ROBERT, 1962
Opaque watercolor on tinted board, 18 x 16" (46 x 40.6 cm.)

outstanding ornithologists and a leading staff member of the Royal Ontario Museum, as well as an outstanding writer on bird life. Baillie immediately recognized Loates' special talents and offered him free access to any of the museum's mammoth collection of bird specimens. He took him about the museum, introducing the eighteen-year old artist to members of the staff who might assist him, including one who was to be of significant help to Loates: Terrence Shortt, the museum's chief artist and a leading bird painter. Shortt gave his young colleague the benefit of a life time's expert knowledge.

Bill Addison did much more than introduce Glen to Terry Shortt and other members of the museum's staff. He also intro-duced him to new areas of northern Ontario, rich in natural beauty and wildlife. During the spring and summer, Addison was employed as a forest ranger at Dorset, a small northern Ontario community. During 1963 and several succeeding years, he took Glen and Bernard with him on camping trips. The two boys would drive up to Dorset, and then head out on wilderness explorations with their older companion. They learned a great deal about nature from their guide, and Glen encountered a vast variety of wildlife to paint. With a tent as his studio headquarters, he sketched every-thing from chipmunks and fox to ravens and whisky-jacks. These expeditions with Bill

Addison proved among the most illuminating and productive of his career.

Once Bernard had obtained his driving licence, the twins often made long trips into the north by themselves in the family Volkswagen. At the time, Bernard was an inveterate rock-hound, and the brothers would travel throughout northern Ontario in search of geological specimens. Then, as later, the activities and careers of the twins were closely linked and temperamentally they formed an ideal balance. Glen had always been creative and reflective; Bernard was outgoing and an enthusiastic organizer.

It was at the request of Mr. James Woodford, director of the Federation of Ontario Naturalists, that Glen undertook a commission that would cement his career as a wildlife artist. He arranged for him to design the 1964 Christmas card for the Federation. Glen chose to depict a pair of cardinals for the occasion and was paid $150 – more than he had ever previously received for a single work. The consequences of the commission, however, far exceeded the initial price paid for it.

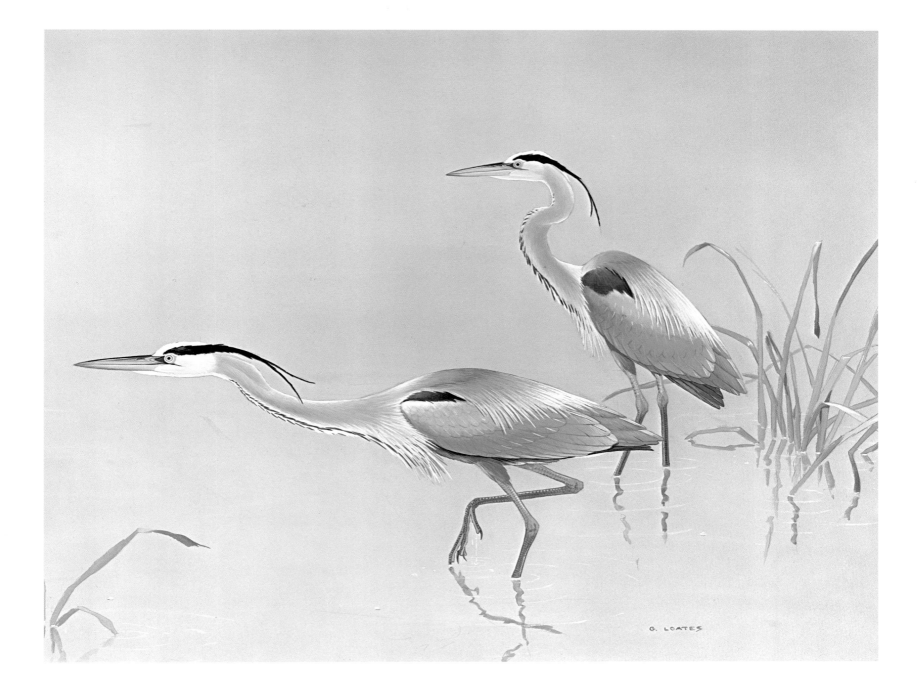

GREAT BLUE HERON, 1962
Opaque watercolor on tinted board, 15½ x 19¼" (39.4 x 48.9 cm.)
Private collection

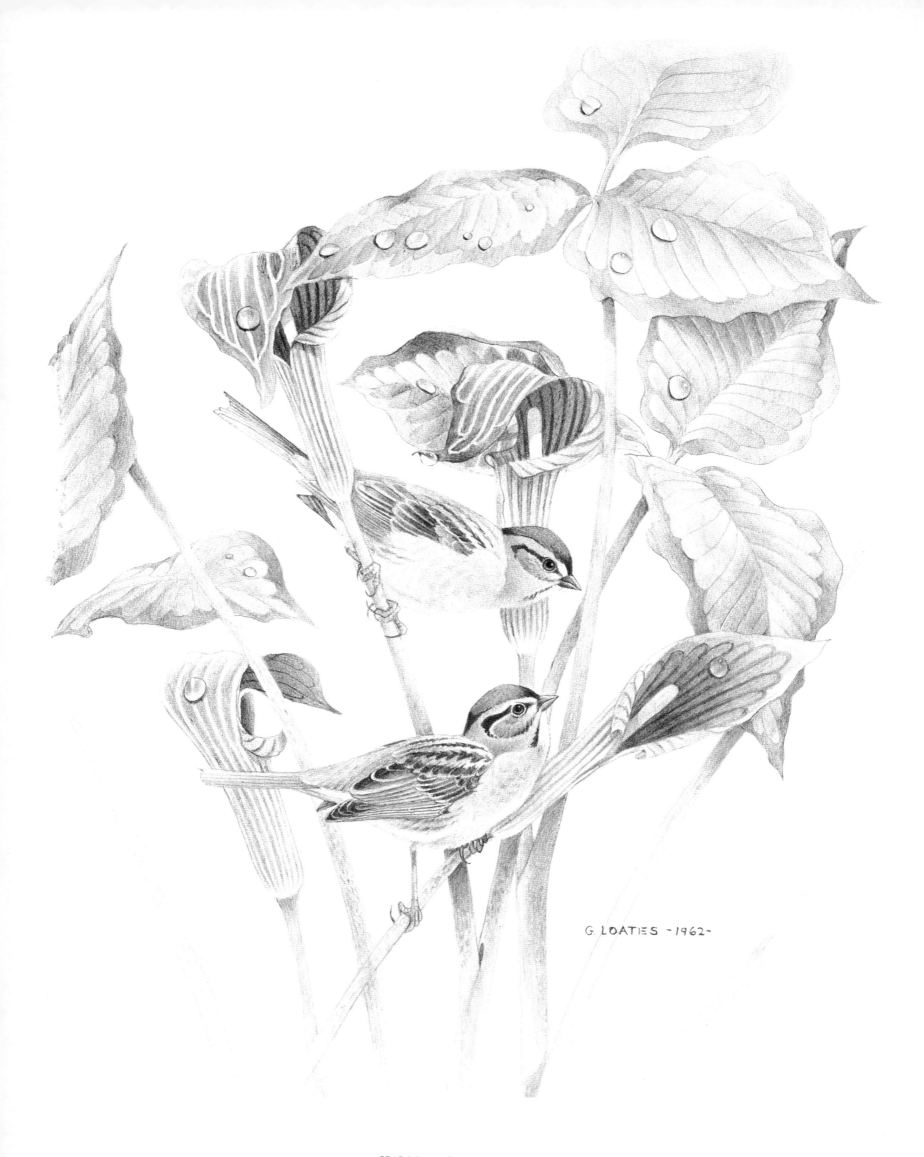

SWAMP SPARROW, 1962
Pencil on paper, 15 x 10¼" (38.1 x 26 cm.)
Private collection
38

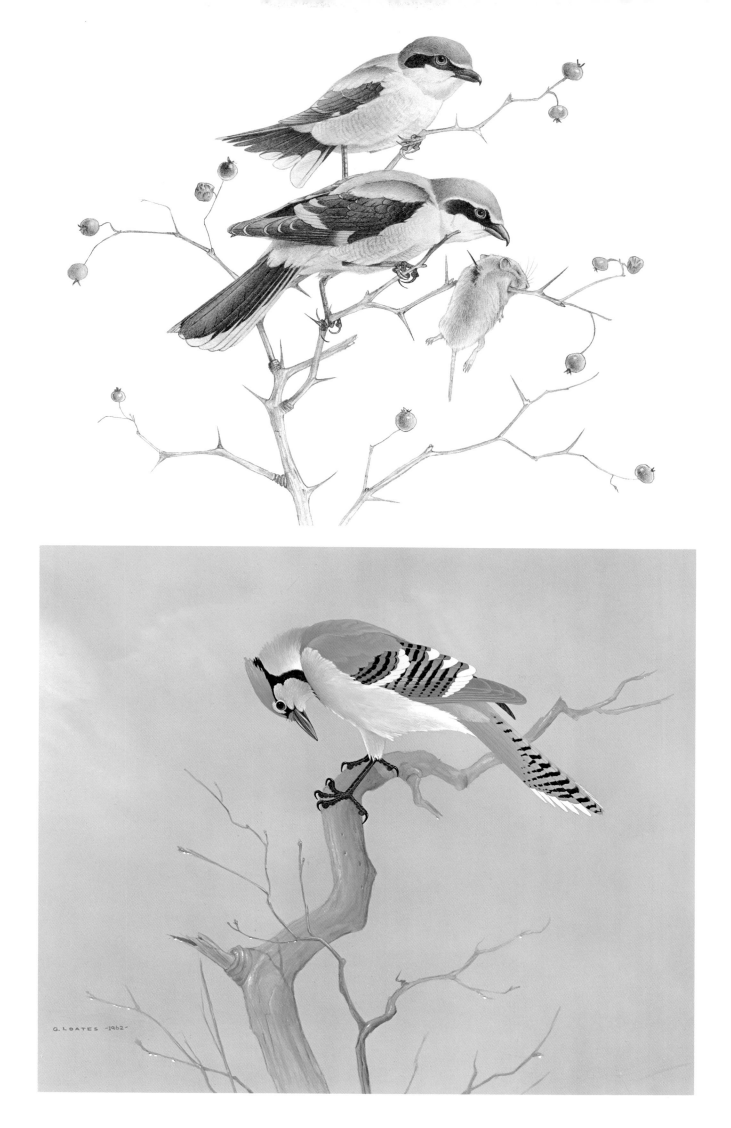

Top: NORTHERN SHRIKES, 1962
Pencil on paper, 10¼ x 15" (26 x 38.1 cm.)
Above: BLUE JAY, 1962
Opaque watercolor on tinted board, 15 x 19½" (38.1 x 49.5 cm.)
39

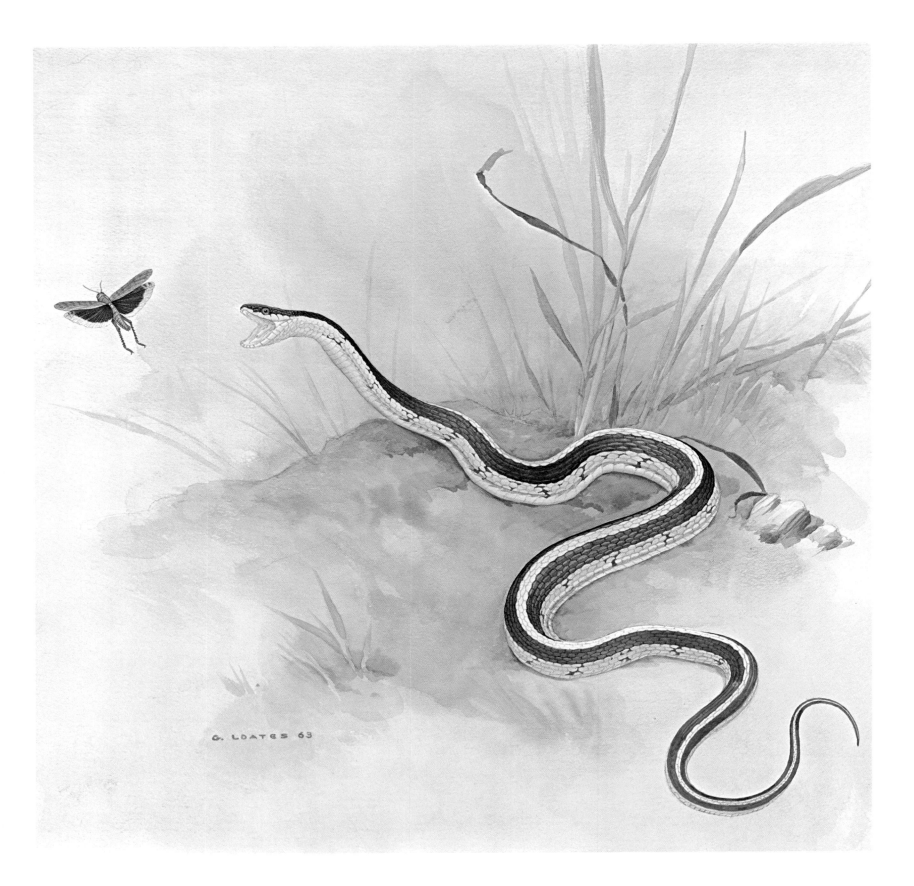

GARTER SNAKE & GRASSHOPPER, 1963
Opaque watercolor on tinted paper, 14⅝ x 15" (37.3 x 38.2 cm.)
Private collection

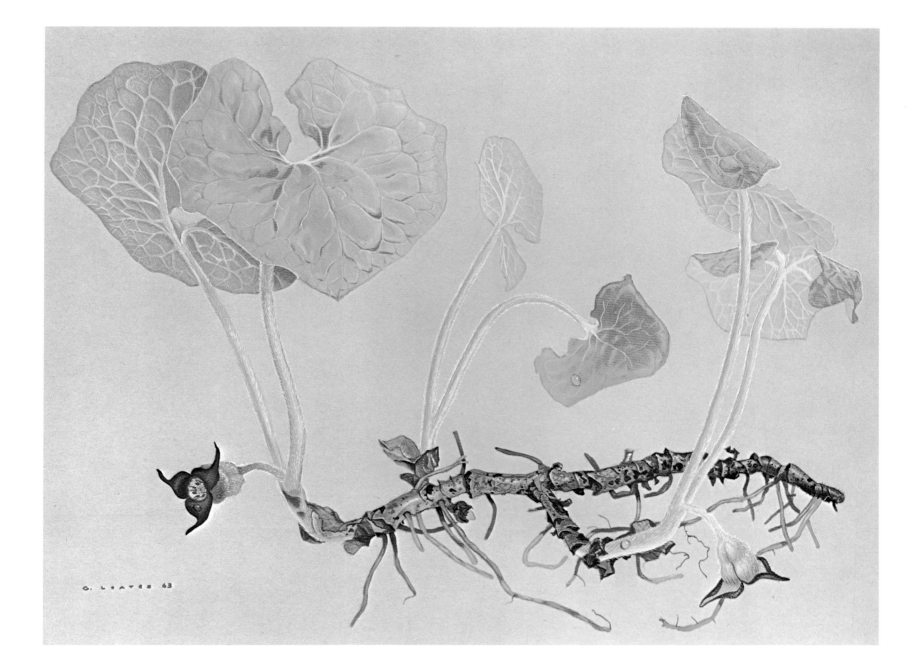

WILD GINGER, 1963
Opaque watercolor on board, 8¼ x 10¾" (21 x 27.3 cm.)

41

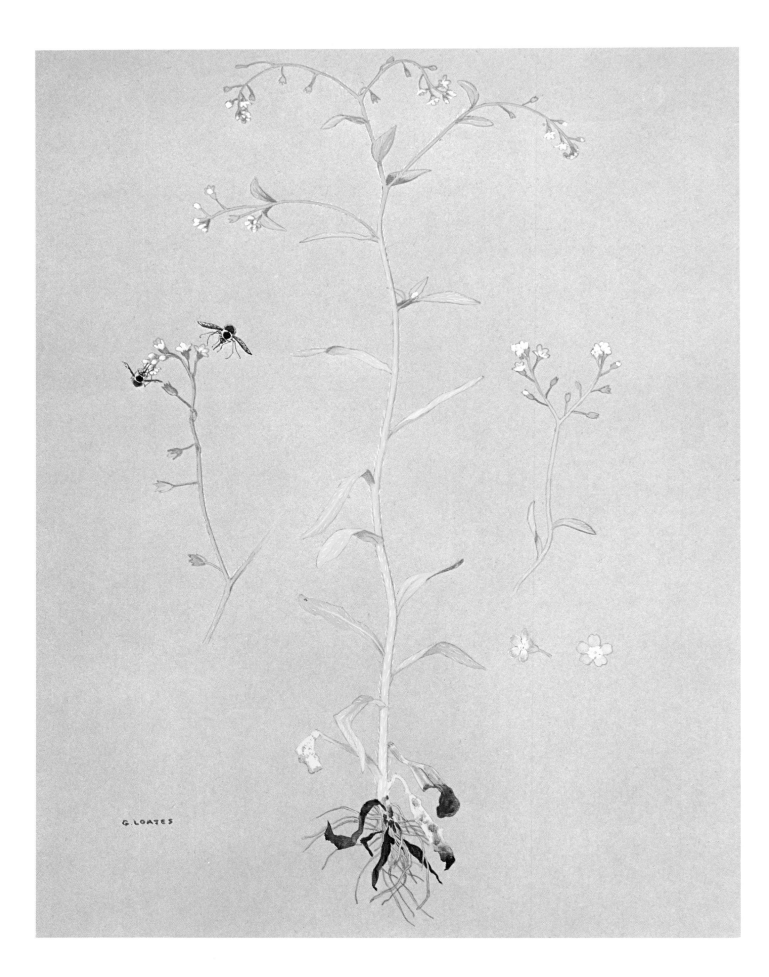

FORGET-ME-NOT, 1964
Opaque watercolor on tinted paper, 11 x 8¾" (28 x 22 cm.)
Private collection

42

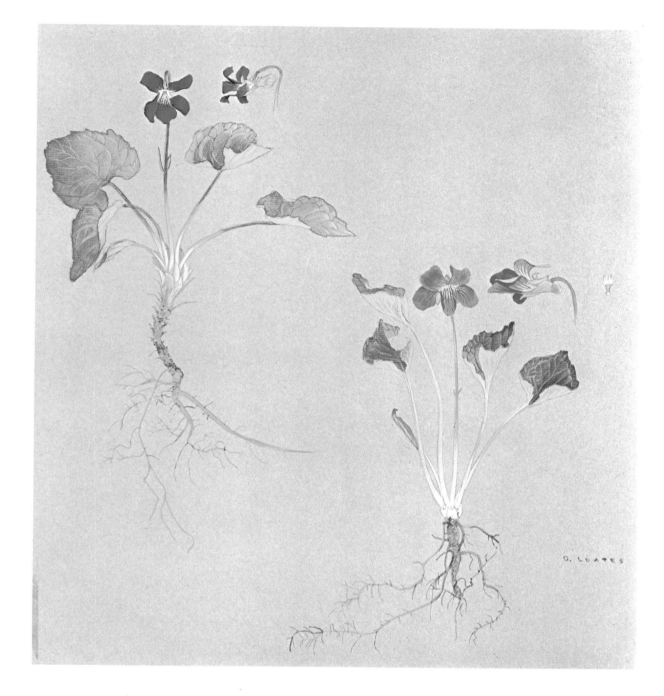

WOODLAND VIOLET STUDY, 1964
Opaque watercolor on tinted paper, 8 x 7" (20.3 x 17.8 cm.)
Private collection

43

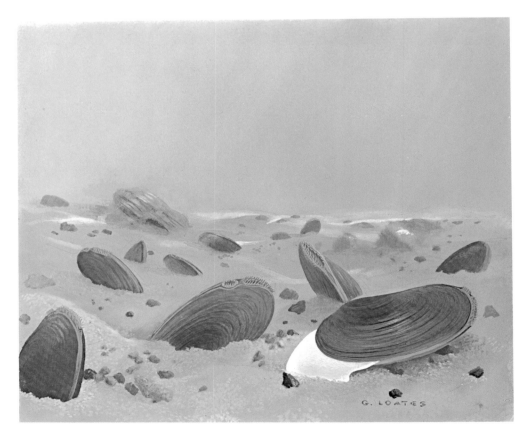

Top: POND LEECHES FEEDING ON FROGS-EGGS, *1963*
Opaque watercolor on board, 14 x 12″ (35.5 x 30.5 cm.)
Above: FRESH WATER CLAMS, *1963*
Opaque watercolor on board, 6 ½ x 7 ¾″ (16.5 x 19.6 cm.)

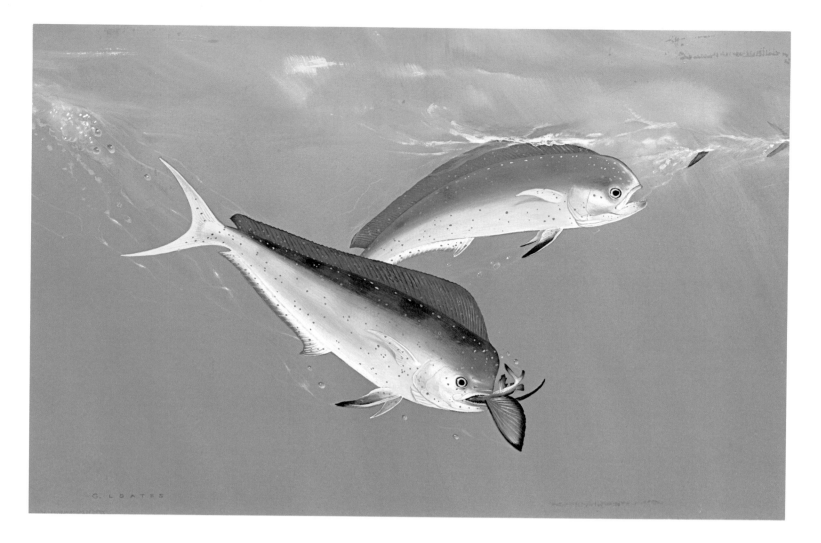

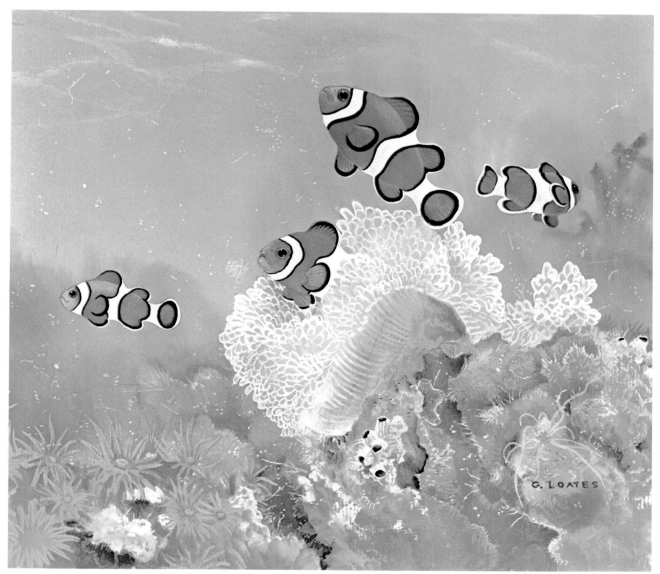

Top: DOLPHIN, 1964
Opaque watercolor on board, 12 x 15" (30.5 x 38.1 cm.)
Above: CLOWN FISH WITH SEA ANEMONES, 1964
Opaque watercolor on board, 9 x 10" (22.8 x 25.4 cm.)

45

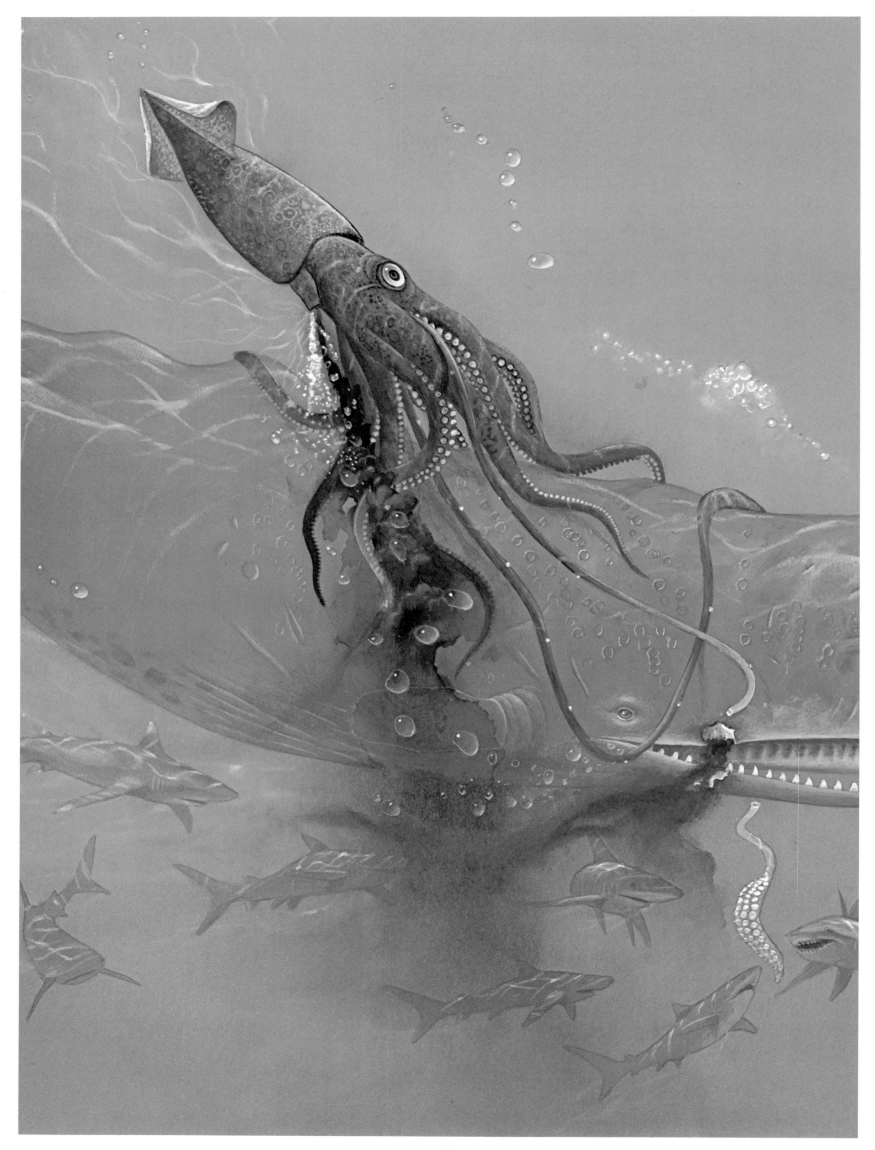

Detail from
SPERM WHALE & GIANT SQUID, 1964

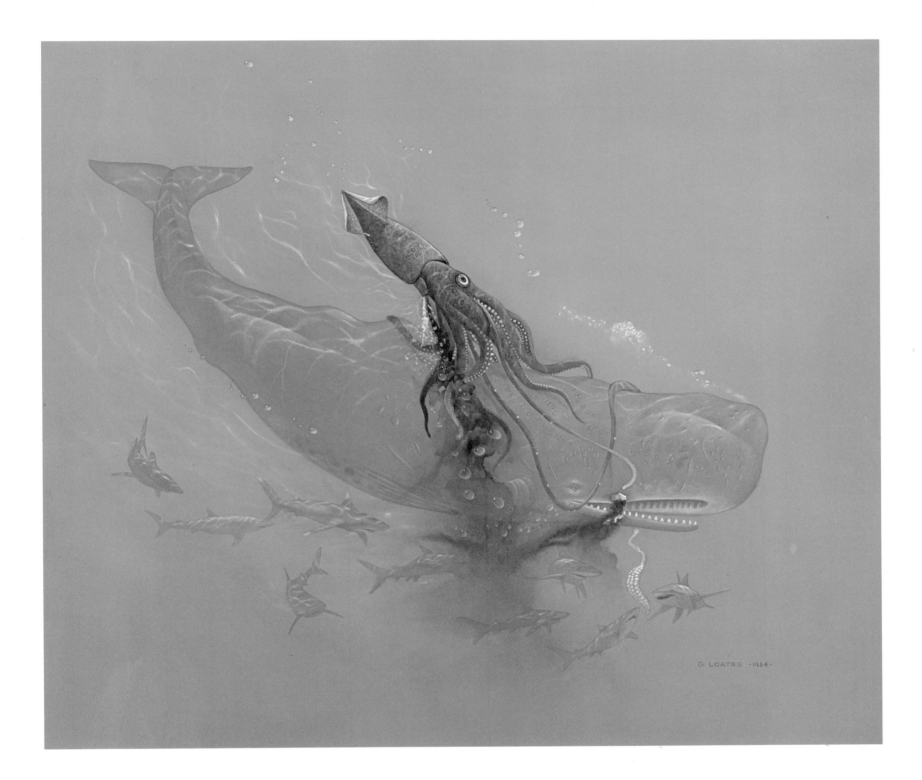

SPERM WHALE & GIANT SQUID, 1964
Opaque watercolor on board, 20 x 22" (51 x 56.5 cm.)
47

II. Transition

ne of the recipients of the Federation's Christmas card was Gene Aliman, art director for the mass-circulation *Canadian Magazine.* The painting of the cardinals so impressed him that he telephoned Loates early in February, 1965, with an invitation to bring a portfolio of his works to the *Canadian* offices. After receiving the samples, Aliman commissioned the artist to paint a series of songbirds for publication later that same year.

Loates recognized the importance of Aliman's offer and worked painstakingly through the first half of 1965 on the project. From the eight paintings he finally submitted, four were chosen for reproduction. The selected compositions are good examples of the near-photographic style the twenty-year old artist then favored. The backgrounds are thrown out of focus, much as they would be by a camera lens. Detail is restricted to the bird subjects and their immediate perch. This was a style originated in 1964 by Loates in a series of floral pieces for a local printing firm, R. G. McLean, and was utilized by the artist for several years.

This photographic style, however, lacked the analytical incisiveness which marked much of the artist's late teenage work. Analyses of form is partially sacrificed in favor of overall pictorial effect. In fact, there is almost a prettiness about the four birds reproduced in the *Canadian* of December 24, 1965. They possess a general softness which was foreign to the main direction of the artist's best wildlife studies until then. The paintings proved enormously successful with readers of the *Canadian,* and literally thousands of letters acclaimed the discovery of a new wildlife artist.

The featured songbirds were the Steller's Jay, Eastern Bluebird, Baltimore Oriole and Bohemian Waxwing. These were chosen for their sheer physical beauty, rather than for any scientific reason. For the occasion, Gene Aliman wanted to present his new artist in a colorful package, and there can be little doubt that he succeeded, for the popularity of that initial appearance led to many more Loates' wildlife features over the ensuing decade.

Two of the birds chosen by Aliman, the Steller's Jay and Bohemian Waxwing are western species which, since Loates had not yet travelled west of Ontario, were painted with the aid of museum specimens and the personal observations of two closely-related eastern species, the Blue Jay and the Cedar Waxwing. The Eastern Bluebird and Baltimore Oriole were based on subjects viewed and sketched at Silver Fern Park, near the artist's home.

Loates received a fee of $1000 from the *Canadian* for single-reproduction rights, a big step forward for him professionally. The

success of the songbirds also led to an invitation to prepare a series of paintings of Canadian Game Fish to be published in April of the following year. This was a project the artist was well-prepared for.

Loates had earlier spent part of the summer of 1964 with his brother, Bernard, netting gamefish at Dorset and drawing and painting them while the fish swam in a portable aquarium where they retained their natural color. (Most fish quickly lose their color when exposed to air for any length of time.) Bernard dove to net the specimens and brought up related underwater plant life for detailed background studies. By the time the *Canadian* commission arrived, Loates had already a considerable file of drawings and color notes for reference.

The final fish paintings were executed in late 1965 and early 1966 using live specimens as well as preserved fish at the Royal Ontario Museum. For scientific accuracy, the artist consulted closely with two members of the museum staff–Dr. Bev Scott, curator, and Dr. Ed Crossman, assistant curator – of the Department of Ichthyology. Loates was particularly concerned that the motion of his subjects should be accurate. He soon learned that many depictions of fish by artists were anatomically impossible in their spinal curvatures. Loates had earlier collaborated in 1965 with Scott and A. H. Lein on a book

about the fish of the Atlantic coast, for which he supplied two watercolor paintings of the Atlantic Halibut and Atlantic Cod. (*Fishes of Atlantic Coast of Canada* by A. H. Lein and W. B. Scott, Queen's Printer, 1966.)

The four fish portrayed by Loates for the *Canadian* magazine – April 30th, 1966, issue – were Rainbow Trout, Muskellunge, Smallmouth Bass and Walleye. The living models were collected in a number of Ontario locations – Bancroft, Rice Lake and the Muskokas. The color of the Muskellunge, a species far too large to be accommodated in Loates' portable aquarium, was studied from the fresh catch of a fisherman at Rice Lake. For each fish portrait, Loates aimed at obtaining the correct underwater environment, crystal clear for the Rainbow Trout, more murky for the Muskellunge. Fidelity of aquatic backgrounds was ensured by the artist's own observations while snorkelling. Accuracy of detail was obtained by the closest study of both live and museum specimens. For example, there are several-thousand scales on one side of a Muskellunge. In his perspective view of the fish, Loates shows only a thousand, since the angle of vision eliminates the rest.

Perhaps the most remarkable aspect about this group of fish portraits is the technical advance and increased confidence achieved by the artist in less than a year. As a group, they share a crispness of rendering, a

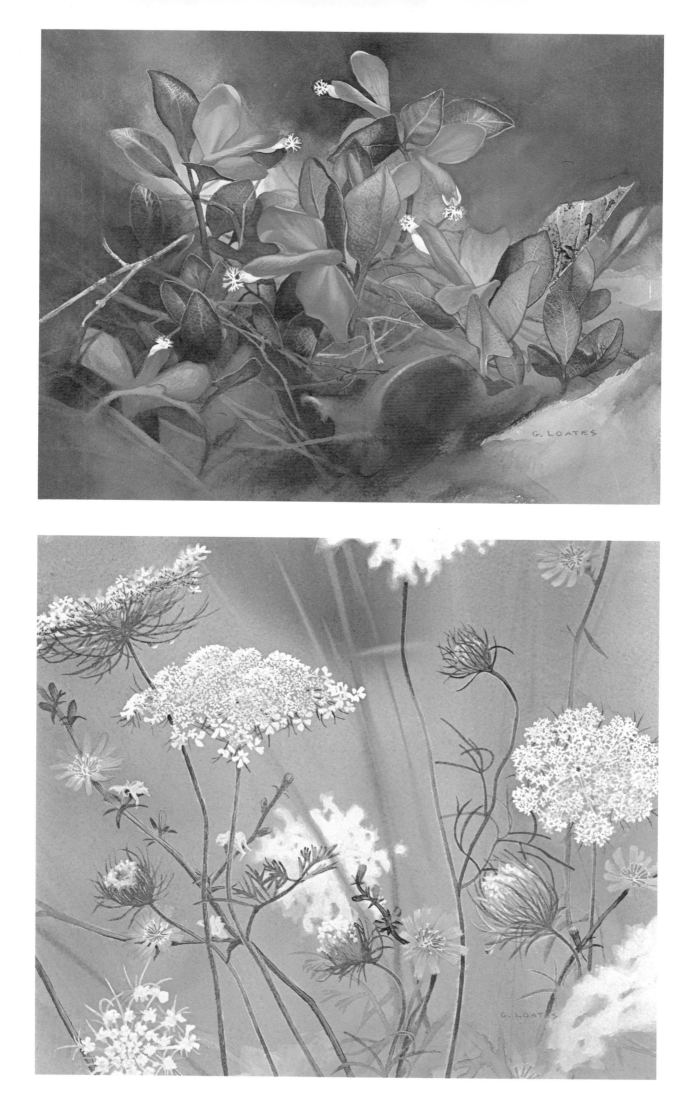

Top: FRINGED POLYGALA, 1964
Opaque watercolor on paper, 11 x 12" (28 x 30.5 cm.)
Above: QUEEN ANNE'S LACE, 1964
Opaque watercolor on paper, 9¾ x 10¾" (24.8 x 27.3 cm.)
Private collection

51

sense of drama and an originality of design almost totally missing from the songbirds of some months before. Individually, each of these fish studies presents a very personal pictorial treatment. What could so easily have been straightforward and commonplace underwater scenes are, instead, creations which are both unexpected and compelling in their originality. The dramatic Rainbow Trout with the Kingfisher attacking the surrounding fry, and the fierce, attacking Muskellunge are two impressive forerunners of those compositions featuring competition between wildlife which were to become a characteristic of Loates' mature achievements.

Closely related to the *Canadian* game fish series is a vivid portrait of Lamprey Eels painted in 1966 from specimens collected at Wilmont Creek, Ontario. Unprepossessing though they are in appearance, these enemies of fresh-water game fish are turned by the artist into one of his finest marine studies. This painting also underlines Loates' refusal to paint a subject merely because of its popularity and possibility of ready sale. Few fresh-water creatures could be less winning than lampreys, but Loates found in their grim character the stuff of a remarkable watercolor.

Glen Loates' earliest one-man exhibitions were in 1965. The first was a show of some twenty pieces at the annual meetings of the Ontario Federation of Naturalists, held at Queen's University in Kingston, Ontario, during April. The second exhibition was a much more ambitious affair, when some fifty of the artist's paintings and drawings went on view at the Royal Ontario Museum, from October 25th to November 22nd. Like an earlier solo-show for young bird painter, Fenwick Lansdowne, this one was arranged by Terrence Shortt, who always revealed a remarkable eye for talent in the wildlife field.

"I feel that these exhibitions for young wildlife artists should be a vital part of the museum's function," says Shortt. "After all, where else were these artists to go?" Nature art represents a unique type of painting, and at the time of Loates' and Lansdowne's early shows, public and commercial galleries in Canada showed no interest in such art."

Loates' Royal Ontario Museum exhibition introduced him to a large new audience, which included collectors who remained his firm supporters for years to come. This same exhibition, plus additional new material, was repeated several months later at the Museum of Natural History in Buffalo, New York.

Much of early 1966 was taken up by Loates preparing for a third *Canadian* magazine feature, this one on game birds, to be published October 22nd, 1966. The subjects included the Ruffed Grouse, Band-tailed Pigeon, Canada Geese, Mallard Ducks, the Ring-necked Pheasant and the American

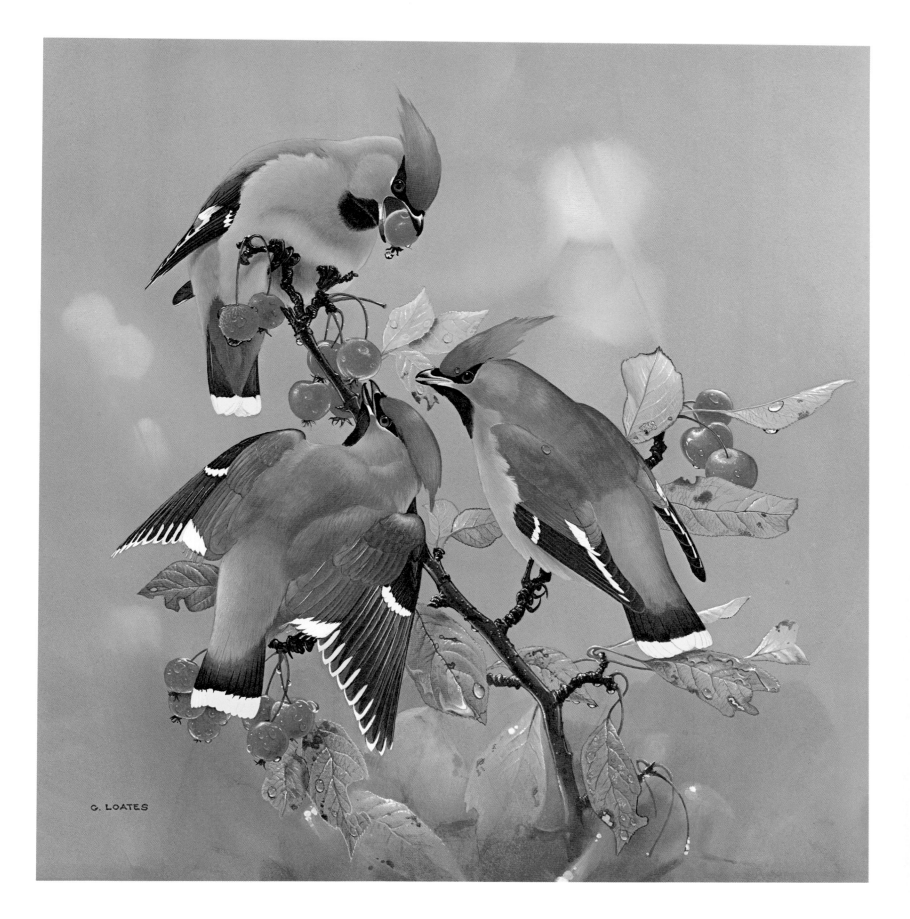

BOHEMIAN WAXWING, 1965
Opaque watercolor on tinted paper, 17 x 17½" (43.2 x 44.5 cm)
Private collection

Woodcock. Generally, these studies are more incisive and confident than the earlier song bird series. Except in the cases of the Band-tailed Pigeon and the Ring-necked Pheasant, the artist no longer needs to shore up his bird portraits with extensive background detail or atmosphere. For the first time in his reproduced works, he has allowed his subjects to stand isolated on their own, with a minimum of vignetted surroundings or, as in the instance of the Mallard Ducks, no background at all.

Perhaps the most impressive composition of the game-bird group is the pair of Canada Geese in flight, but the study that most suggests his future development is the small portrait of an isolated American Woodcock. In the execution of the Woodcock, there is a suggestion of that relentless pursuit of detail for which Loates was later to become noted, forming a style which is almost devoid of superficial pictorial flourishes.

The source material for the Game Bird Series was varied. The Ruffed Grouse was based mainly on field sketches made in the Bruce Peninsula. The Band-tailed Pigeons, since they are western birds, were portrayed with the aid of museum specimens, plus drawings of similar eastern pigeons. The Canada Geese derived from studies made at Toronto's Riverdale Zoo and in the field. As always, details were checked against museum specimens.

Late in 1967, Glen Loates received a letter from the Postmaster General's office in Ottawa, asking if he would be interested in competing for a stamp design commission. Post Office officials had seen his work in the *Canadian* magazine and were extending an invitation to submit designs for a projected postal issue devoted to the Gray Jay, or "Whiskey Jack." A small number of other Canadian wildlife artists had received identical invitations. Loates submitted five designs and, early in 1968, was informed that he had won the competition, and to proceed with his final color presentation. The Gray Jay was one of the artist's favorite birds and he had earlier, in 1966, executed a watercolor of three of them gambolling among branches, the original of which now belongs to the Royal Ontario Museum's Department of Ornithology. Loates completed the 7½ x 4⅜″ (190 x 111 mm.) final rendering of the vertical format five-cent stamp in two weeks and it was issued in February 1968. The Post Office Department, as is its custom, retained all submitted sketches and notes relating to the stamp. The design itself won the Royal Philatelic Award for the most beautiful stamp of the year. It also was the first Canadian stamp to be printed by four-color lithography.

The success of Loates' Gray Jay stamp prompted the Post Office to commission three more bird issues from him in 1968.

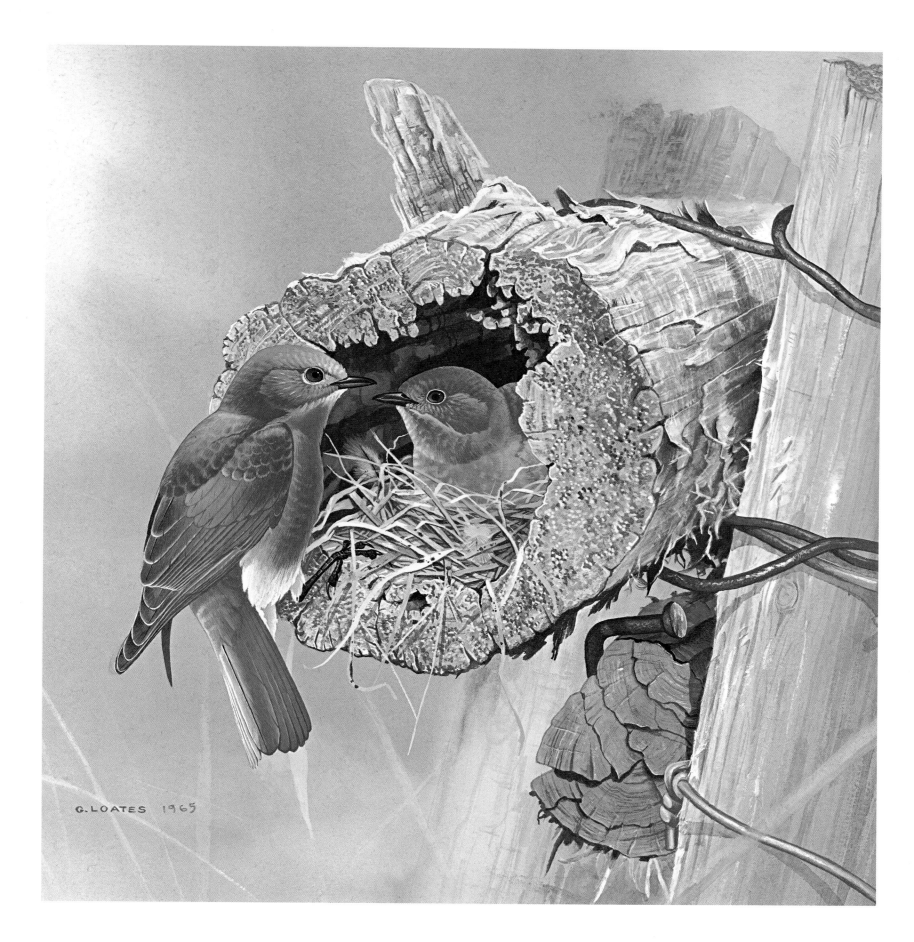

EASTERN BLUEBIRD, 1965
Opaque watercolor on tinted paper, 17 x 17½" (43.2 x 44.5 cm.)
Private collection

55

These were to represent the White-throated Sparrow, a vertical design five-cent issue; a ten-cent denomination Ipswich Sparrow and a twenty-five cent Hermit Thrush, the latter two in a horizontal format. Each stamp measures 1⅝ x ¾" (40 x 20 mm.) The artist had no part in selecting the subjects, which were chosen by the Post Office Department in consultation with the Natural History Branch of the National Museum of Canada. The colors of the three birds are closely related and resulted in a very harmonious set. Issued on July 23rd, 1969, they soon joined the Gray Jay among Canada's most popular contemporary postal issues.

The year 1967 was a busy one for Loates. Besides designing the Gray Jay stamp, he painted a major series of mammals and went on two important field trips.

In May, he was invited to spend a week at Manitoulin Island by Dr. Ronald Tasker, a Toronto neurosurgeon, who earlier had bought a number of the artist's works. Tasker owned a large property at the western end of Manitoulin Island, which is situated in the North Channel between Lake Huron and Georgian Bay. The property also is located on a major migration route. The doctor thought Loates might benefit from a trip to the site during the height of the northward flyway.

Loates helped Tasker and his family to band the hundreds of birds they briefly captured in mist nets. He was able to view a large number of species at close hand and in flight, many of which he had never seen before. He eagerly studied and sketched a large number of the species and sub-species that he observed and handled.

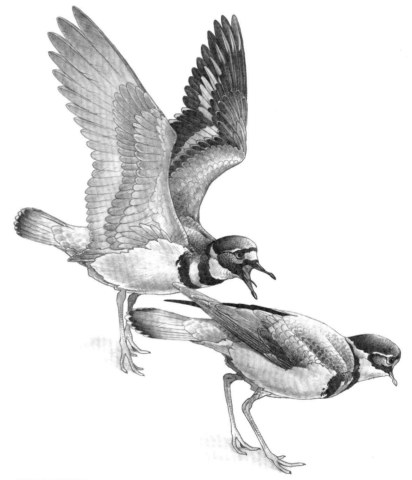

KILLDEER, 1965
Pencil on paper, 24 x 18" (61 x 45.7 cm.)

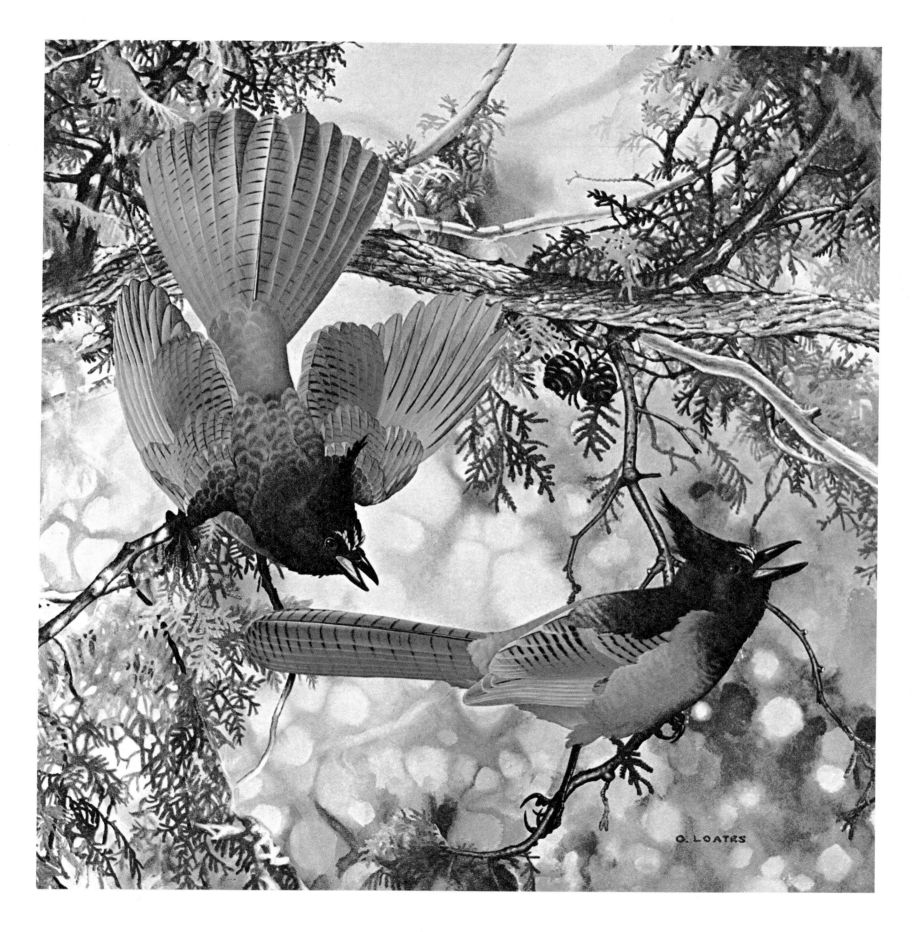

STELLER'S JAY, 1965
Transparent watercolor on paper, 26 x 24" (66.1 x 61 cm.)
Private collection

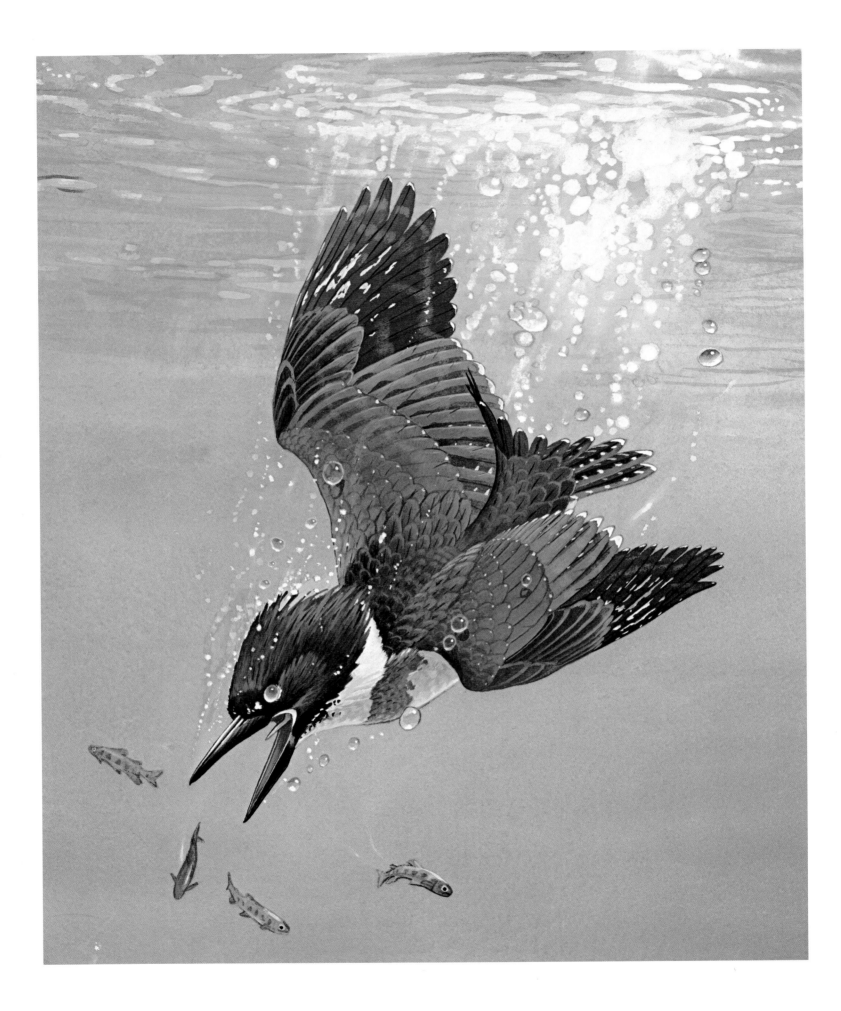

Detail from
KINGFISHER & RAINBOW TROUT, 1965

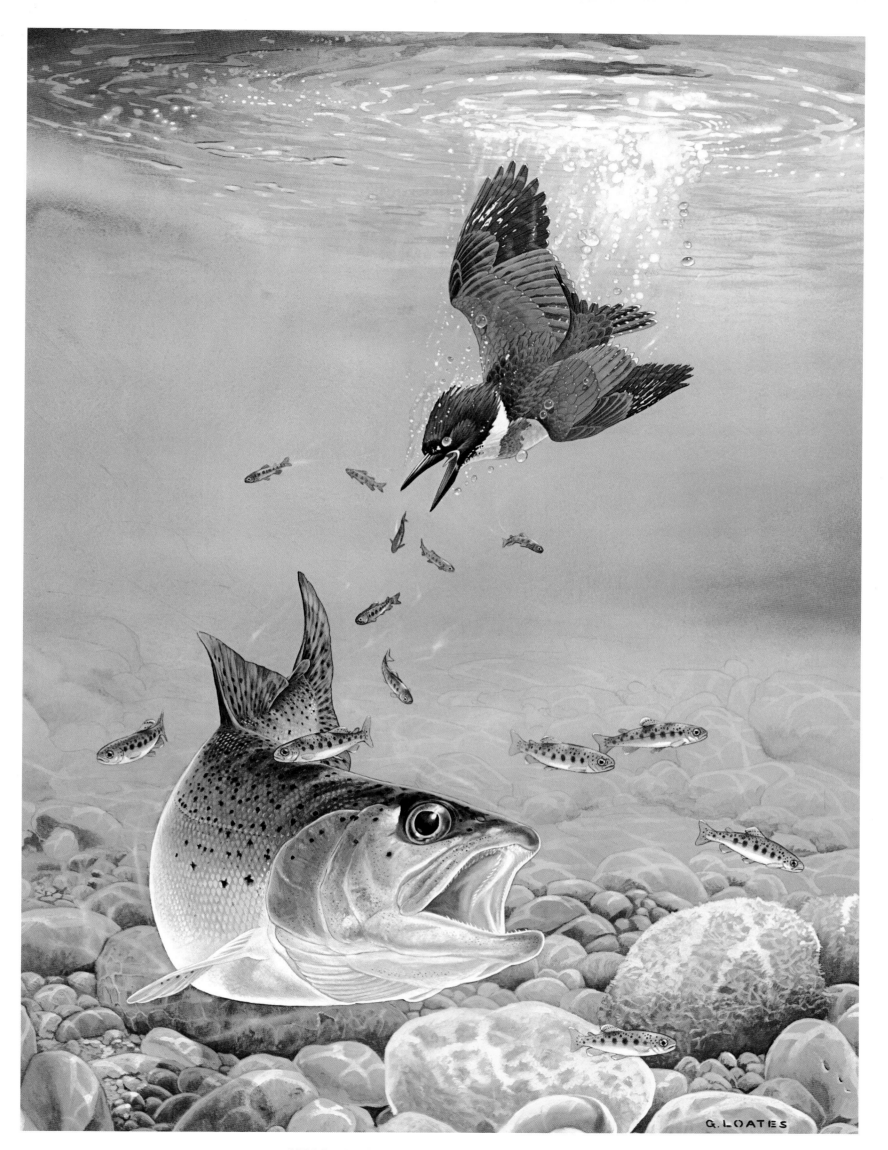

KINGFISHER & RAINBOW TROUT, 1965
Opaque watercolor on paper, 30½ x 23" (77.5 x 58.4 cm.)
Private collection

59

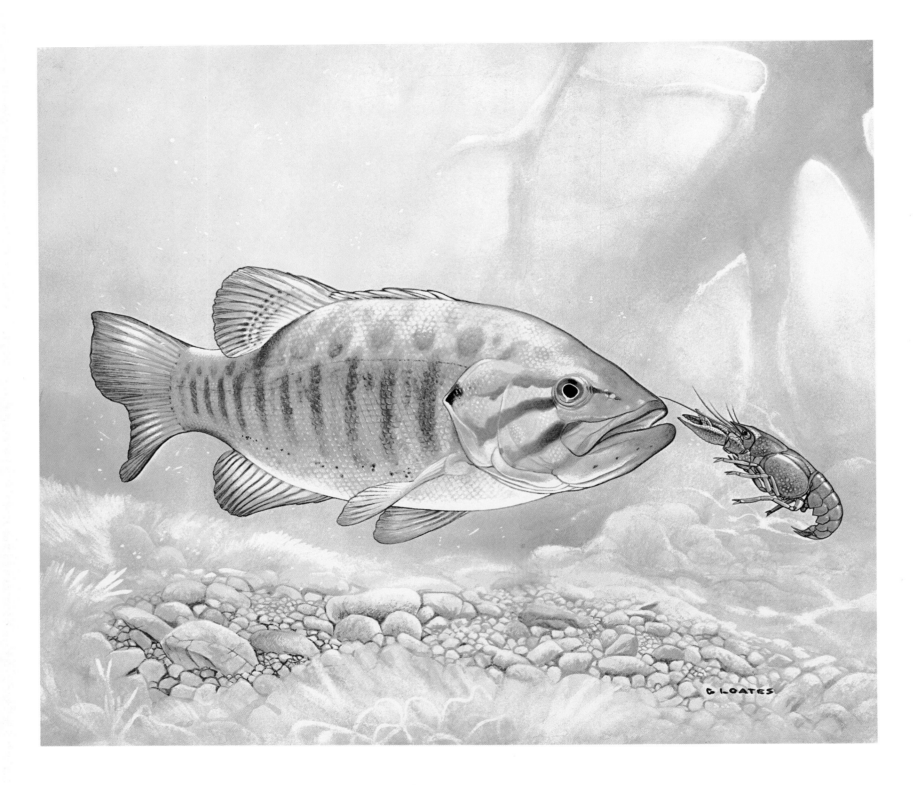

SMALLMOUTH BASS PURSUING CRAYFISH, 1965
Opaque watercolor on paper, 18½ x 22½" (47 x 57.2 cm.)
Private collection

60

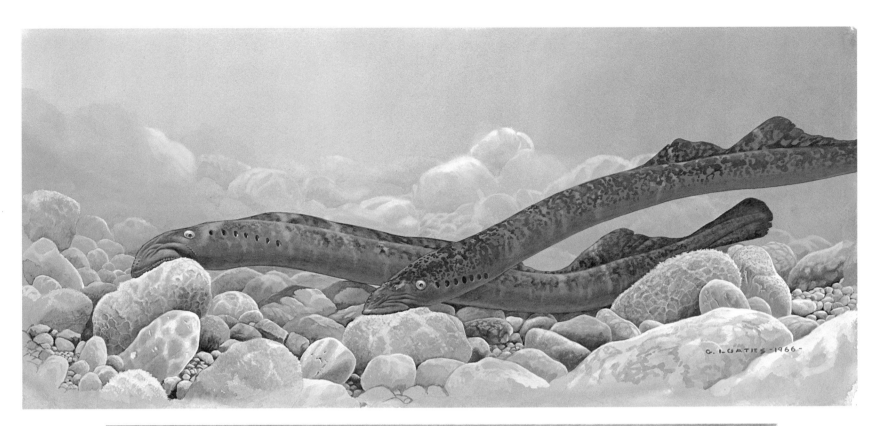

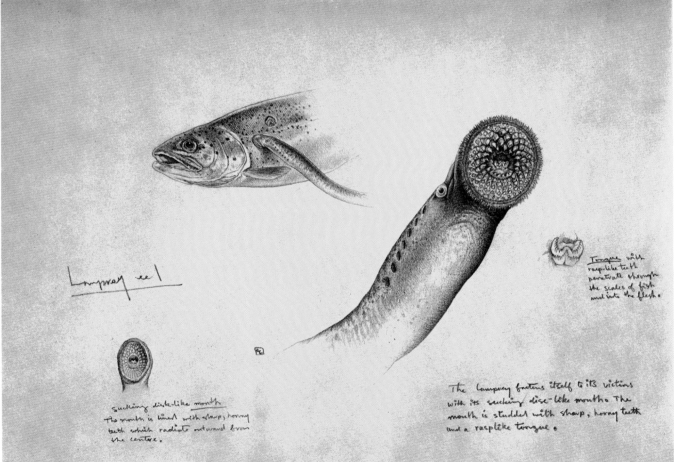

Top: LAMPREY EEL, 1966
Opaque watercolor on paper, 14 x 29½" (35.6 x 75 cm.)
Above: LAMPREY EEL STUDY, 1966
Pencil on tinted paper, 9 x 12½" (22.9 x 31.8 cm.)

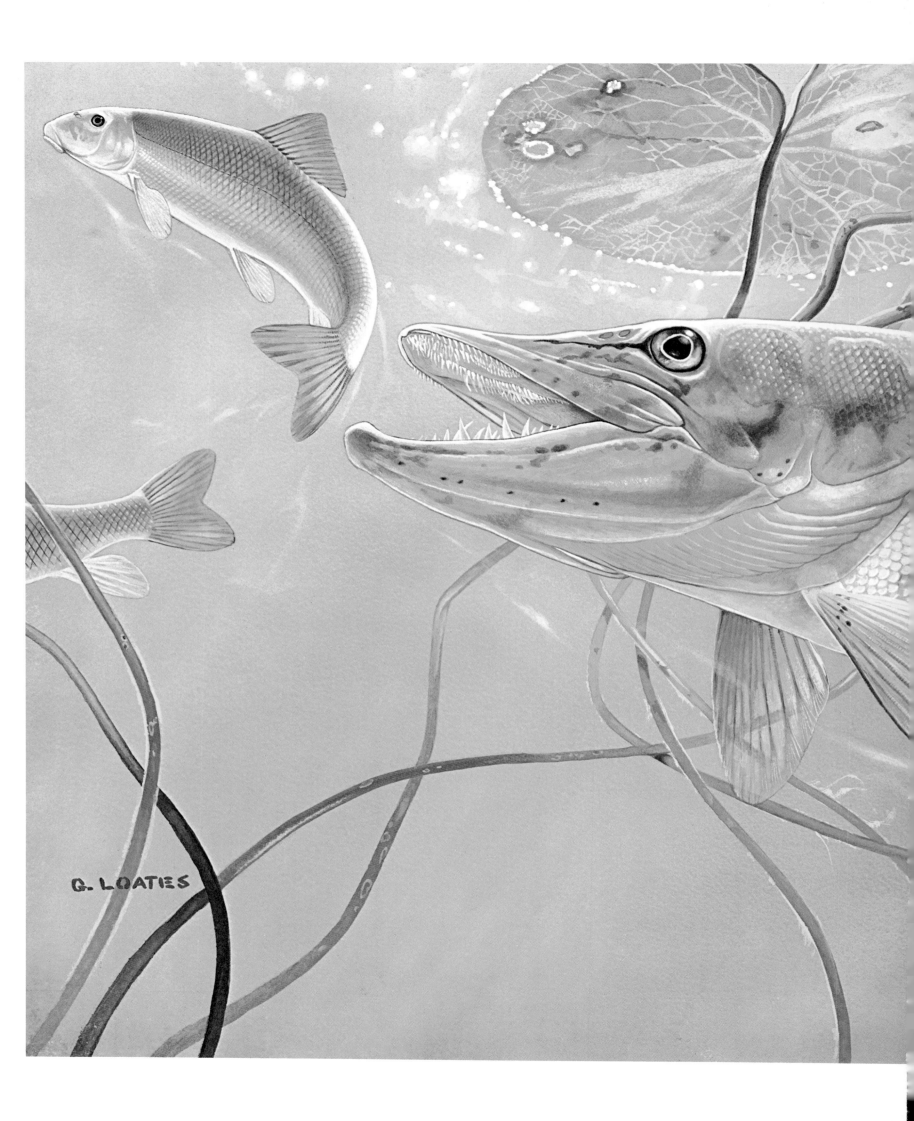

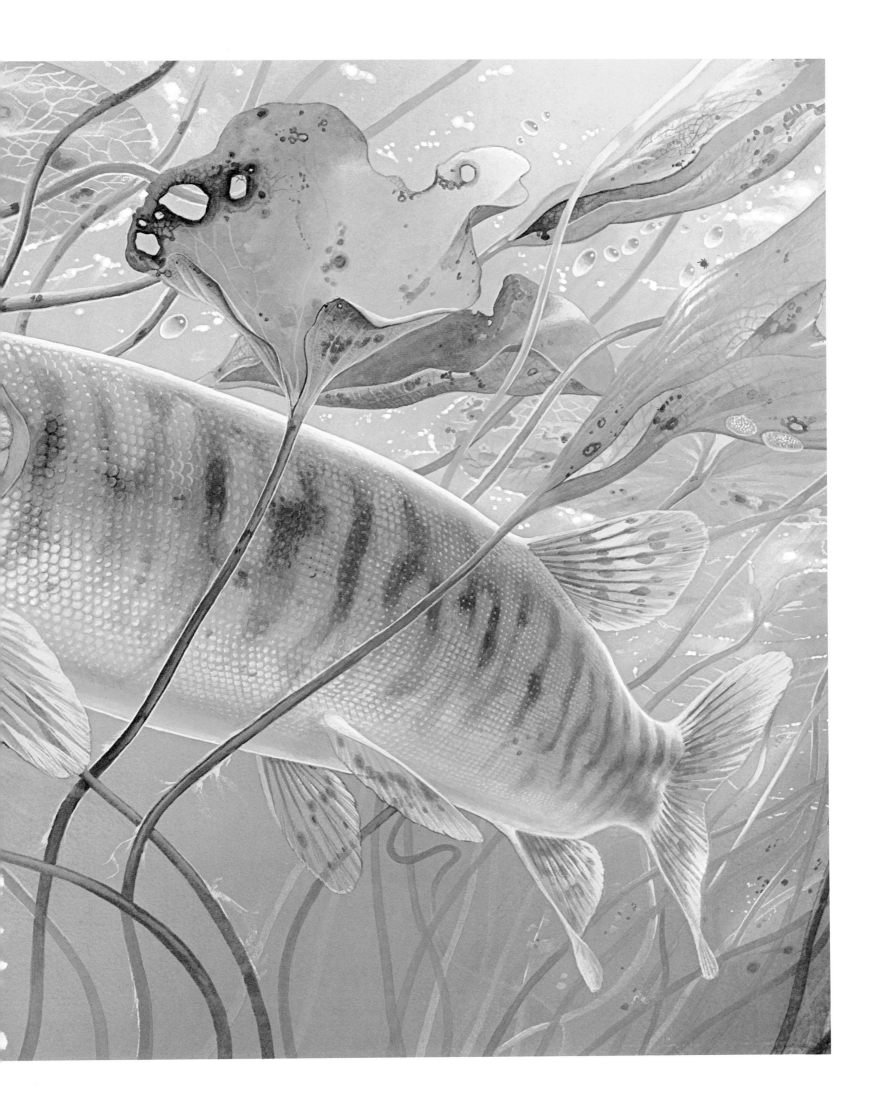

MUSKELLUNGE PURSUING WHITE SUCKER, 1966
Opaque watercolor on paper, 21¼ x 30½" (54 x 77.5 cm.)
Private collection

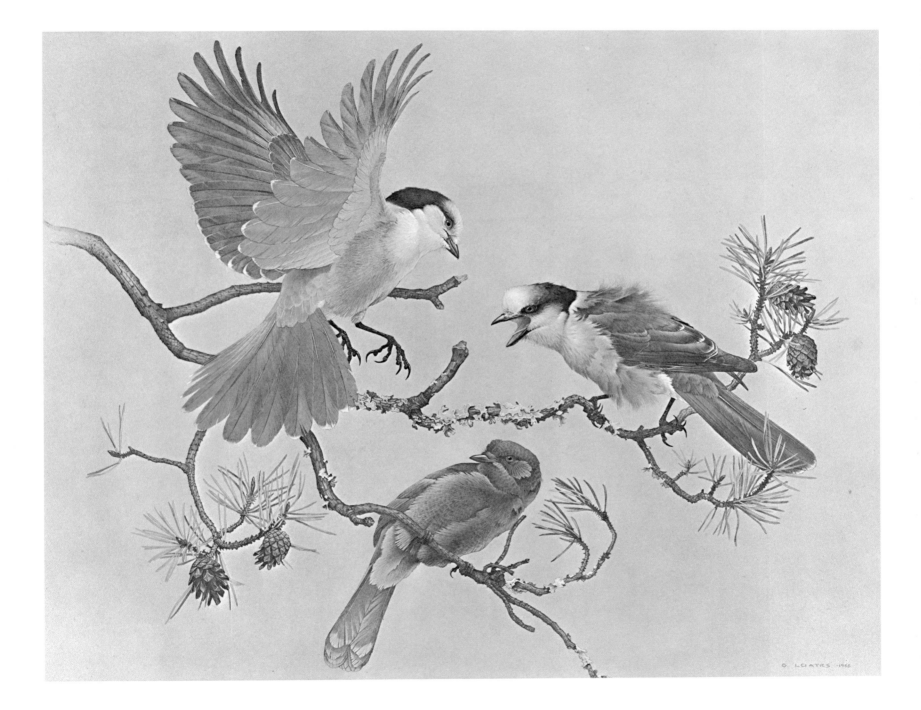

GRAY JAY, 1966
Opaque watercolor on paper, 25 x 29" (63.5 x 73.7 cm.)
Private collection

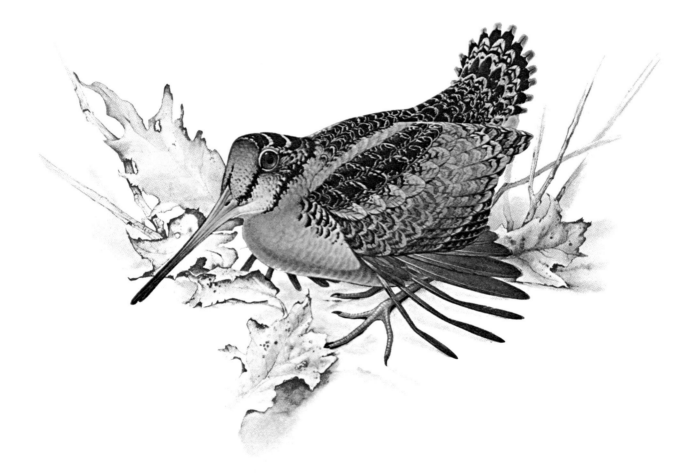

AMERICAN WOODCOCK, 1966
Transparent watercolor and ink on paper, 14 x 16" (35.6 x 40.7 cm.)
Private collection

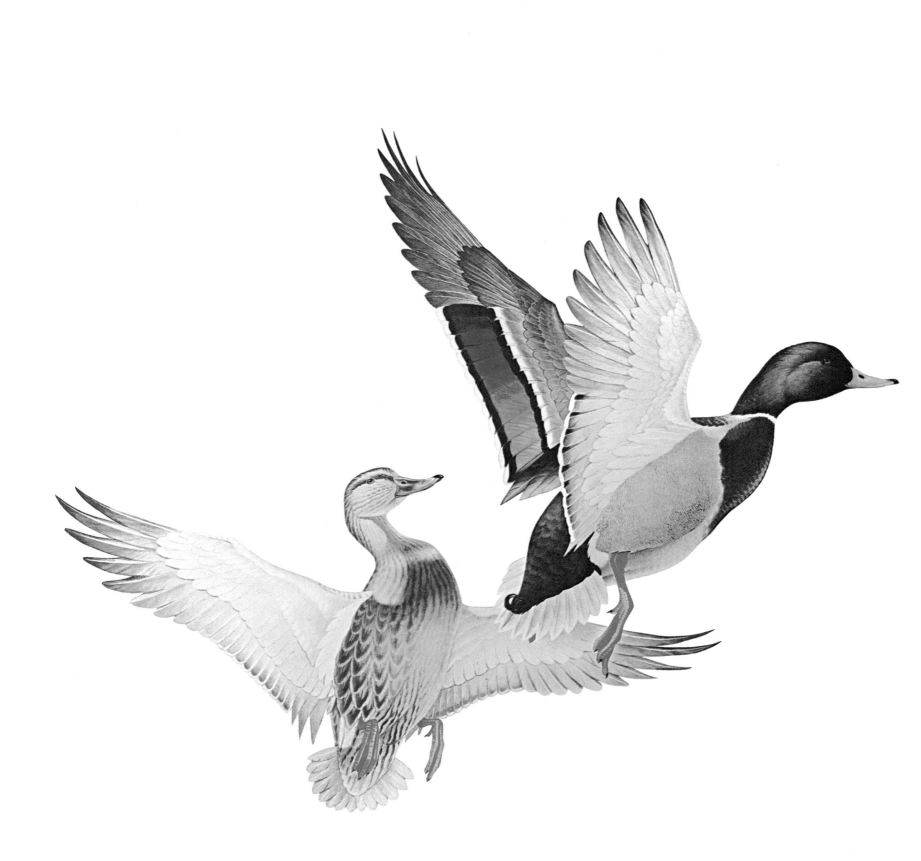

MALLARD DUCK, 1966
Transparent watercolor on paper, 26 x 30" (66.1 x 76.2 cm.)
Private collection

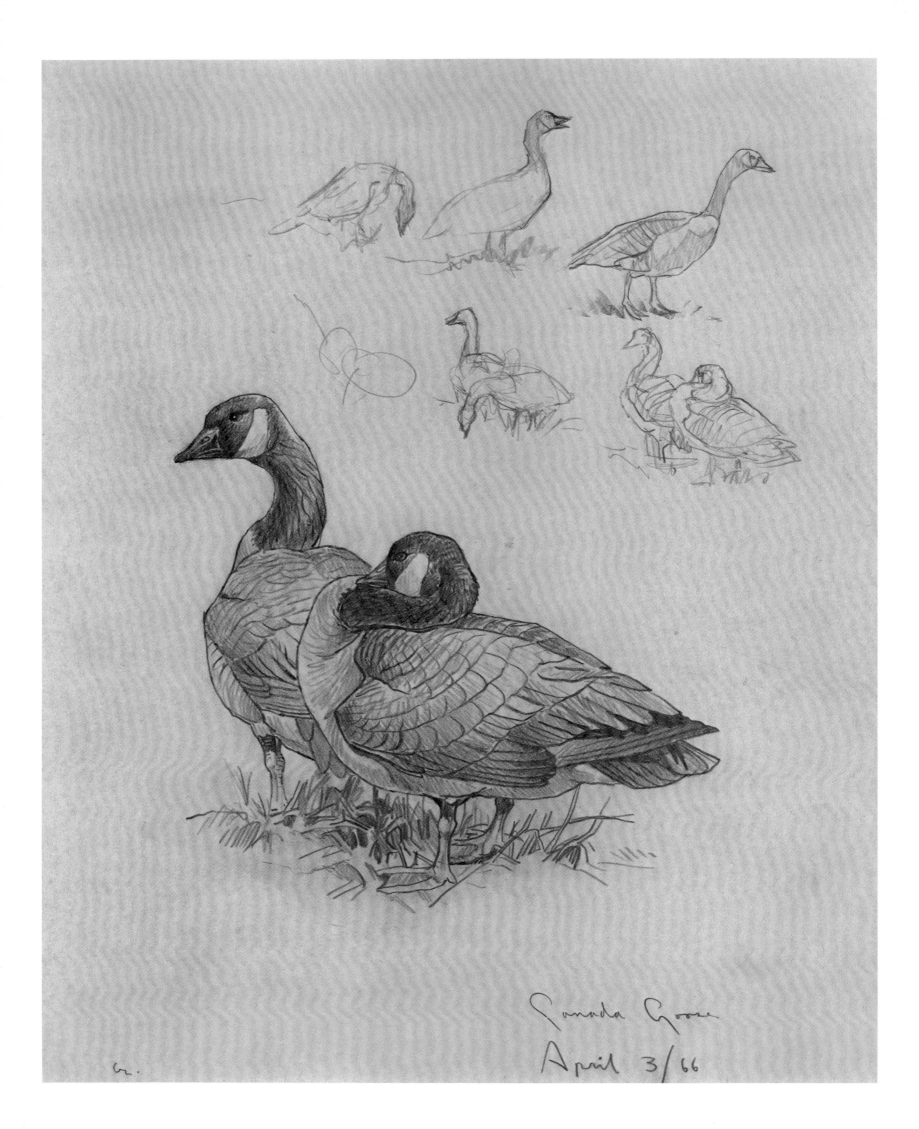

CANADA GOOSE FIELD SKETCH
Pencil on tinted paper, 12¾ x 11″ (32.4 x 27.9 cm)
Private collection

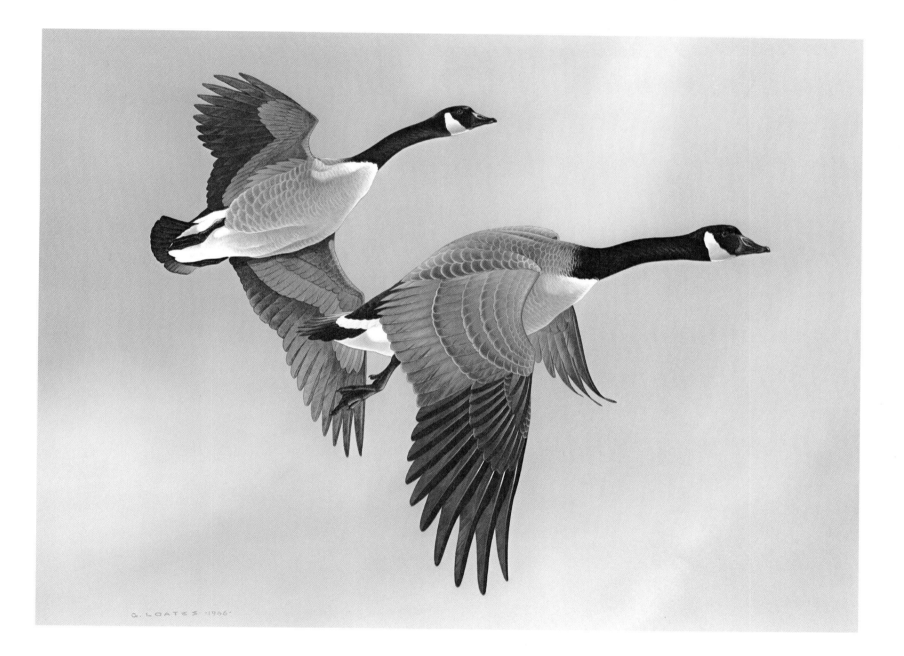

CANADA GOOSE, 1966
Opaque watercolor on tinted paper, 18 x 24" (45.7 x 61 cm.)
Private collection

67

ENGLISH SPARROW, 1966
Opaque watercolor on paper, 18½ x 18½" (47 x 47 cm.)
Private collection

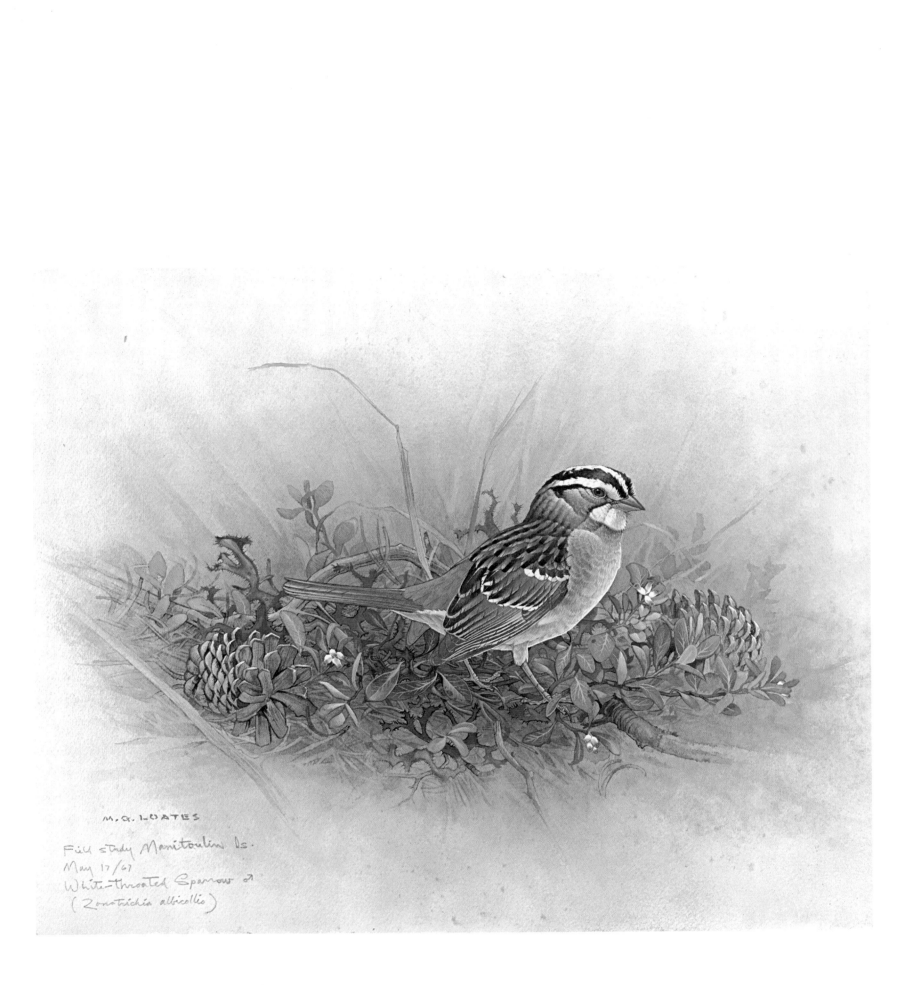

WHITE-THROATED SPARROW, 1967
Opaque watercolor on paper, 10 x 13" (25.4 x 33 cm.)
Private collection

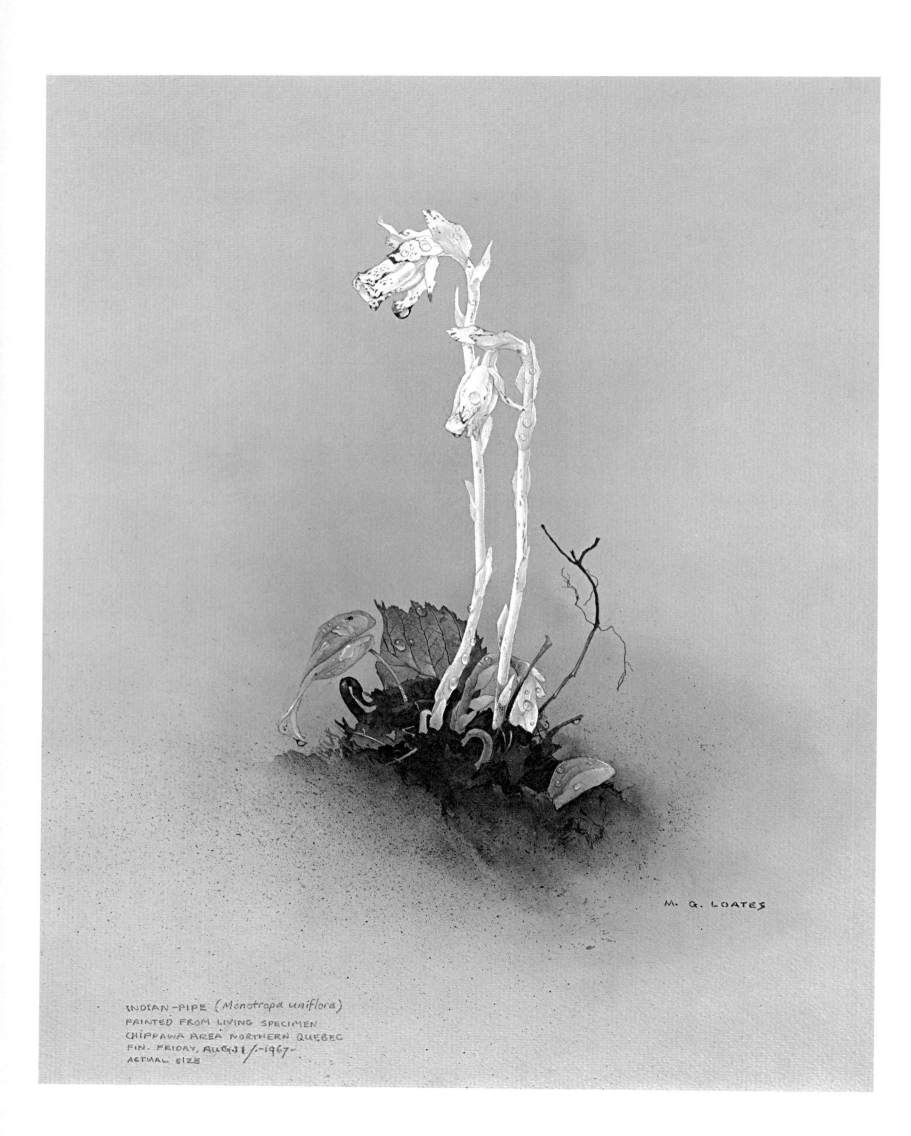

INDIAN-PIPE (*Monotropa uniflora*)
PAINTED FROM LIVING SPECIMEN
CHIPPAWA AREA NORTHERN QUEBEC
FIN. FRIDAY, AUG.11/-1967-
ACTUAL SIZE

M. G. LOATES

INDIAN PIPE, 1967
Opaque watercolor on tinted paper, 12 x 10" (30.5 x 25.4 cm.)
Private collection

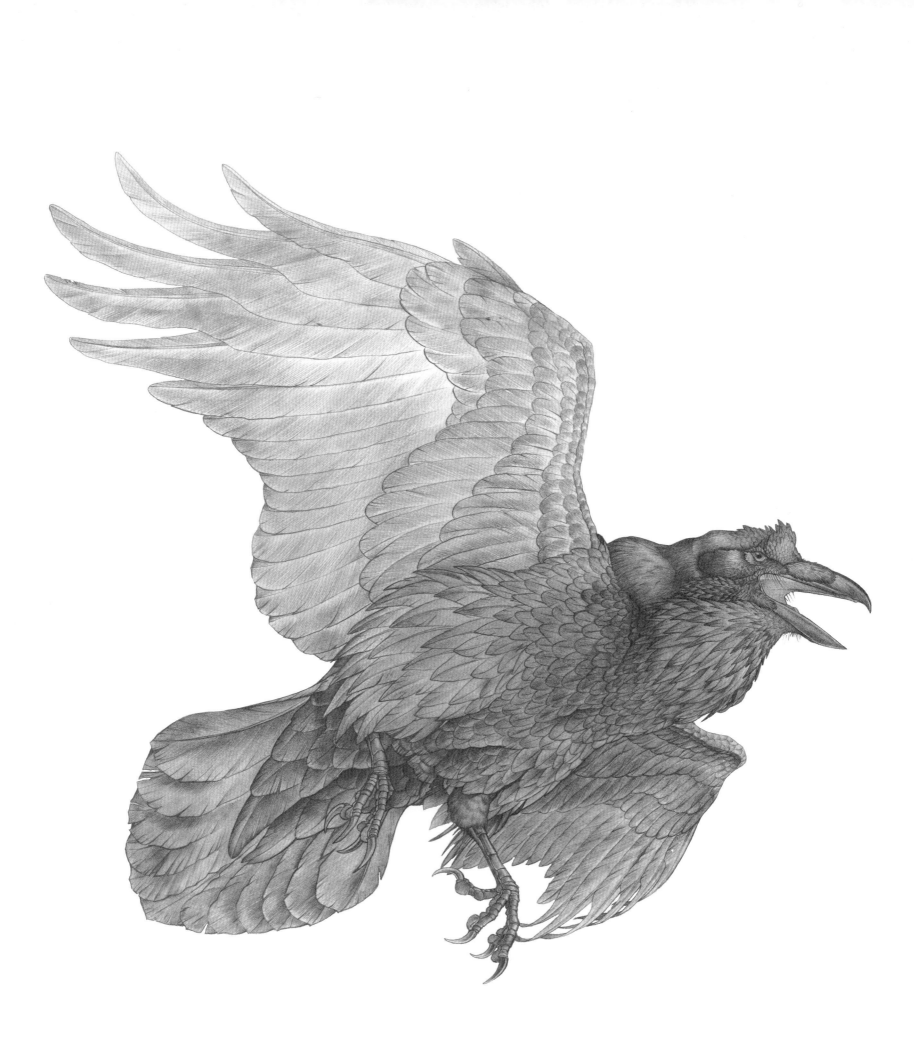

RAVEN, 1967
Pencil on paper, 17½ x 23" (44.5 x 58.4 cm.)
Private collection

III. New Horizons

few months after Manitoulin, Glen and his brother, Bernard, made a one-month field trip into Northern Quebec, a journey prompted in part by a commission from the *Canadian Magazine* to paint a series of native big game animals for 1968 publication. Since one of the featured mammals was to be a moose, Quebec seemed a logical research ground. The two left Toronto by car the second week in July on their one-month sojourn, heading first for Chibougamau, a small village some four hundred miles distant. Chibougamau had an air base where they could hire a float plane to fly further north into the forested interior. They flew to their final destination, Lac Mistassini, in about an hour, their canoe lashed to one of the single-engined Beaver's floats.

Travelling mainly by canoe, they paddled the northward-flowing rivers which connected a vast network of lakes, along the banks of which many animals dwelled and a large variety of summer flowers bloomed. During the next few weeks, while his brother fished, Loates drew and painted a large number of studies, including some upon which his final large moose painting was based. A group of finished flower paintings also emerged from the Mistassini site. Apart from a bout with a whirlpool at the base of one of their river descents, the canoe voyage

was devoid of drama. But for Glen it was one of his most rewarding field trips, in terms of both observation and achievement.

Loates' big game paintings, including the Mistassini moose were published on February 3rd, 1968. The moose, splashing and angered at being disturbed while feeding, was featured on the cover. The other subjects were the Cougar, Whitetail Deer, Mountain Goat, Black Bear and Grizzly Bear. The pair of Whitetail Deer standing in the snow were a composite of studies made at Ontario's Algonquin Provincial Park. The Cougar and Grizzly Bear were mainly studied at Toronto's Riverdale Zoo, where Loates would observe and sketch for hours just to obtain the Grizzly's walk and the glare of his small, red-rimmed eyes.

"For me," says Loates, "as for most wildlife painters, zoos are a major source of information. To understand an animal's relationship to its natural environment, it must be seen and sketched as much as possible in the field, to capture the anatomy and movement. That is a vital necessity. But for details of eye color, expression and texture, it is essential to view the subject leisurely at very close range and this can only be done from live animals in zoological parks or compounds."

Of the five mammals in the 1967 series, the Whitetail Deer is perhaps the most successful, and the closest to the artist's eventual style. It is exact and analytical in

drawing, acutely observed, and is pristine in its execution without being fussy. Its spatial arrangement, with the deers silhouetted against a light snow-laden sky while standing on a hillock of snow, is almost oriental in its evocative simplicity. Three of the other mammals are revealed in their more dramatic moods – the Cougar and Grizzly in attacking postures, the Moose alarmed and about to take angry flight. In their pictorial presentation, these show the same scientific care evident in the Whitetail Deer, while revealing the maximum of theatrical vitality and mobility. It is one of Loates' main achievements in these early mammal paintings that he is already able to convey the sheer bulk and power of those massive animals without sacrificing important detail.

This early big game series probably is most important because it introduces Loates for the first time as a major painter of mammals, for it is in that field of wildlife art that he eventually was to produce his most memorable and characteristic paintings.

It was one of Glen Loates' long time ambitions to visit Western Canada. Finally, in 1968, after many frustrations, he was able to make that trip – a trip, it turned out, that was to prove mainly abortive.

Loates was eager to view some British Columbia mammals, particularly grizzlies, in their natural habitat. A close acquaintance,

Don Gray, arranged the journey west, with a view to shooting a documentary movie of the artist at work on location. Glen had earlier appeared on Gray's television interview show in London, Ontario, and the two young men had become good friends. Accompanied by Bernard, they set out in the last week of July for a three-week visit to the northern Rockies. Loates looked forward to it as the most stimulating and potentially rewarding field trip of his career.

After stopping overnight in Vancouver, the trio flew north to Whitehorse, in the Yukon. There, by pre-arrangement, they met a guide who had been recommended as one who could lead them to view big game in their natural habitat. The guide put the travellers and their gear into a ramshackle truck and headed for his lodge in Atlin, some forty miles distant. Within a few miles of the airport, the truck began to break down and they returned to Whitehorse for repairs. Finally, toward evening, they started out again and reached Atlin, a small coastal range settlement, astride the British Columbia-Yukon boundary, by nightfall. The next day, after a short sight-seeing trip around the immediate vicinity, the guide and his three charges set out on their quest for big game in a converted lifeboat from an ancient paddle wheeler. By the time they were a few hundred yards from shore, the boat began to spring leaks, and the rest of the

journey across Lake Atlin was spent bailing out freezing water. It took two days for the group to reach the guide's specified goal, camping at small islands on the way.

Although the guide was supposed to provide food, virtually the only thing he supplied to eat was fish caught from the lake. His provision of big game subjects turned out to be equally sparse.

After arriving at their final stop, the search for wildlife began. For most of the first day, the guide led the tenderfeet up the side of a mountain, through brush and forest and finally to bare rock. Toward the top, they caught their first –and, as it turned out – only glimpse of wildlife, a large flock of friendly and inquisitive mountain goats. The guide took advantage of their friendliness to kill one, even though it was out of season. His shot was one more than film maker, Don Gray, was able to get since, by this time, his lens was totally fogged from the moisture which had settled into the camera during the watery trip from Atlin.

Having got his clients up the mountain, the guide demanded the last half of the money owing to him which, by agreement, he was to receive only after the expedition ended. When he didn't get it, he explained that he had to check out an easy route of descent, and then disappeared, never to return. By this time, the three easterners were beginning to wish they

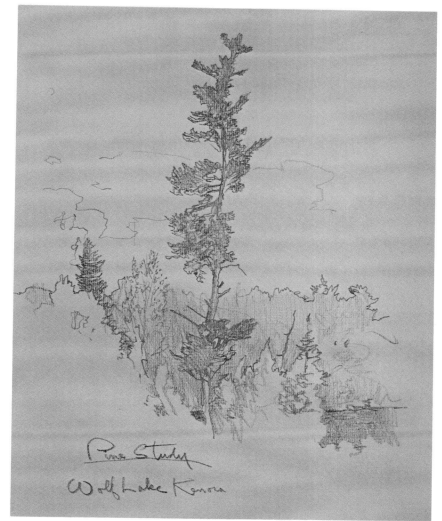

PINE STUDY, 1967
Pencil on tinted paper, 11 x 8½" (27.9 x 21.5 cm.)
Private collection

had never seen the west. The sun was setting and their knowledge of mountain climbing –

or descending – was as dim as the sky was rapidly becoming.

In the fading light, they began to cross a glacier which increased in slipperiness as they descended. At the top there had been a light base of snow to cup their feet, but on the sheer ice they began to slip and slide and Gray, who followed behind the brothers, shortly plummeted by them dragging his equipment as he shot toward a distant clump of rocks which stopped his descent. After that, the three decided to settle precariously on the rocks for the night. It snowed and rained during the night, and it was a bedraggled, tired and literally foot-torn group which finally made it back to the bottom, and the waiting guide, next day. The guide's unconcealed humor at their predicament added nothing to their enjoyment of their near-disastrous experience.

After a long sleep, the unhappy group started back on the long, leaky return trip to Atlin – the young men cursing the guide, while he muttered threats of what would happen to them if he didn't receive the balance of his fee. Within an hour of reaching the dock at Atlin, his boat sank to the bottom, with only its mast in view. This angered the guide to the point of threatening to kill them all. The local R.C.M.P. firmly suggested that the three easterners should leave town, and radioed for a plane to take them back to Vancouver. It had been an expensive, mostly fruitless, adventure, though Loates insists that visually it was an important plus for him.

While Bernard returned to Toronto from Vancouver, Glen and Don Gray decided to go up the Pacific Coast to Rivers Inlet, in an attempt to salvage something from their western trip. They remained at Rivers Inlet for little more than a week, but in that short time they achieved a good deal, both in painting and photography. Here some of the footage was successfully shot for *Color it Living*, an award winning 30 minute portrait of Glen that has received international acclaim and distribution. The artist was able to obtain glimpses of grizzlies and more mountain goats, while pursuing bald eagles and a variety of smaller mammals. The host of their lodge purchased a painting of a ring-necked pheasant from the artist for $1,100, which enabled Glen to protract his field trip longer than the few days his budget would have allowed. On the way back to Toronto, Loates stopped off in Vancouver to draw a number of mammal studies in Stanley Park Zoo.

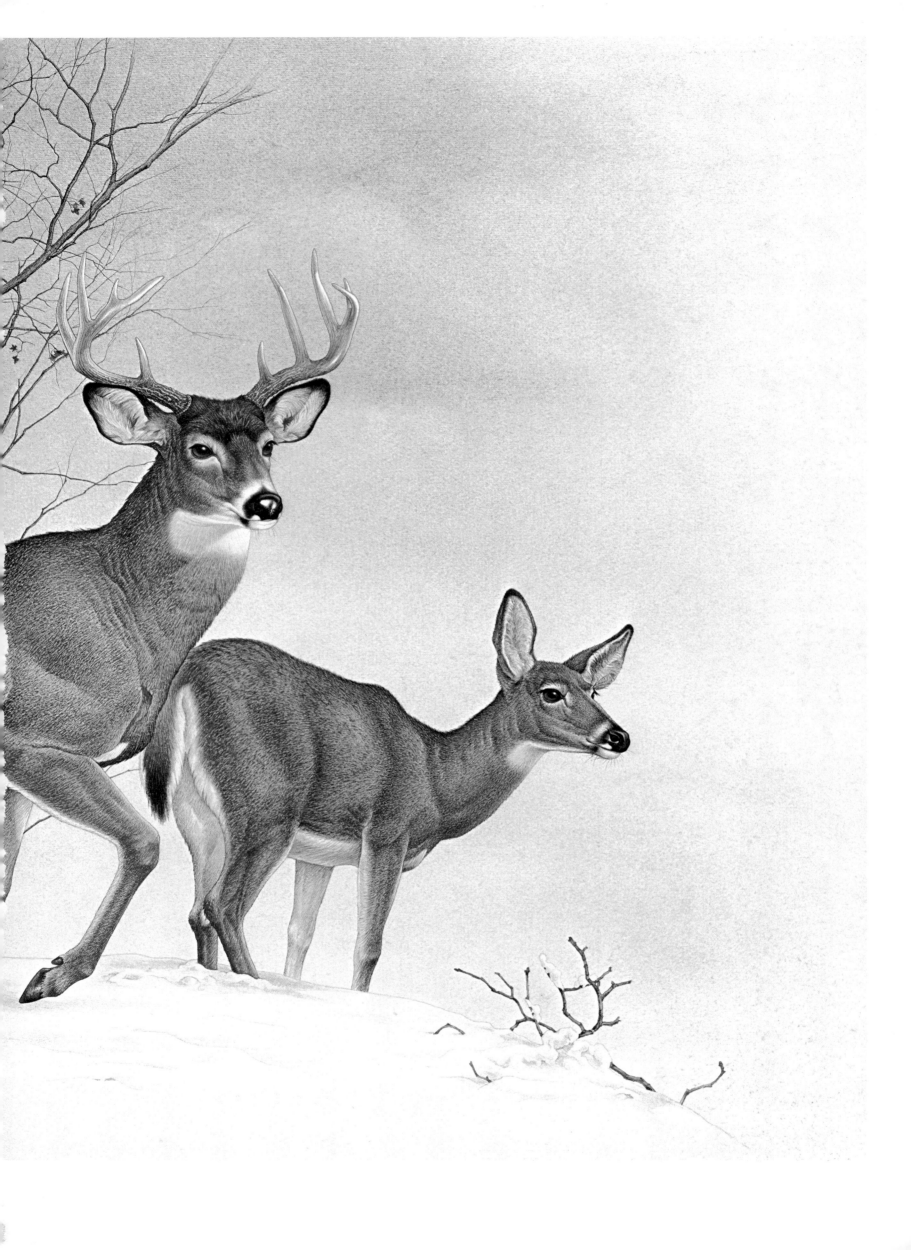

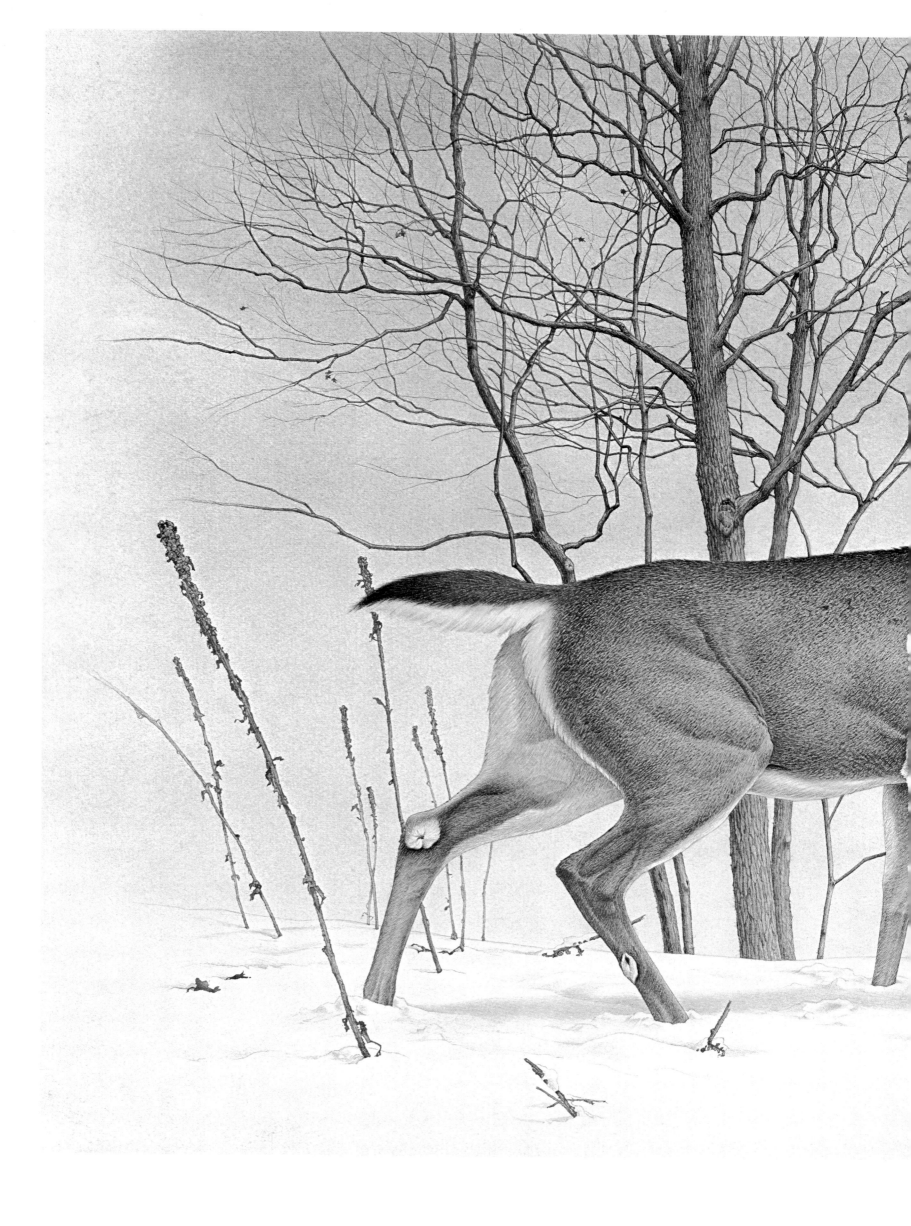

MOOSE FIELD SKETCH
Transparent watercolor and pencil on paper, 19½ x 13″ (49.5 x 33 cm)

MOOSE, 1967
Opaque watercolor on tinted paper, 24 x 26" (61 x 66.1 cm.)

M. G. LOATES

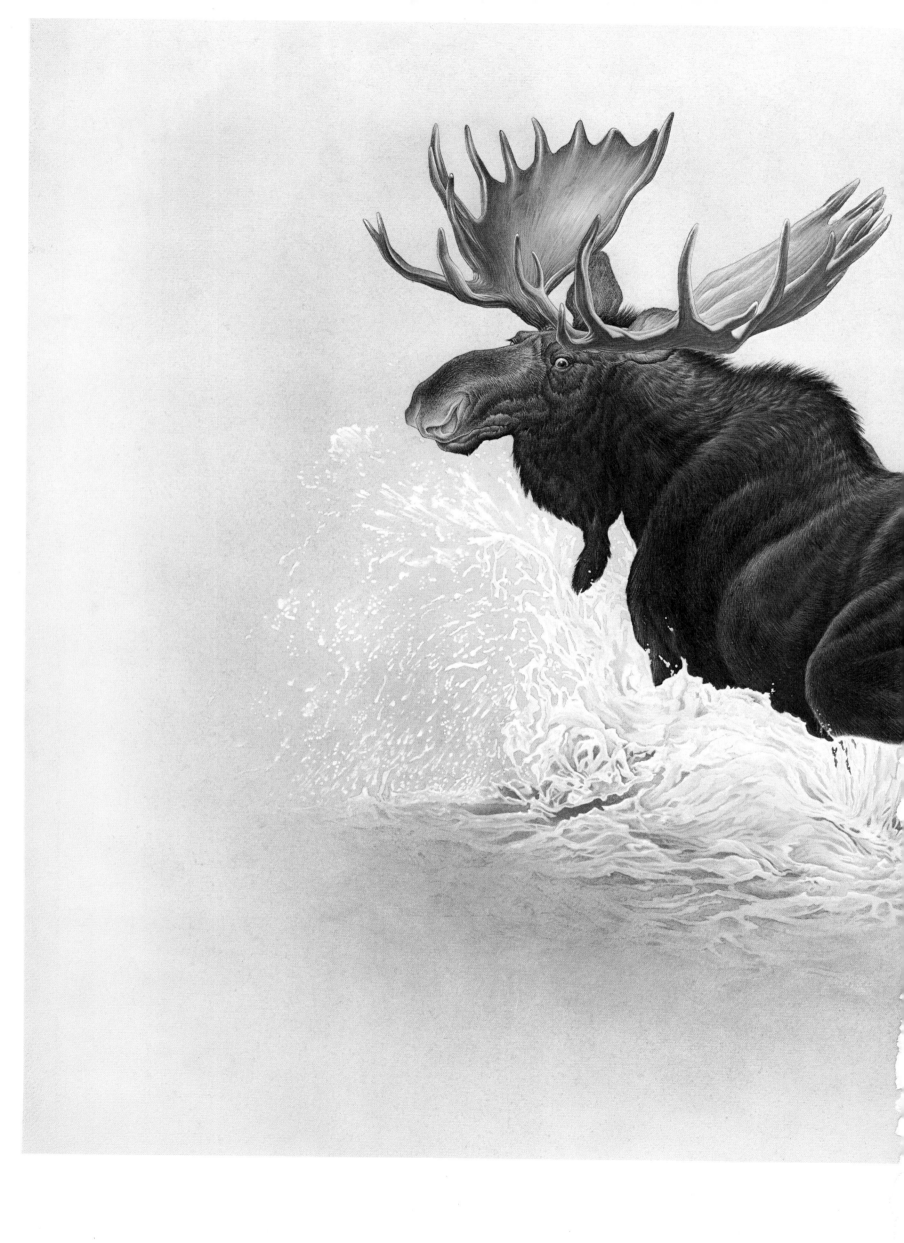

MOUNTAIN GOAT FIELD SKETCH
Opaque watercolor and pencil on paper, 13 x 19¼" (33 x 48.9 cm.)

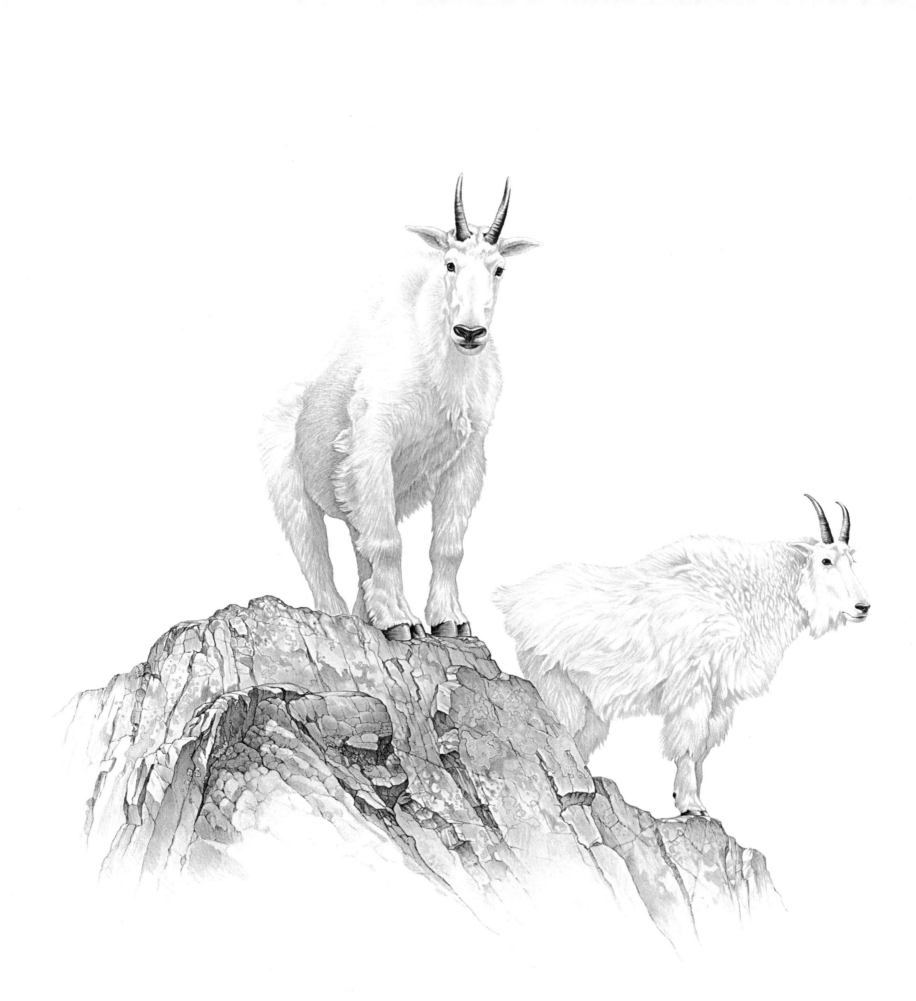

MOUNTAIN GOAT, 1967
Opaque watercolor on paper, 25½ x 22½" (64.8 x 57.2 cm.)
Private collection

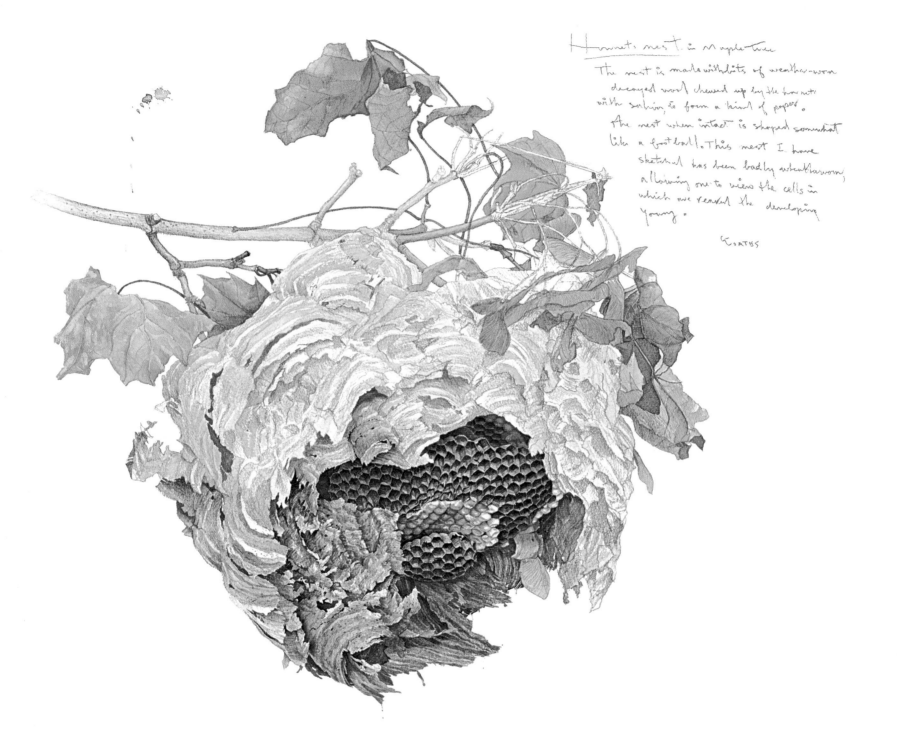

Hornets nest in maple tree

The nest is made with bits of weather-worn
decayed wood chewed up by the hornets
with saliva, to form a kind of paper.
The nest when intact is shaped somewhat
like a football. This nest I have
sketched has been badly weatherworn,
allowing one to view the cells in
which are reared the developing
young.

COATES

HORNET'S NEST STUDY
Transparent watercolor and pencil on paper, 22 x 18⅞" (55.9 x 47.9 cm.)
Private collection

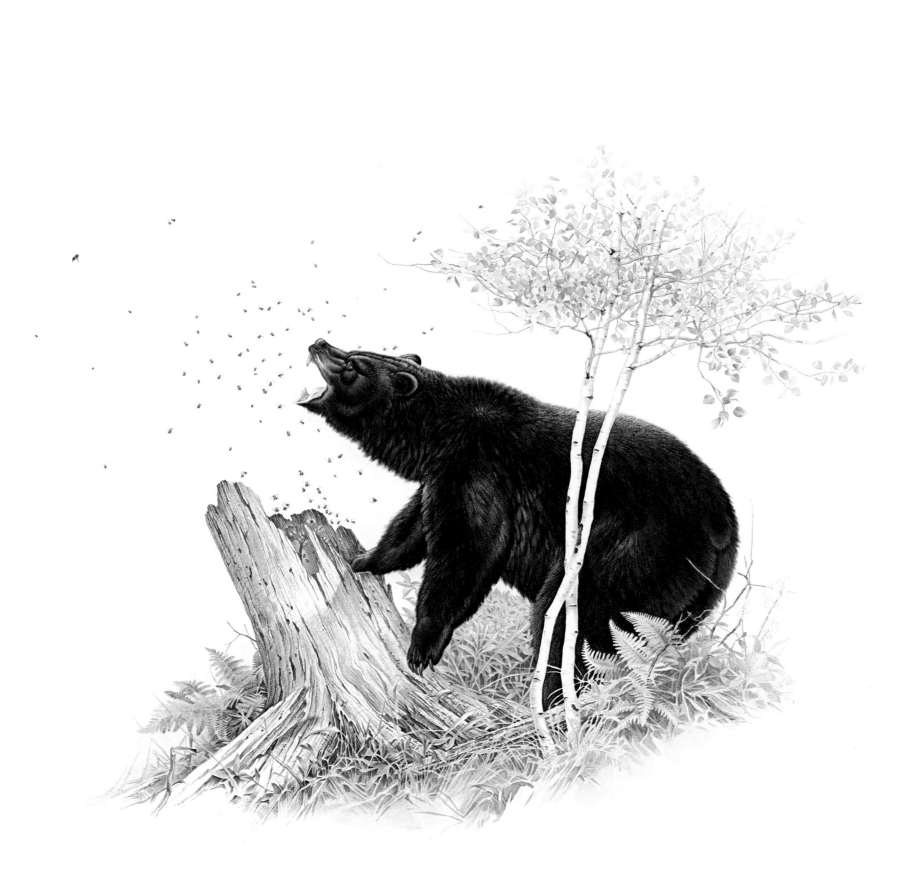

BLACK BEAR, 1967
Opaque watercolor on paper, 25 x 26" (63.5 x 66.1 cm.)
Private collection

GRIZZLY BEAR FIELD SKETCH
Pencil on tinted paper, 26 ½ x 39″ (67.3 x 99 cm.)
Private collection

COTTONTAIL RABBIT FIELD SKETCH
Opaque watercolor and pencil on paper, 17 x 15¾″ (43.2 x 40 cm.)
Private collection

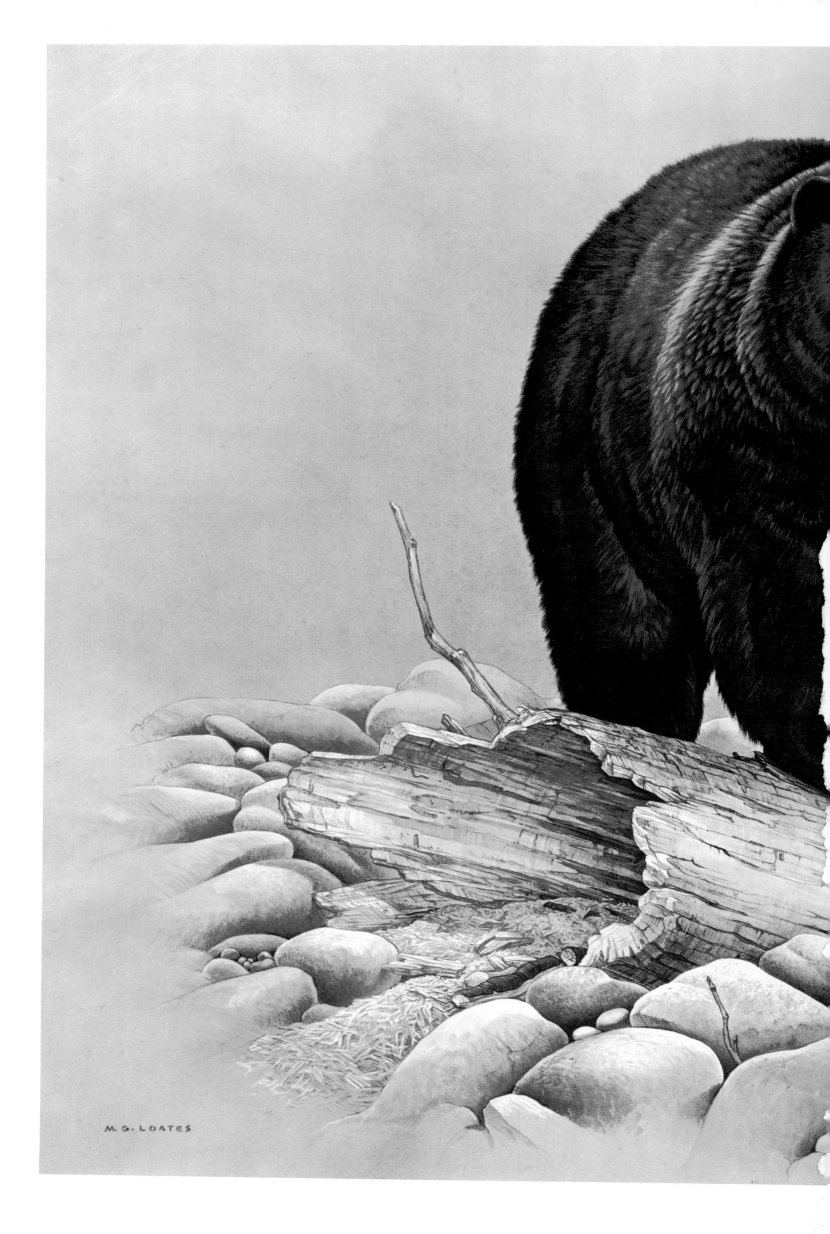
M. G. LOATES

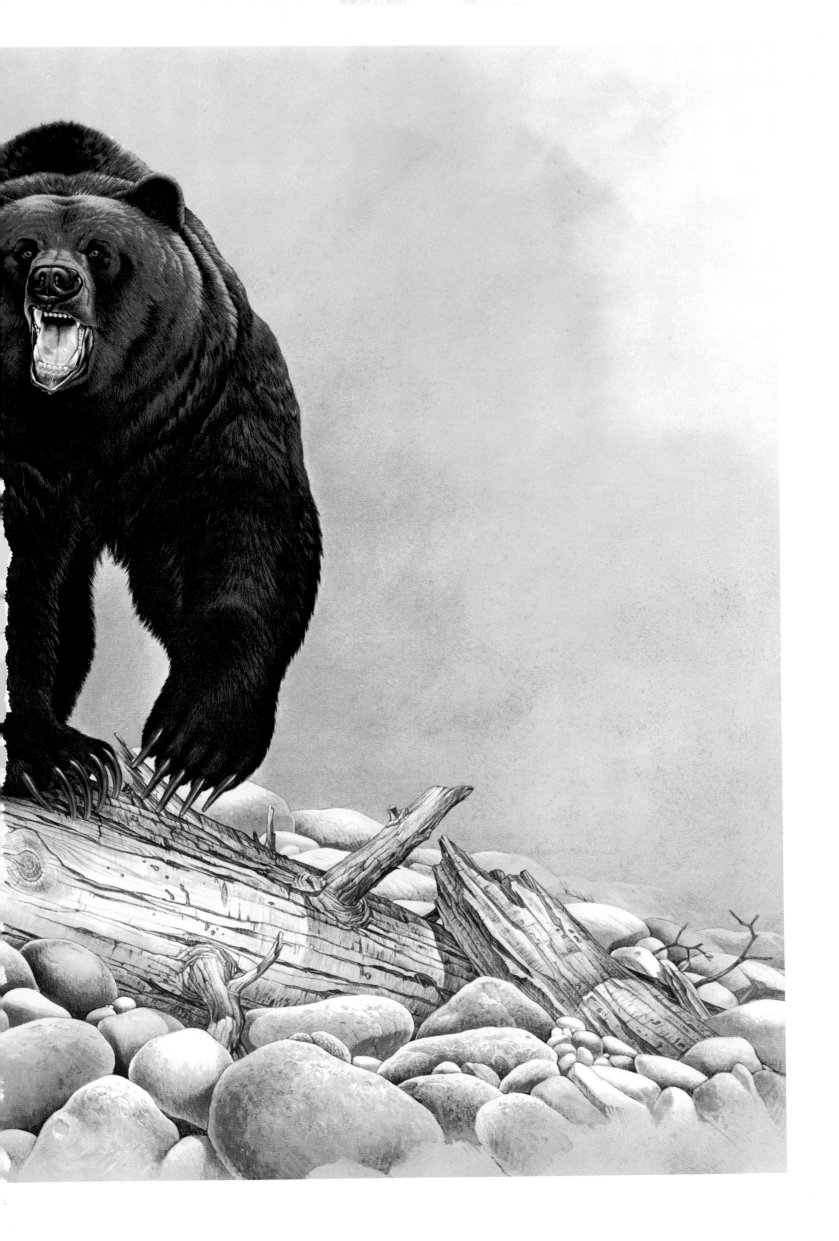

GRIZZLY BEAR, 1967
Opaque watercolor on tinted paper, 28 x 32" (71.1 x 81.3 cm.)
Private collection

85

COTTONTAIL RABBIT, 1968
Transparent watercolor on paper, 19¾ x 17¼" (50.2 x 43.8 cm.)
Private collection

KOKANEE SALMON, 1967
Transparent watercolor on paper, 20¼ x 26¼" (51.4 x 66.7 cm.)
Private collection

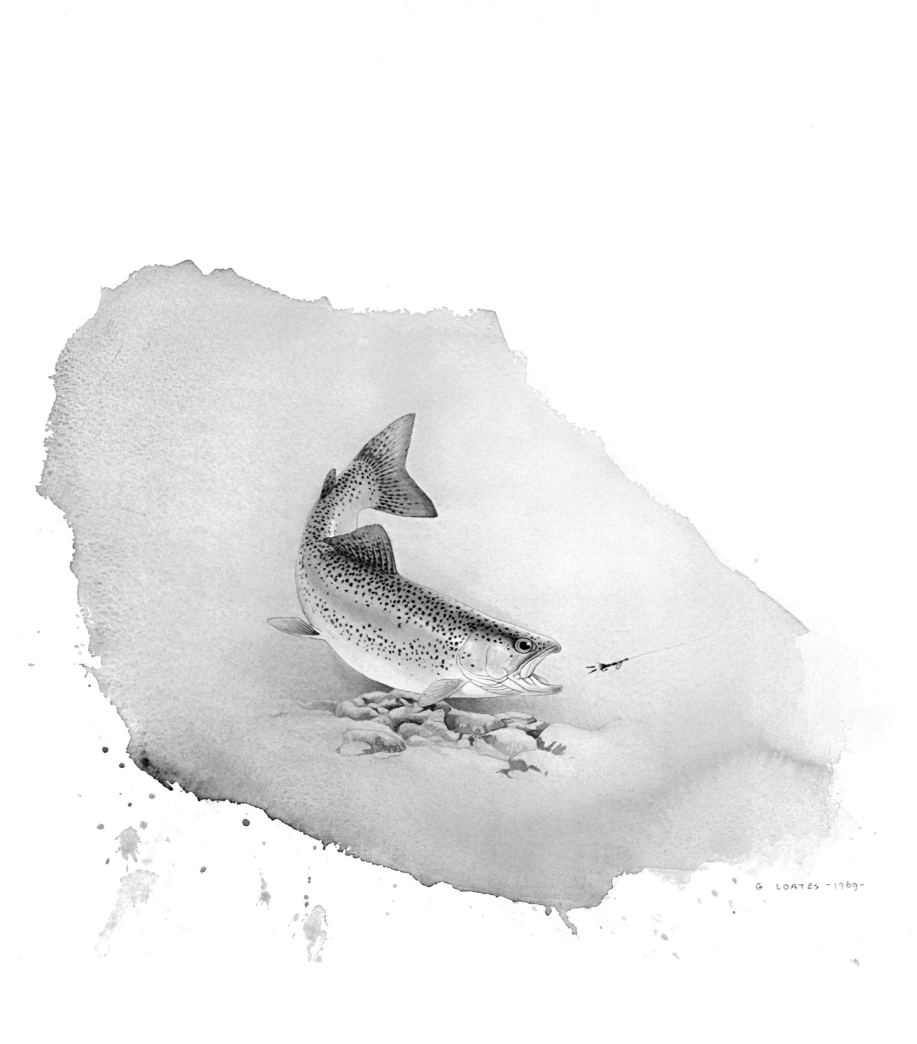

RAINBOW TROUT, 1969
Transparent watercolor on paper, 11 x 14¾"(27.9 x 37.4 cm)
Private collection

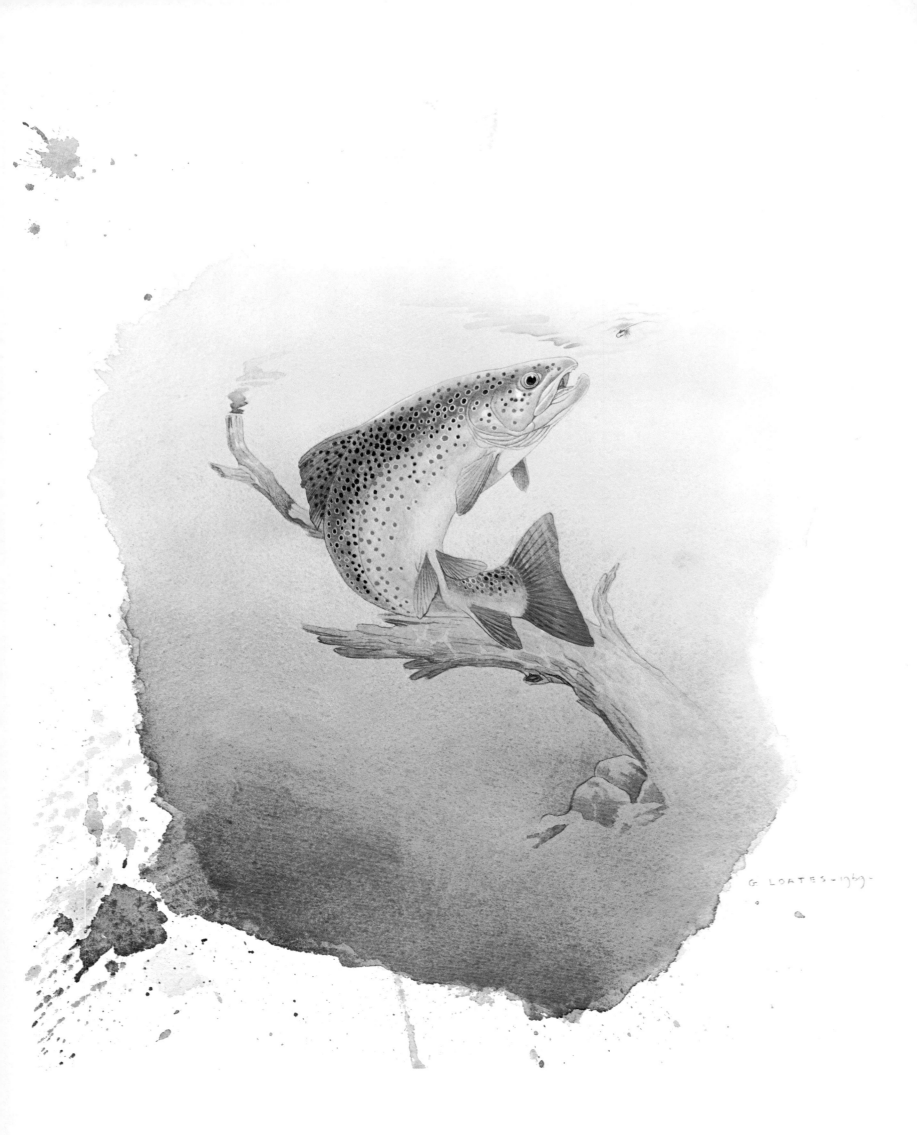

BROWN TROUT, 1969
Transparent watercolor on paper, 14¼ x 12¾" (36.2 x 32.4 cm.)
Private collection

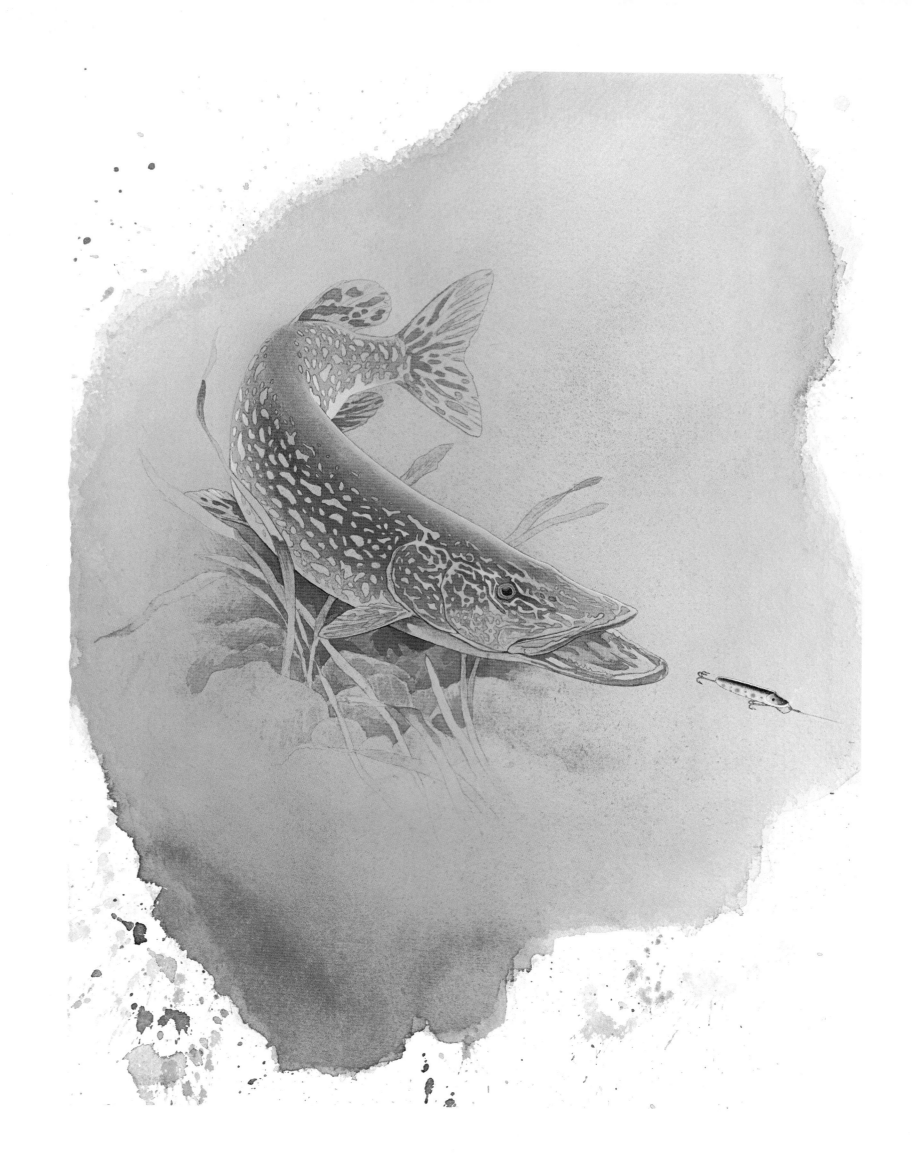

NORTHERN PIKE, 1969
Transparent watercolor on paper, 14¾ x 11" (37.5 x 28 cm.)
Private collection

IV. A Wider Recognition

lthough mammals were to occupy an increasing amount of Glen Loates' attention, he continued to reveal his versatility with two 1969 series for the *Canadian* magazine, one devoted to butterflies and moths, the other to wild flowers. These nature themes had been his first preoccupation as a schoolboy artist.

The butterflies and moths, published in May 17, 1969, included the Cecropia Moth, Polythemus Moth, Luna Moth, Virginia Ctenucha Moth, and the Monarch, Red Admiral, Mourning Cloak and Orange Sulphur Butterflies. Each of these is portrayed in a familiar setting, the early-appearing Mourning Cloak on the ground, surrounded by dead leaves with a Spring Beauty blossom nearby. The pair of Red Admirals are hovering about the nectar of blue-eyed grass; the Luna Moth is nearly camouflaged upon a birchbark branch, amidst a sprig of leaves, and the Monarch in its milkweed feeding ground. The incisive, delicate renderings of these colorful insects contrast vividly in style with the big game paintings of a year before. The color washes are as light as gossamer, but given a firm form by the artist's disciplined drawing and sure sense of form. There is nothing weak about these sensitive renderings of some of the most elusive representatives of wildlife.

Equally confident in their rendering are the wild flower paintings in Loates' succeeding *Canadian* series of May 16th, 1970. Here, the subjects were chosen by the artist to display a cross-section of wood and field blossoms. His selection also was guided by a desire to reveal the widest possible variety of shape in nature. Loates' final choice ran the gamut from the Morning Glory to Swamp Iris, and included Evening Primrose, Day Lily, Columbine, Purple-flowering Raspberry, and Turk's-cap Lily. These paintings were conceived in two stages. First, the flowers were drawn with color notes in their natural environment. The final watercolors were then painted from the same plants which had been transferred to the artist's studio in large pots. The design and style of the finished paintings once again reflect Loates' admiration for many of the great oriental wildlife masters.

One of the most winning of all Loates' combinations of bird and floral themes was also painted in 1969, "Ruby-throated Hummingbird with Columbine." In its delicacy of brush work and lace-like composition, it is oddly reminiscent of some of the best English 19th century wildlife artists.

By 1970, the art of Glen Loates was becoming widely known in natural history circles in the United States. On September 27th of that year, the twenty-five year old artist was honored by a showing of forty-one of his works at the noted Jesse Besser Museum

of Natural History at Alpena, Michigan. It was his first American exhibition since the exhibit at Buffalo's Museum of Natural History, but many more were to follow.

During much of 1970, Loates labored on the last of his mammal series for the *Canadian,* which had done so much to make his work known to an audience numbering in millions. He found the vast amount of mail that poured in after each publication of his art exhilarating and rewarding. It pleased him to learn that reproductions of his paintings were hanging in trapper's cabins and school rooms, thousands of miles apart.

"I have never painted simply for immediate popularity," say Loates. "I am completely absorbed by my subject, whether it is an attractive one or not, while I am doing it. But I must admit it is satisfying to learn, after a painting is researched and finished, that my efforts have brought enjoyment to so many people, particularly the younger ones."

The series, "Animals of Field and Forest," which was published March 20th, 1971, proved one of the most popular of Loates' ventures and, more importantly, it saw his art rise to a rich new standard of achievement. Here he was finally emerging into the mainstream of world wildlife art. Before this, his work had shown flashes of technical brilliance, some noteable composing and exceptional insight into animal behaviour, but it had still not coalesced into a highly personal style. Now, in such paintings as "Red Fox" and "Eastern Flying Squirrel," he pulled all of the elements together into works that had an almost easy inevitability about them. There is the seemingly effortless grace that is found in the fine art of any painter in the full flow of his maturity. There can be little question that 1970 saw the emergence of Loates as a noteworthy wildlife artist, comparable to the best of his contemporaries.

Altogether, there were five mammals in the Field and Forest feature – the Raccoon, Skunk and Vole, as well as the Red Fox and Eastern Flying Squirrel. All of these share the same immediacy of movement and independence of character. There is nothing stilted or photographically frozen about these images. They are eloquently convincing, and Loates' subtle personal technique is perfectly suited to his aims. The easy control of texture, accent of detail and richness of tone evident in these five paintings show that he has finally wedded his creative concepts and technique.

Loates painted one of his finest bird studies, "Goldfinch and Thistle," in 1970. Crisp and fragile in its execution, this painting was dedicated by the artist to his fiancee, Sally Harding. Glen had met Sally in mid-June of 1970, and shortly after their early engagement they travelled together to Maryland and Washington, D.C., to visit her relatives. While

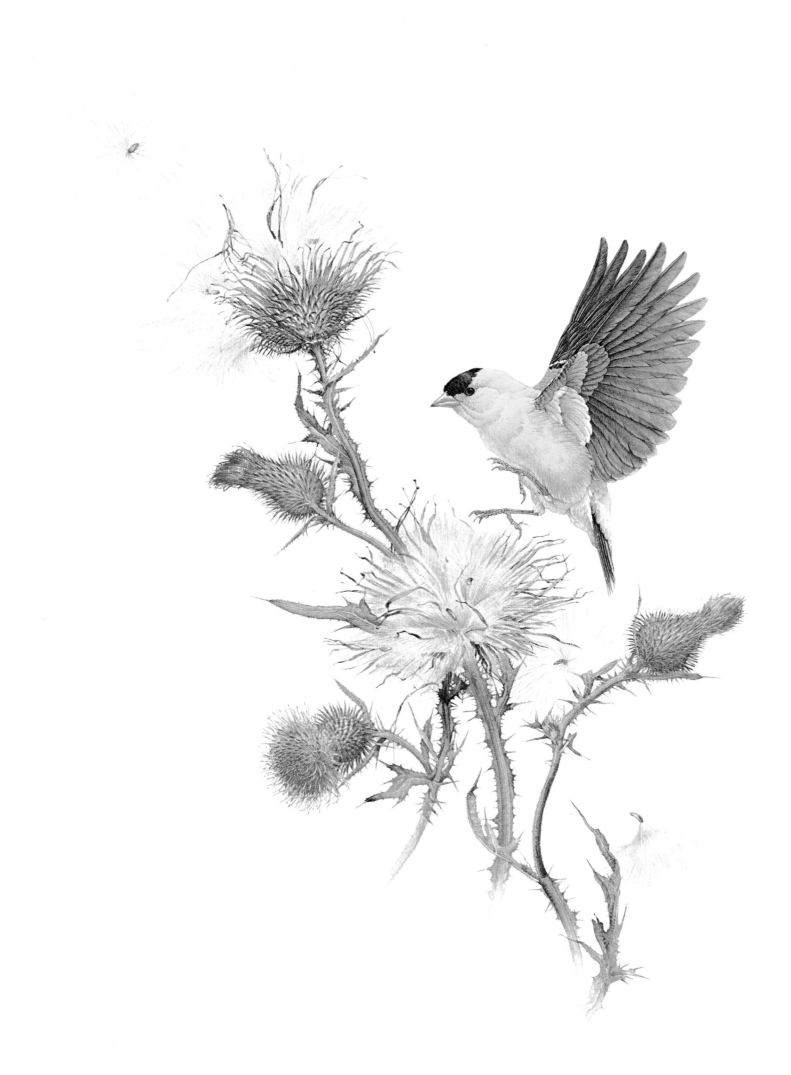

GOLDFINCH, 1970
Transparent watercolor on paper, 17 x 13¼″ (43.2 x 33.6 cm.)
Private collection

there, Loates had his first opportunity to visit the Smithsonian Institute. Although the natural history department was of interest, the Institute's major attraction for him were the original paintings by Audubon and the opportunity to examine at leisure that great bird artist's famed *Elephant Portfolio* of bird lithographs.

"Audubon in the original was one of my greatest revelations," says Loates. "Looking at his originals, I realized just how far wildlife painting could be carried as a fine art. Those Audubons certainly inspired me, and still do."

Sally, his companion on that visit to the Smithsonian, also inspired him to do a number of sensitive portrait drawings during the following year. They suggest how successful Loates also might have been if he had pursued a career in straight realist painting of figure and landscape.

The next fall and winter, Loates divided his time between Toronto, where he was busy working on his "Field and Forest" animal paintings, and London, Ontario where Sally was studying at the University of Western Ontario. The couple married the following year, on June 12, 1971. One month before their wedding, the Arts and Letters Club of Toronto held a large retrospective exhibition of Loates' paintings and drawings, which included more than 125 pieces. For the occasion, a few of the artist's infrequent landscape compositions were interspersed among the wildlife subjects. This show was organized by Walter Coucill, a friend of the artist, and a frequent sketching companion.

A second major exhibition was organized in 1971 by James Hubbard, of the McMichael Canadian Collection at Kleinburg, Ontario. Located in a protected semi-wilderness setting, the McMichael Gallery is renowned for its comprehensive collection of Canada's greatest landscape artists. The invitation to exhibit there was a signal honor for Loates. In return, the young artist provided the gallery with one of its most popular one-man shows. More than one-hundred thousand visitors viewed Loates' paintings during their seven-month display.

The McMichael show included a number of new mammal paintings executed during 1971, such as the large preliminary watercolor sketches of Big Horn Sheep, Mule Deer, Prong-horn Antelope, Muskox and Brown Bear. Perhaps the most important composition of this period is the arresting portrait of a Canada Lynx, caught in a close-up, frontal view. To get the exact rendition of the winter coat of the Lynx, Loates spent several days studying the species in an open air animal preserve at Wasaga Beach, Ontario. To achieve the ferocious expression, he had the keeper frustrate the animal by repeatedly offering and snatching away a feast of fresh meat.

1972 was a difficult year for Loates. Although settling happily into his new marriage, he was involved much of the time in serious contractual litigation, breaking away from a business arrangement which had proved harmful to his future. One major painting to emerge from that trying and distracting time turned out to be one of his finest works, a monumental study of a Cougar. This painting represents Loates at the peak of his performance. Silhouetted against a plain white background, this tawny, giant cat is surely a symbol of all the grace, arrogance and deadly power contained within this magnificent and endangered American Lion.

CECROPIA MOTH CATERPILLAR, 1969
Transparent watercolor on paper, 11 x 11½" (27.9 x 29.2 cm.)

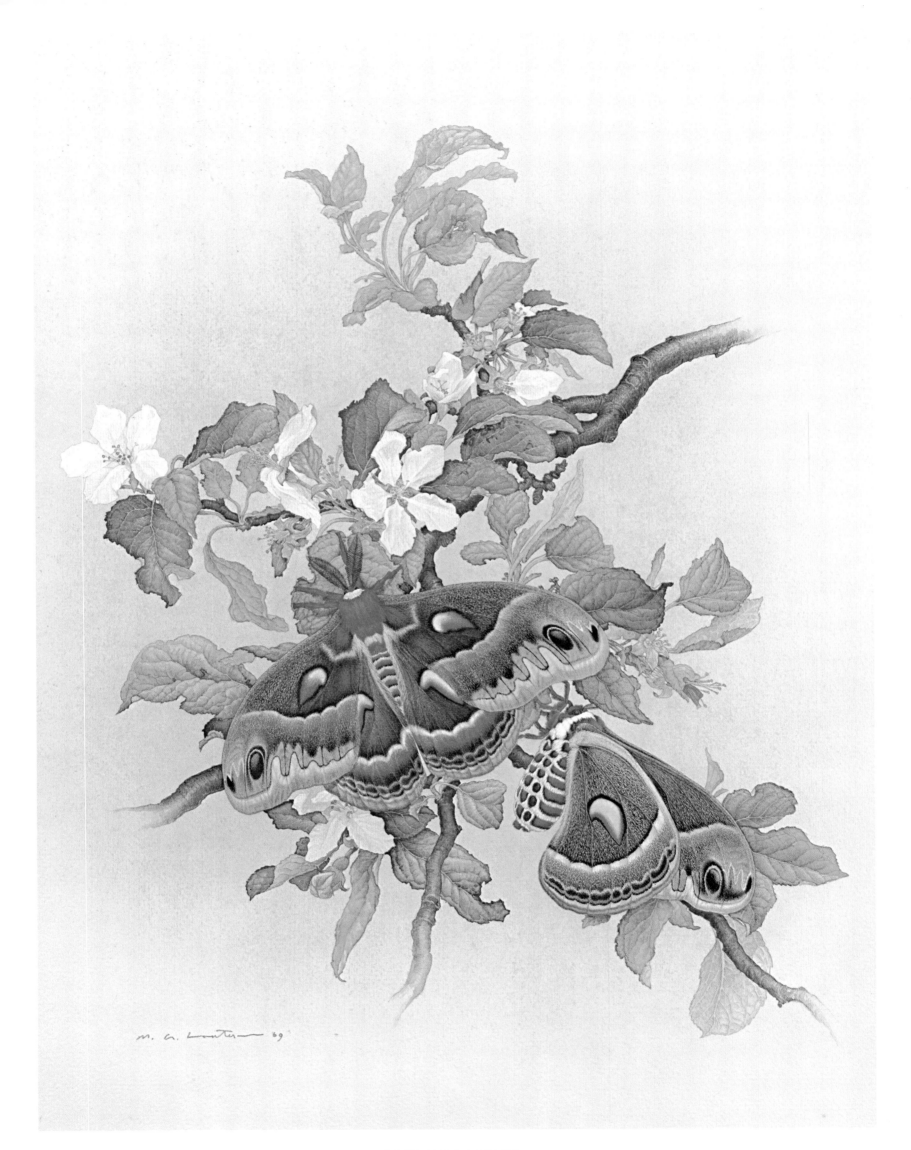

CECROPIA MOTH, 1969
Transparent watercolor and ink on paper, 14⅝ x 12¼" (37.2 x 31.1cm)
Private collection

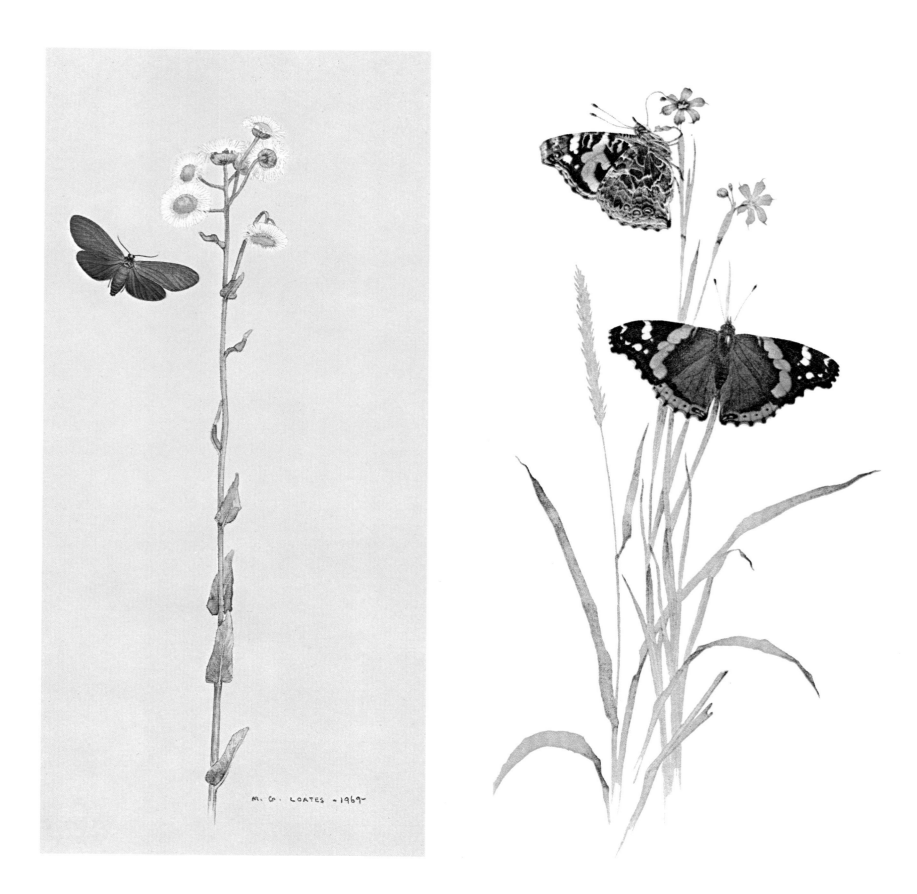

Left: VIRGINIA CTENUCHA MOTH, 1969
Transparent watercolor and ink on paper, 12½ x 10" (31.8 x 25.4 cm.)
Private collection
Right: RED ADMIRAL, 1969
Transparent watercolor on paper, 10 x 9½" (25.4 x 24.1 cm.)
Private collection

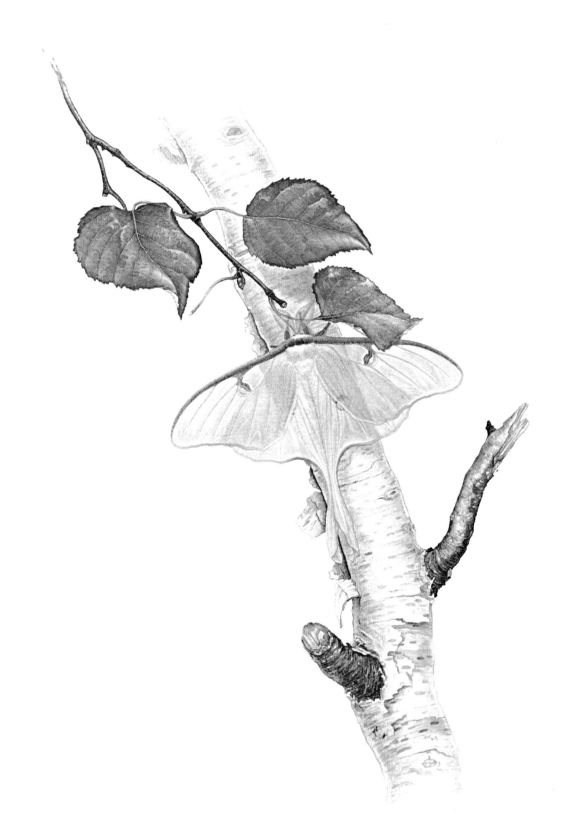

LUNA MOTH, 1969
Transparent watercolor on paper, 10¾ x 9¼″ (27.3 x 24.8 cm.)

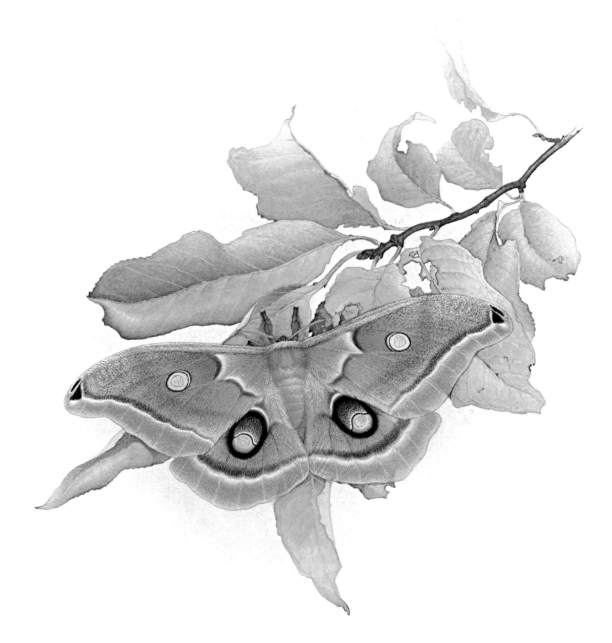

POLYPHEMUS MOTH, 1969
Transparent watercolor on paper, 11½ x 10″ (29.2 x 25.4 cm.)
Private collection

Top, ORANGE SULPHUR COLOR COMPOSITION
Transparent watercolor on tinted paper, 10¼ x 8¾" (26 x 22.2 cm)
Above, ORANGE SULPHUR BUTTERFLY, *1969*
Transparent watercolor on tinted paper, 12¼ x 10" (31.1 x 25.4 cm.)

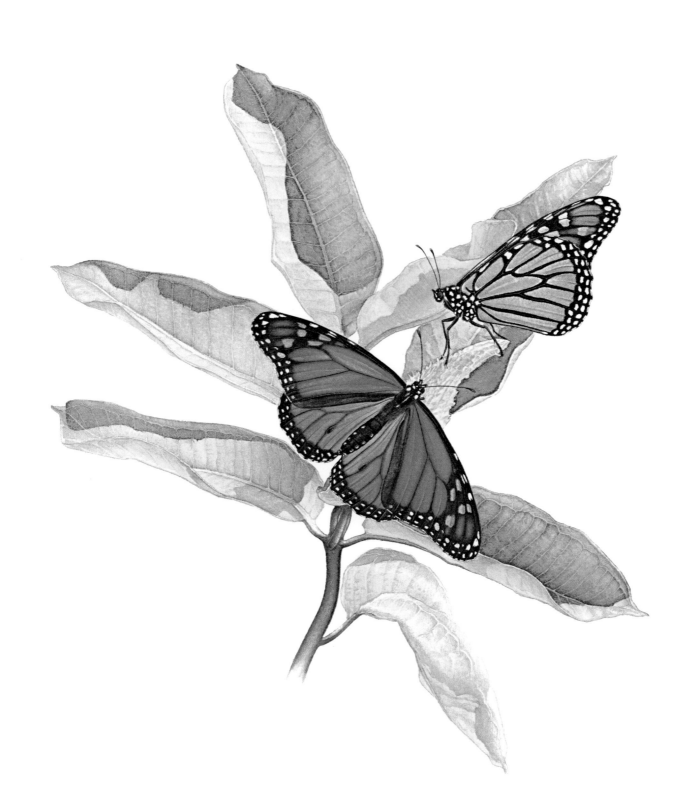

MONARCH BUTTERFLY, 1969
Transparent watercolor on paper, 12¾ x 10¼″ (32.4 x 26 cm.)
Private collection

103

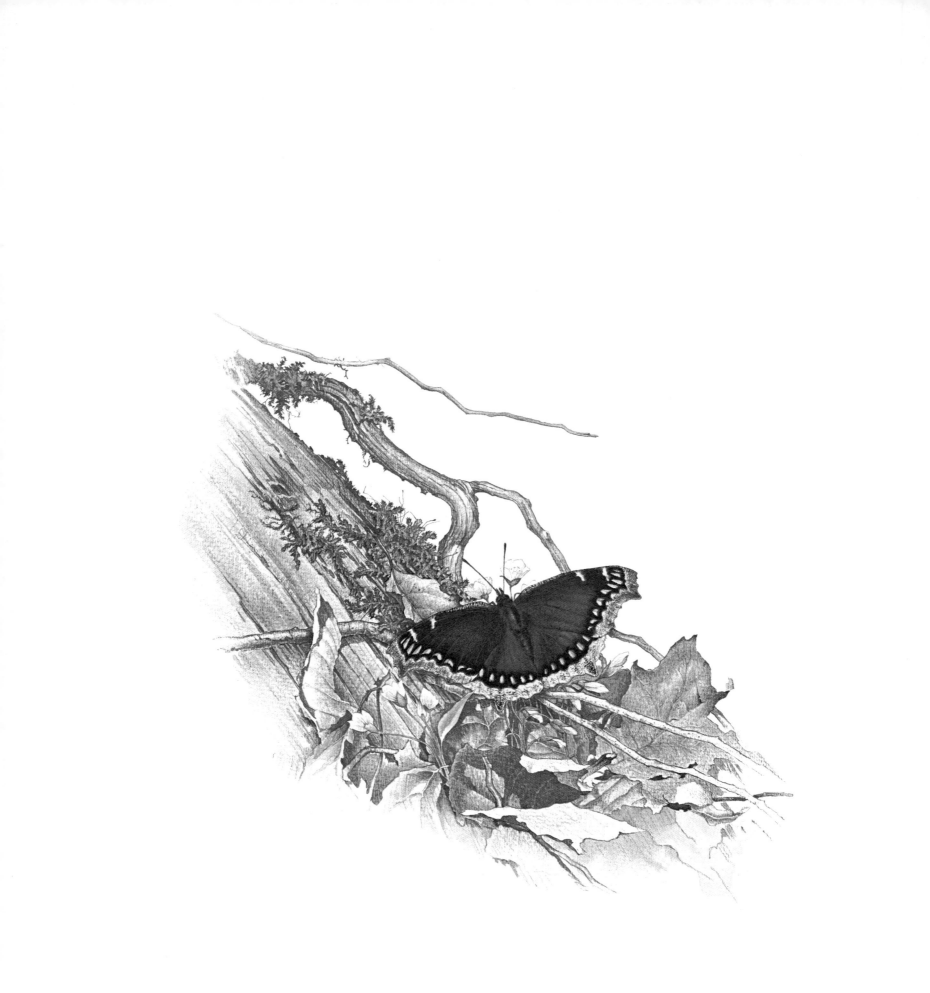

MOURNINGCLOAK BUTTERFLY, 1969
Transparent watercolor on paper, 11 x 10⅛" (28 x 25.7 cm.)
Private collection

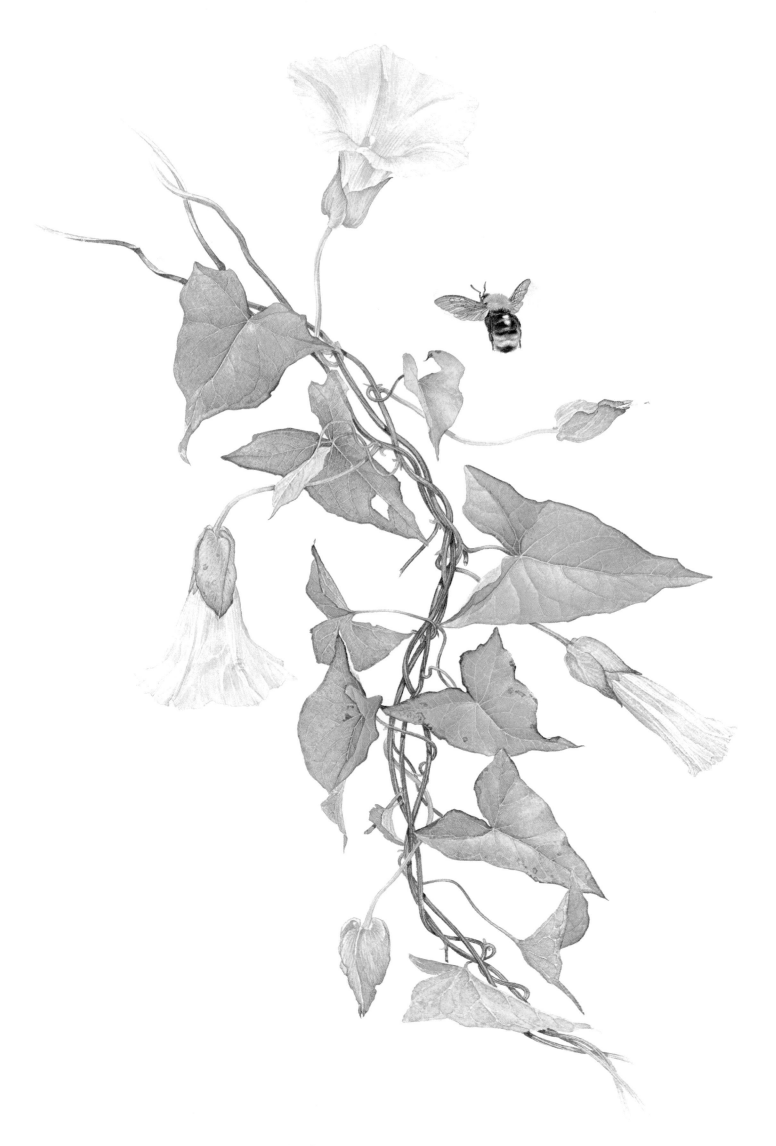

MORNING-GLORY, 1969
Transparent watercolor on paper, 15 x 12½" (38.1 x 31.8 cm.)
Private collection

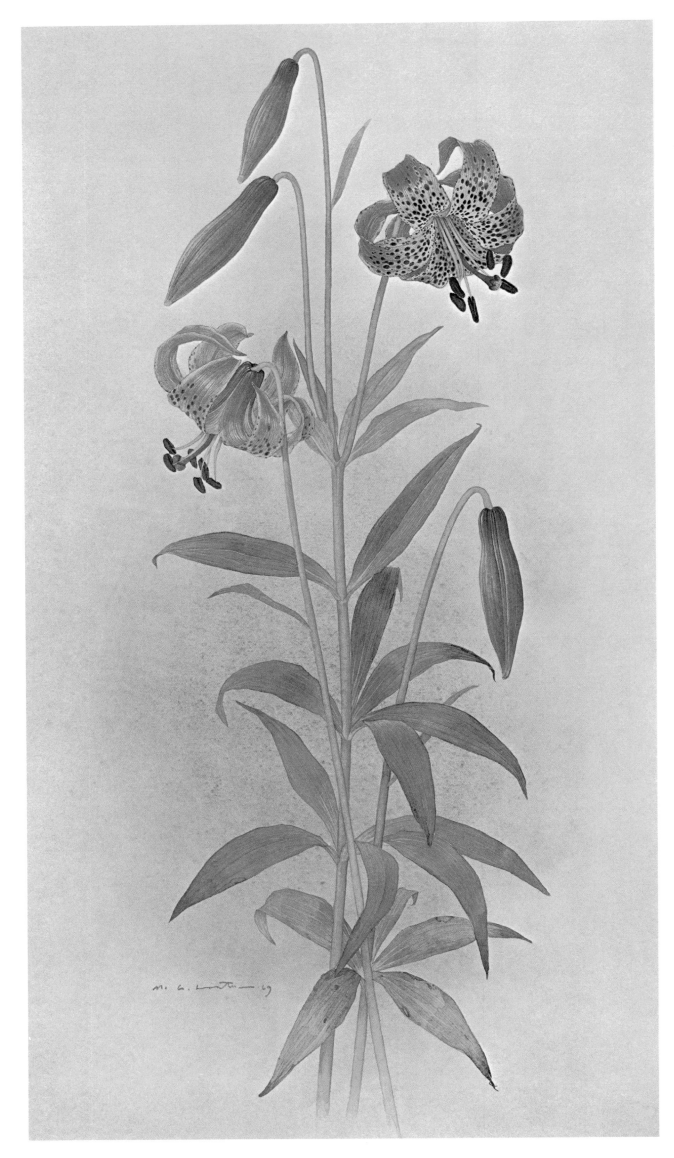

TURK'S-CAP LILY, 1969
Transparent watercolor and ink on paper, 17¾ x 9½" (45.1 x 24.2 cm.)

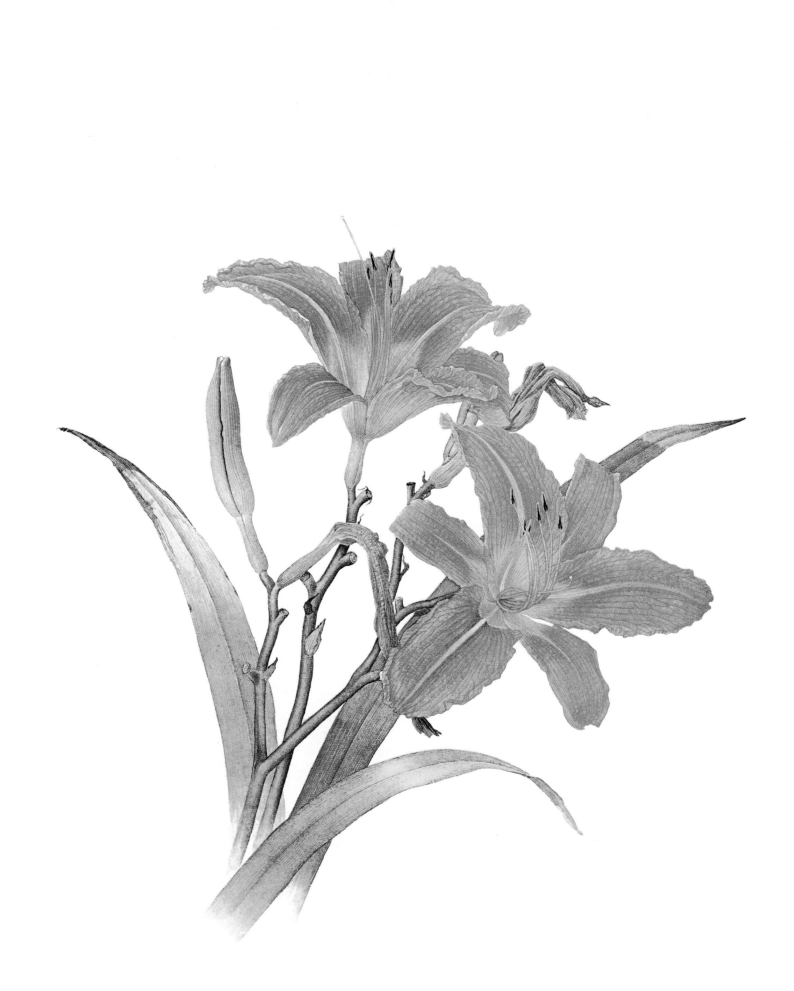

DAY-LILY, 1969
Transparent watercolor on paper, 11½ x 10" (29.2 x 25.4cm.)
Private collection

107

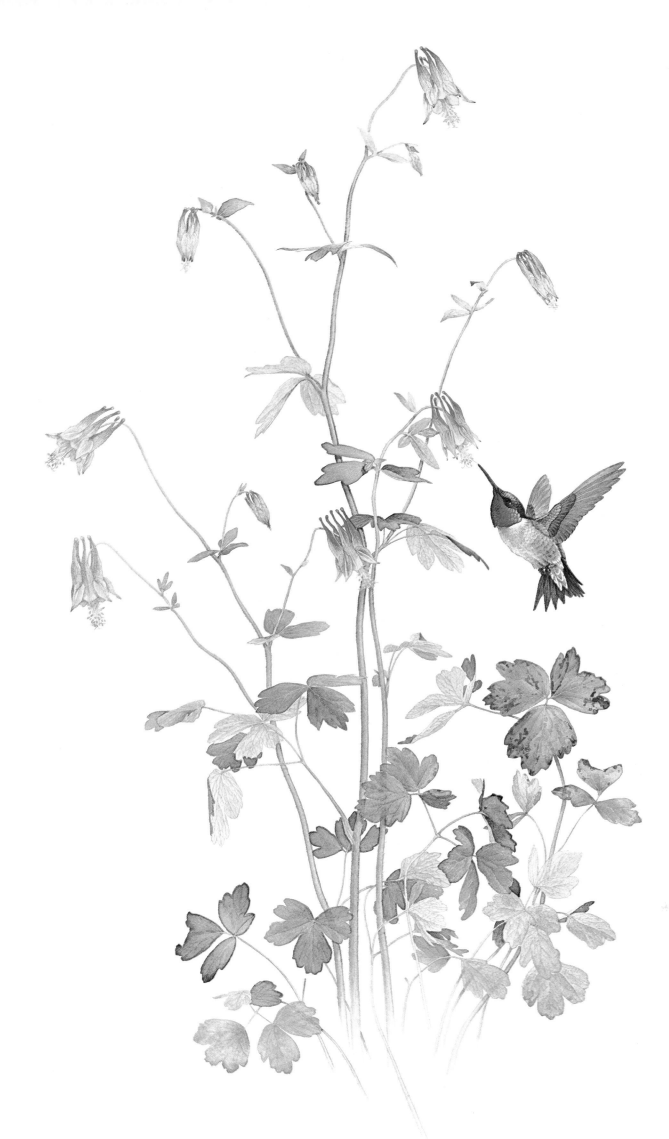

COLUMBINE & RUBY-THROATED HUMMINGBIRD, *1969*
Transparent watercolor on paper, 24¾ x 16½" (62.9 x 42 cm.)
Private collection

IRIS, 1969
Transparent watercolor on paper, 25 x 19½" (63.5 x 49.6 cm.)

PURPLE-FLOWERING RASPBERRY, 1969
Transparent watercolor on paper, 12⅜ x 10″ (31.5 x 25.4 cm.)
Private collection

VETCH, 1969
Opaque watercolor on tinted paper, 7⅞ x 10⅛" (20 x 25.7 cm.)
Private collection

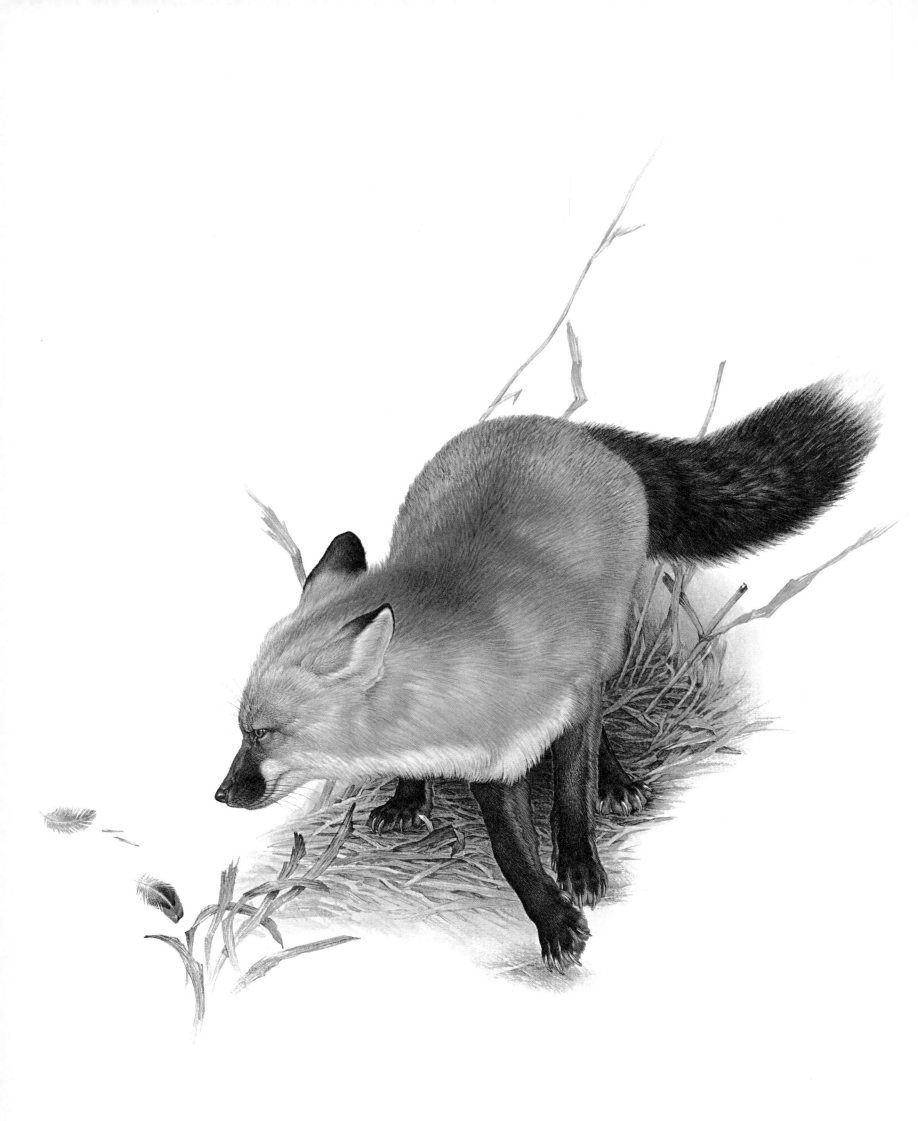

RED FOX, *1969*
Transparent watercolor and ink on paper, 17¾ x 12⅛" (45.1 x 31 cm.)
Private collection

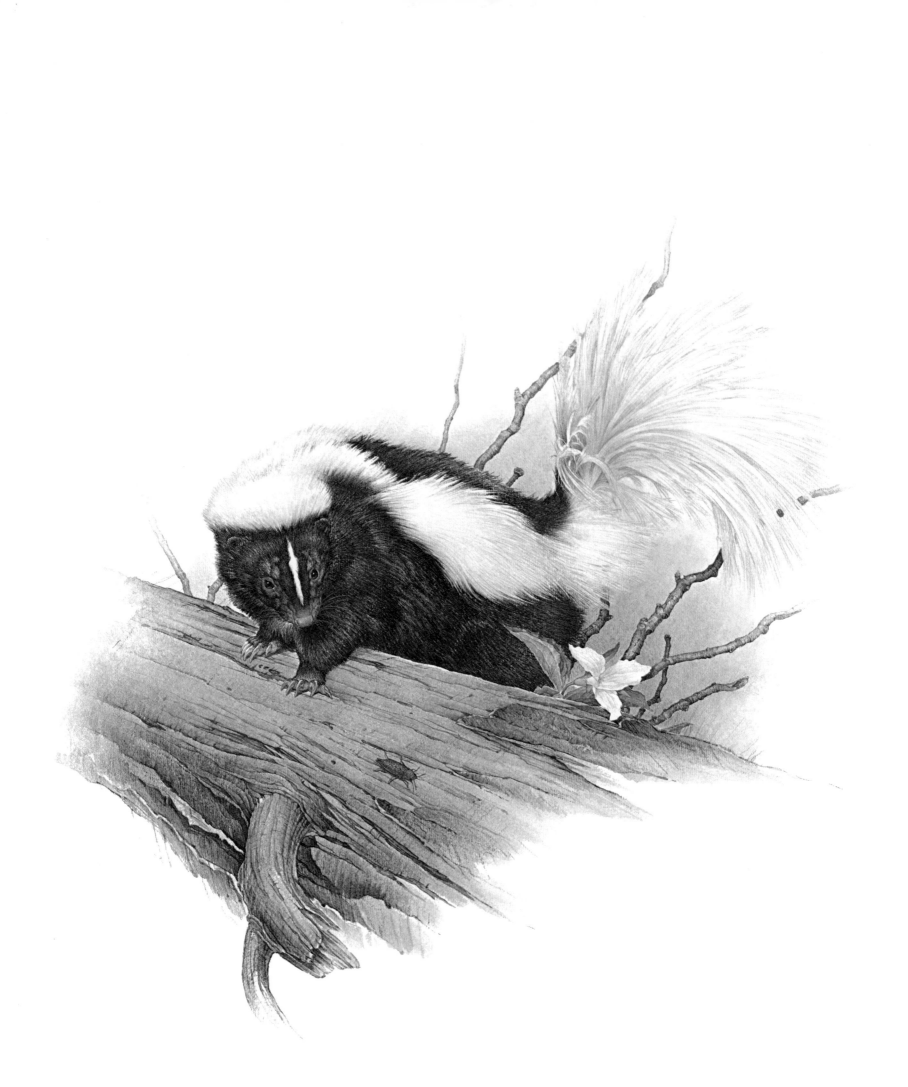

STRIPED SKUNK, 1970
Transparent watercolor and ink on paper, 17¼ x 14¾" (43.8 x 37.5 cm.)
Private collection

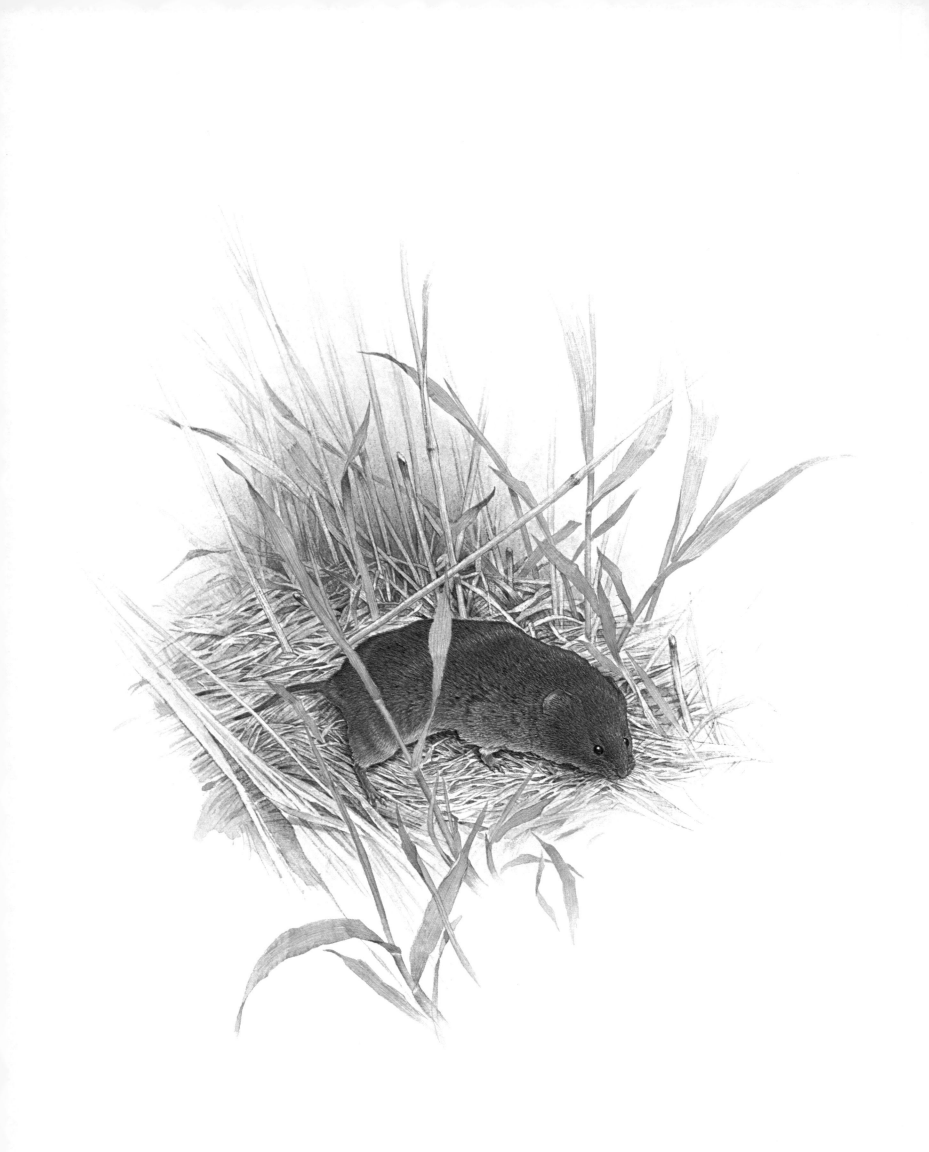

MEADOW VOLE, *1970*
Transparent watercolor on paper, 18 x 13" (45.7 x 33 cm.)
Private collection

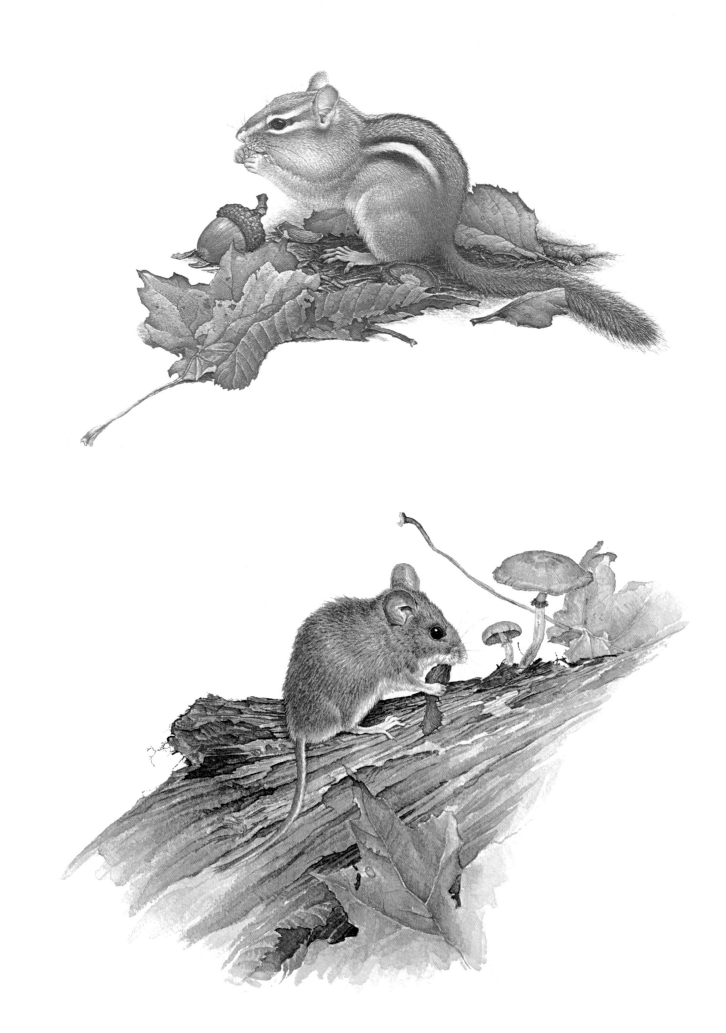

Top: EASTERN CHIPMUNK, 1970
Transparent watercolor on paper, 10 x 10½" (25.4 x 26.7 cm.)
Private collection
Above: DEER MOUSE, 1971
Transparent watercolor on paper, 13 x 11¾" (33 x 29.8 cm.)
Private collection

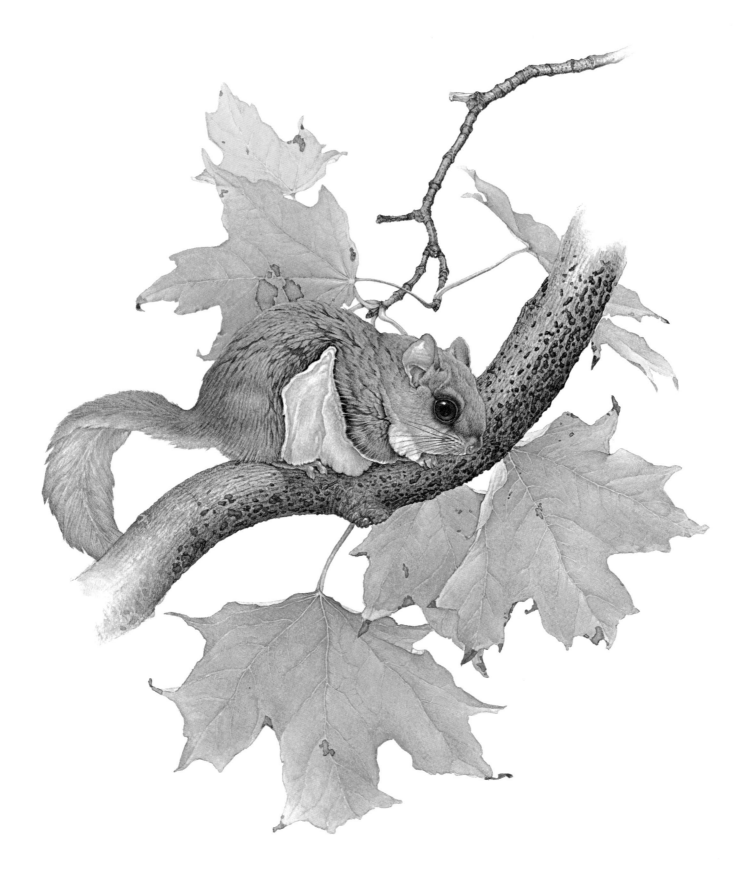

FLYING SQUIRREL, 1970
Transparent watercolor on paper, 20 x 15½" (50.8 x 39.4 cm.)
116

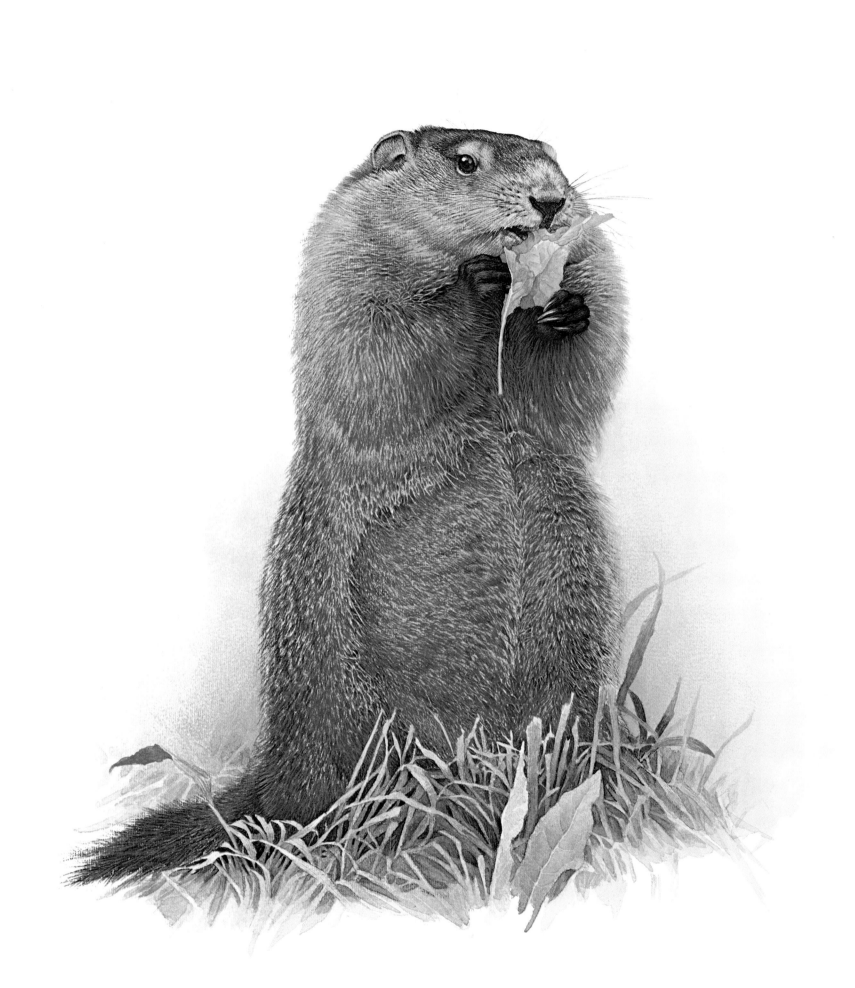

WOODCHUCK, 1971
Transparent watercolor on paper, 18 x 14" (45.7 x 35.6 cm.)
Private collection

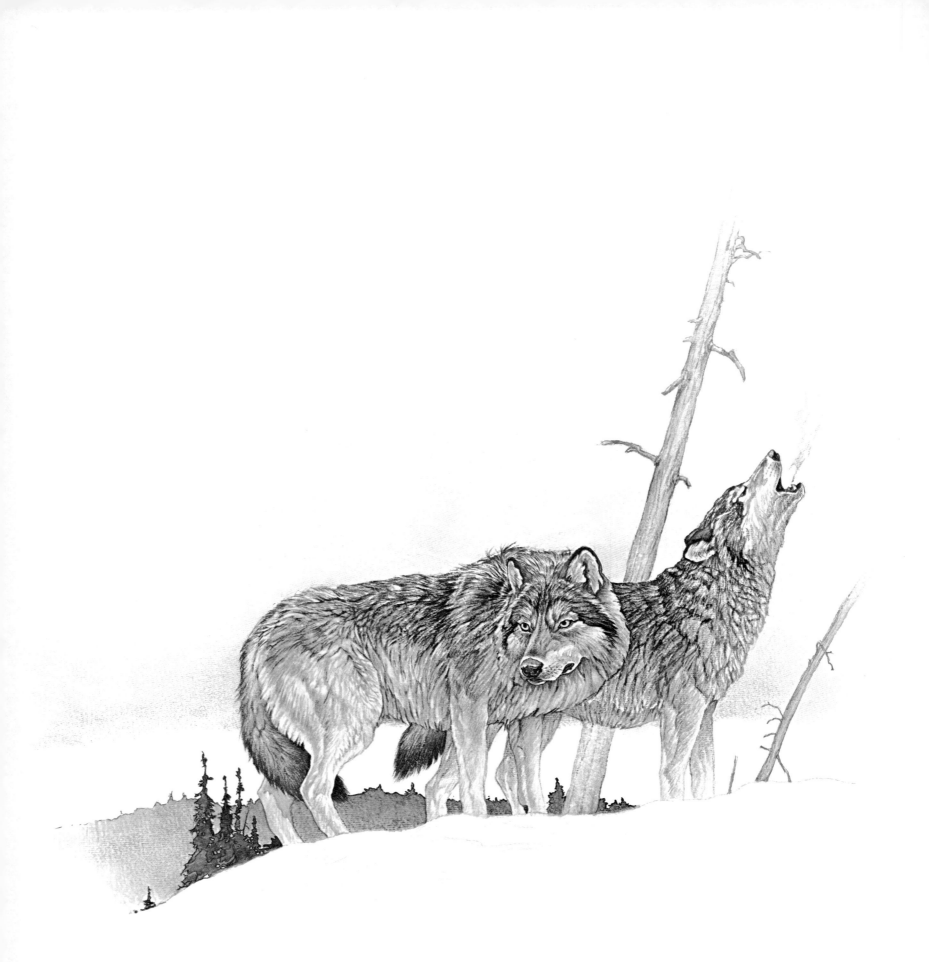

TIMBER WOLF PRELIMINARY WATERCOLOR, 1971
Transparent watercolor on paper, 14½ x 12¾" (36.9 x 32.4 cm.)
Private collection

MUSKOX PRELIMINARY WATERCOLOR, 1971
Transparent watercolor on paper, 10 ⅝ x 13 ⅛" (27 x 33.3 cm.)
Private collection

CANADA LYNX STUDY, 1971
Pencil on tinted paper, 12 x 8¾" (30.5 x 22.2 cm.)
Private collection

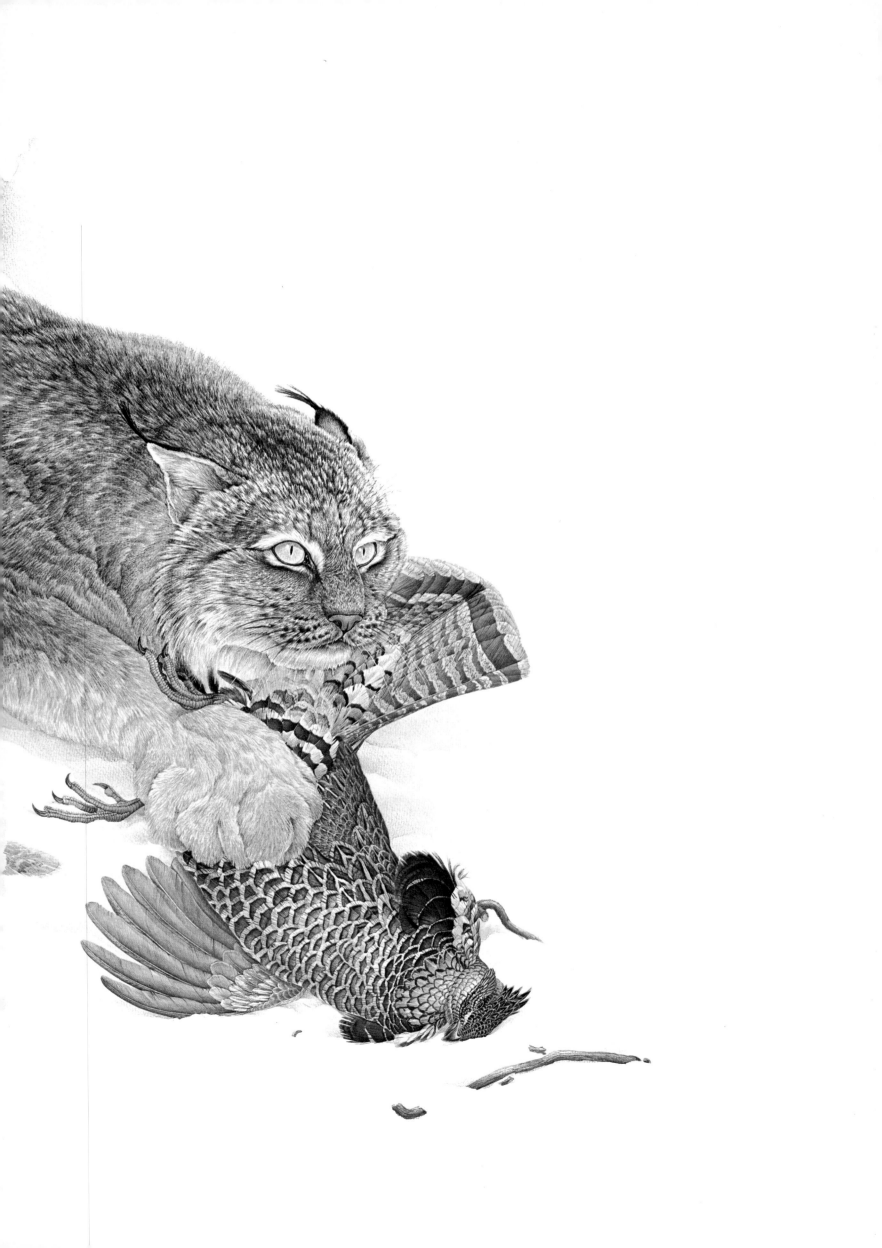

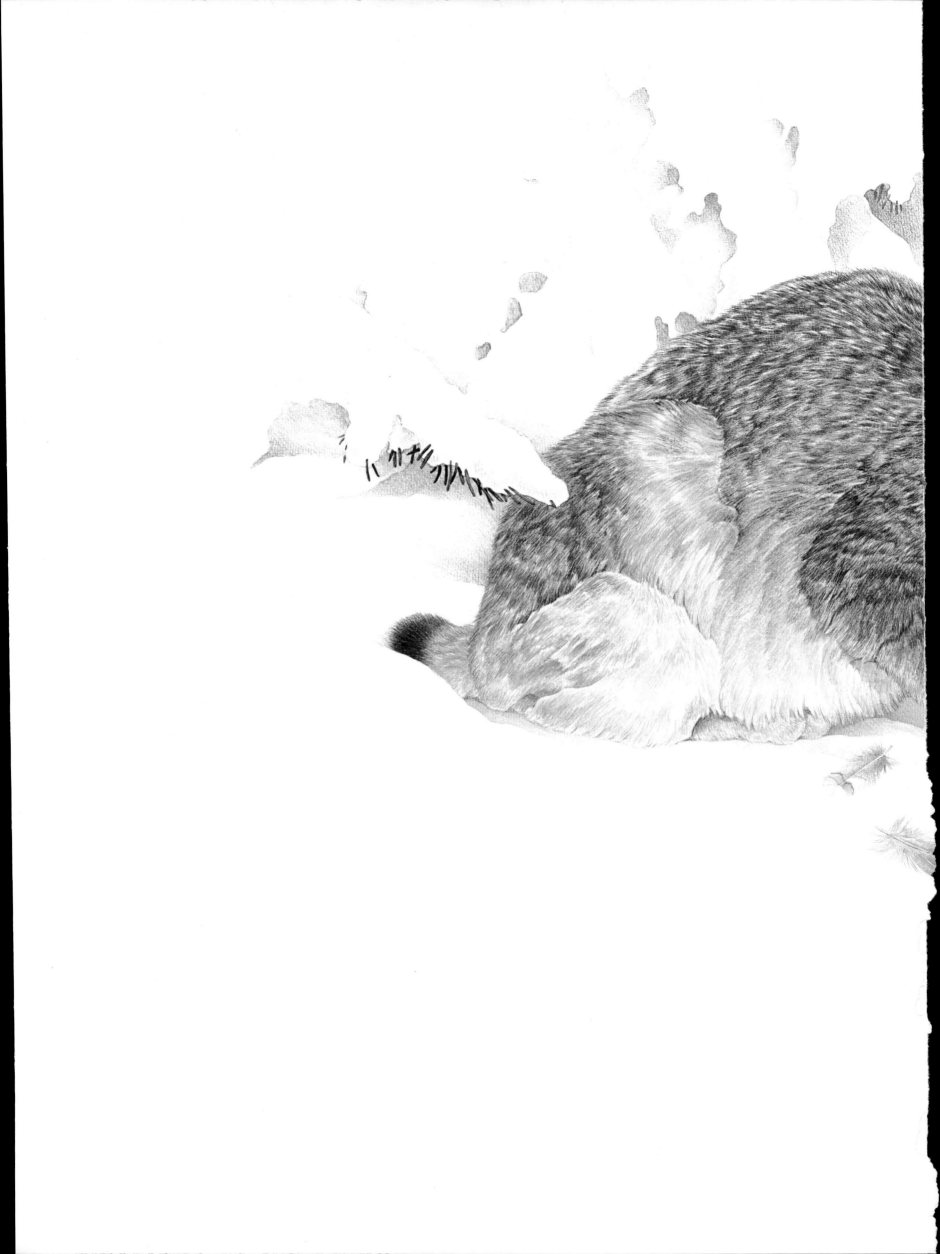

BIGHORN SHEEP PRELIMINARY WATERCOLOR, 1971
Transparent watercolor on paper, 13 x 9¾" (33 x 24.8 cm.)
Private collection

BROWN BEAR PRELIMINARY WATERCOLOR, 1971
Transparent watercolor on paper, 15 x 17½" (38.1 x 44.5 cm.)
Private collection

American Elk

Bull elk in morning
mist

ELK FIELD SKETCH, 1971
Pencil on tinted paper, 25¾ x 19½" (65.4 x 49.6 cm.)
Private collection

Water color sketch
preliminary to finished painting — G.L.

Elk or Wapiti

ELK PRELIMINARY WATERCOLOR, 1971
Opaque watercolor on tinted paper, 13 x 15⅜″ (33 x 39 cm.)
Private collection

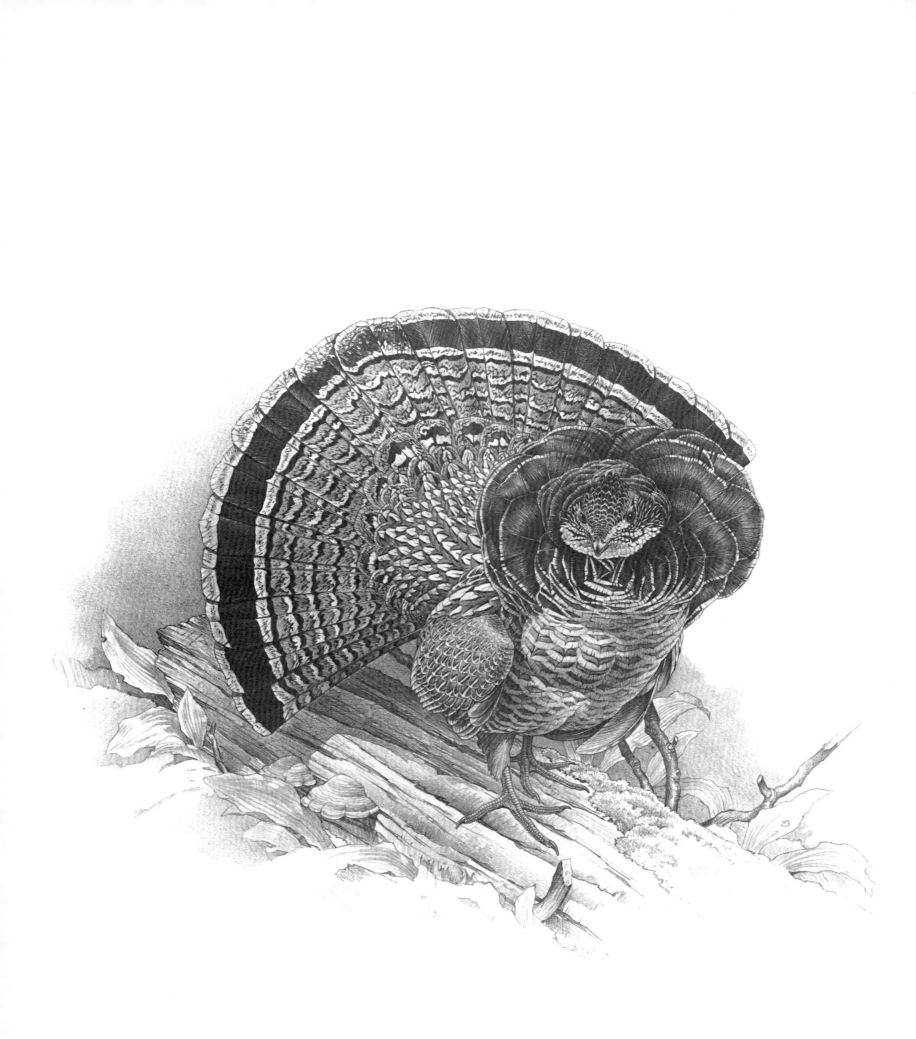

RUFFED GROUSE, 1971
Pencil on paper, 14 x 16⅝" (35.6 x 42.3 cm.)
Private collection

BALD EAGLE, 1971
Pencil on paper, 11⁷⁄₈ x 9³⁄₈" (30.2 x 23.9 cm.)
Private collection

127

MEADOWLARK FIELD SKETCH
Transparent watercolor and pencil on paper, 15⅛ x 12" (38.3 x 30.5 cm.)
Private collection

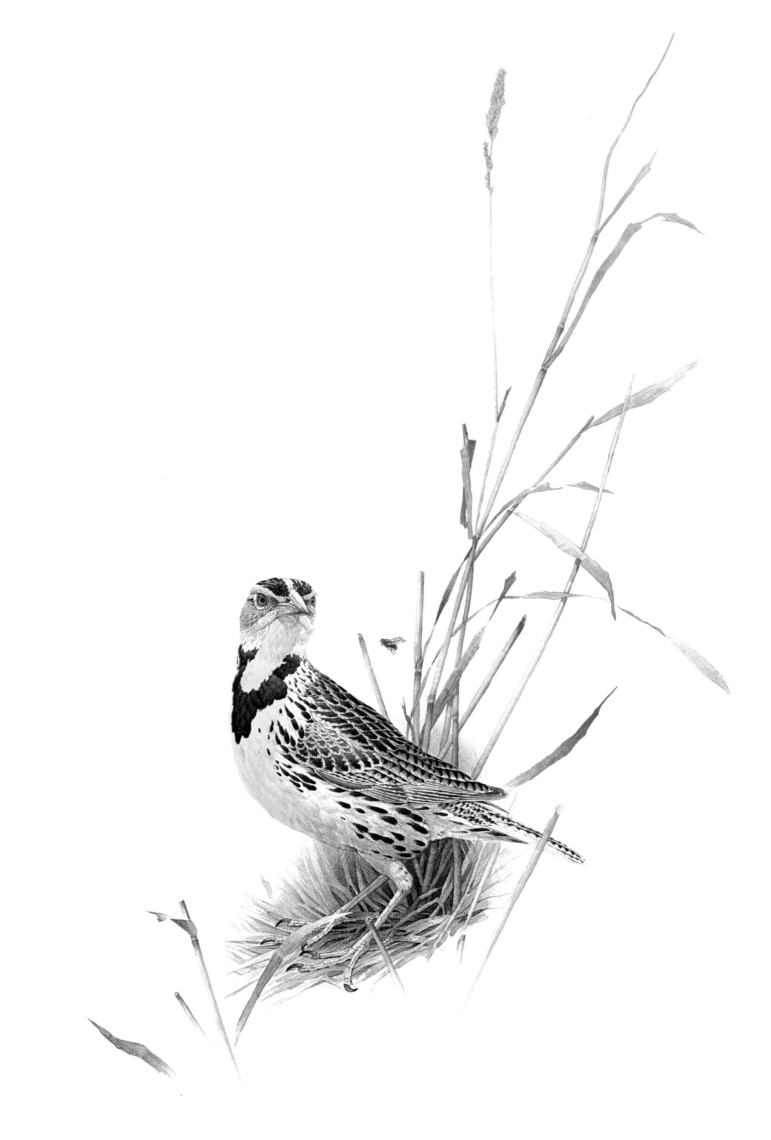

EASTERN MEADOWLARK, 1971
Transparent watercolor on paper, 34½ x 23¾" (87.7 x 60.3 cm.)
Private collection

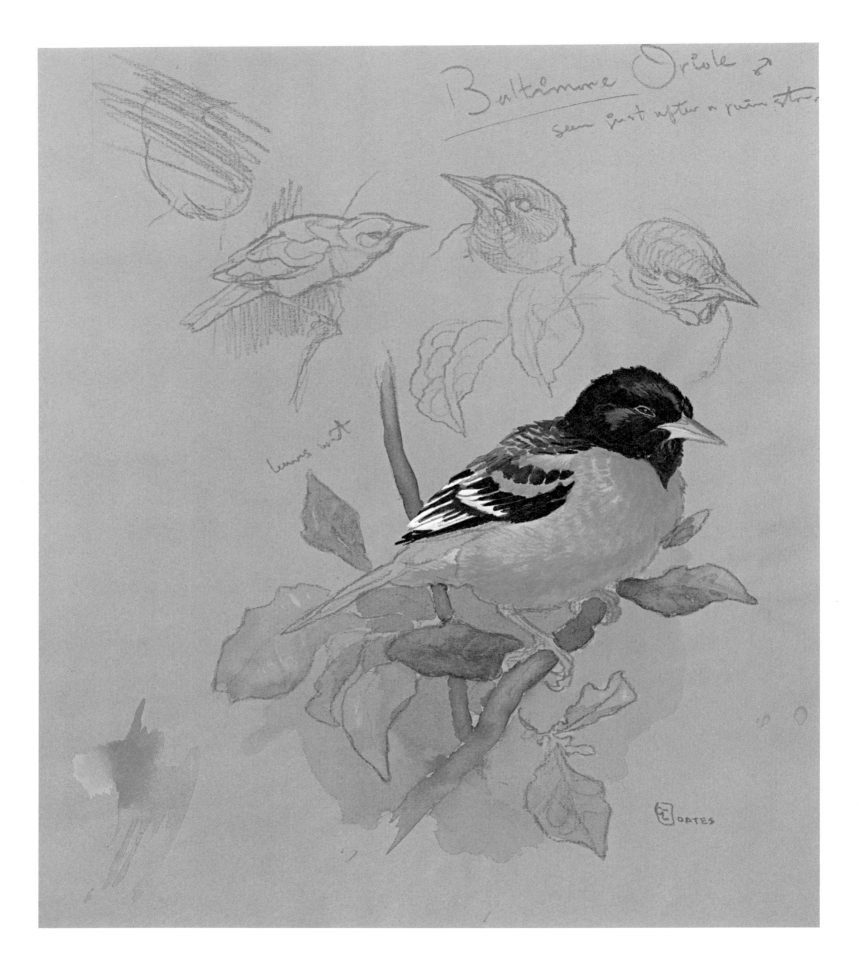

BALTIMORE ORIOLE FIELD SKETCH
Transparent watercolor and pencil on tinted paper, 11 x 9½" (28 x 24.2 cm.)
Private collection

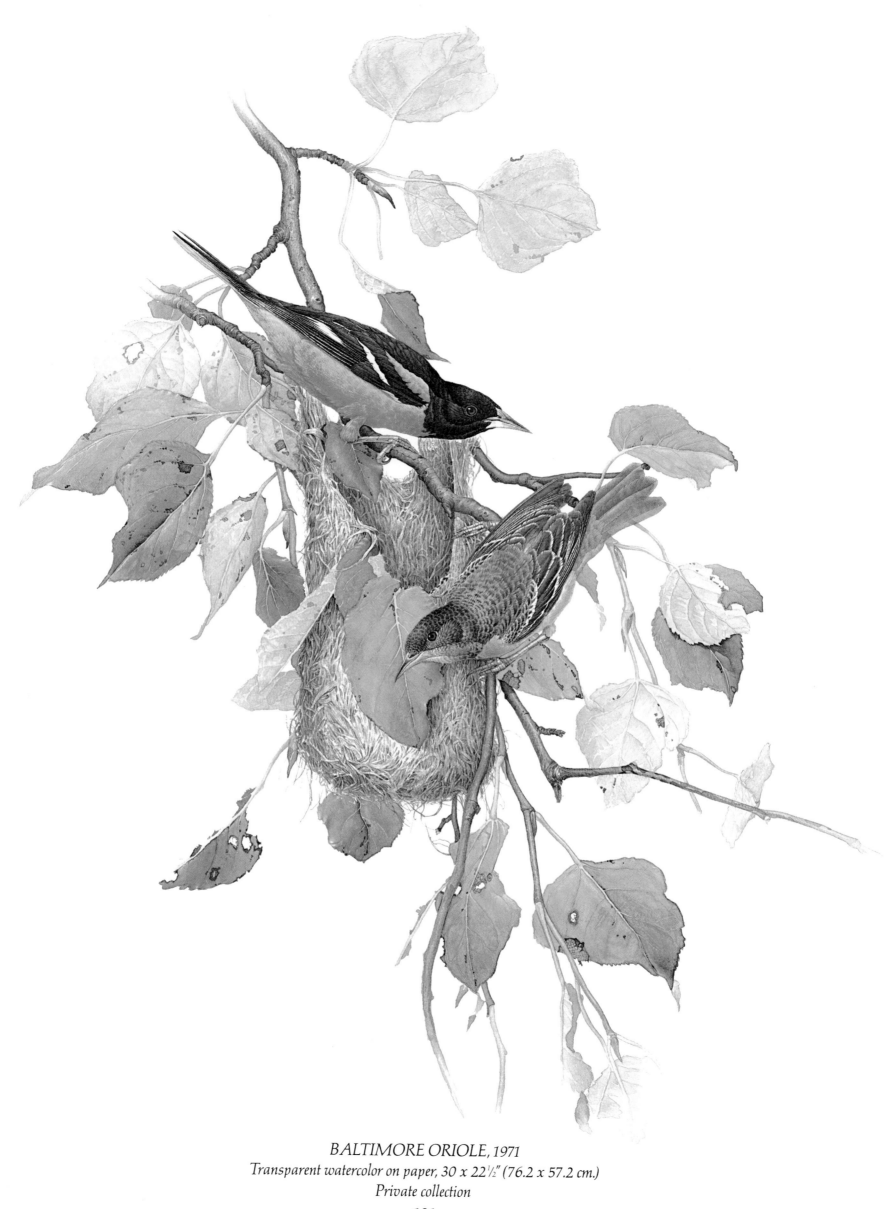

BALTIMORE ORIOLE, 1971
Transparent watercolor on paper, 30 x 22½″ (76.2 x 57.2 cm.)
Private collection

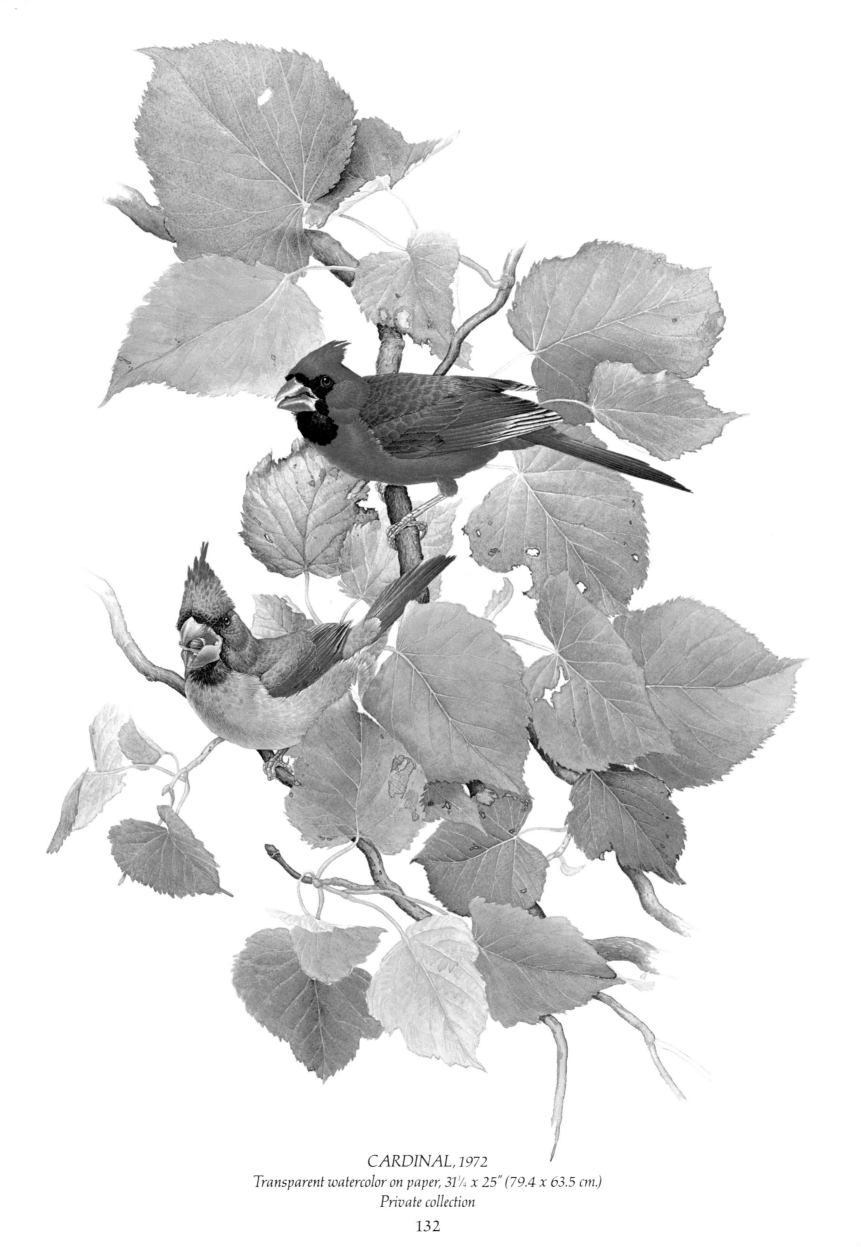

CARDINAL, 1972
Transparent watercolor on paper, 31¼ x 25" (79.4 x 63.5 cm.)
Private collection

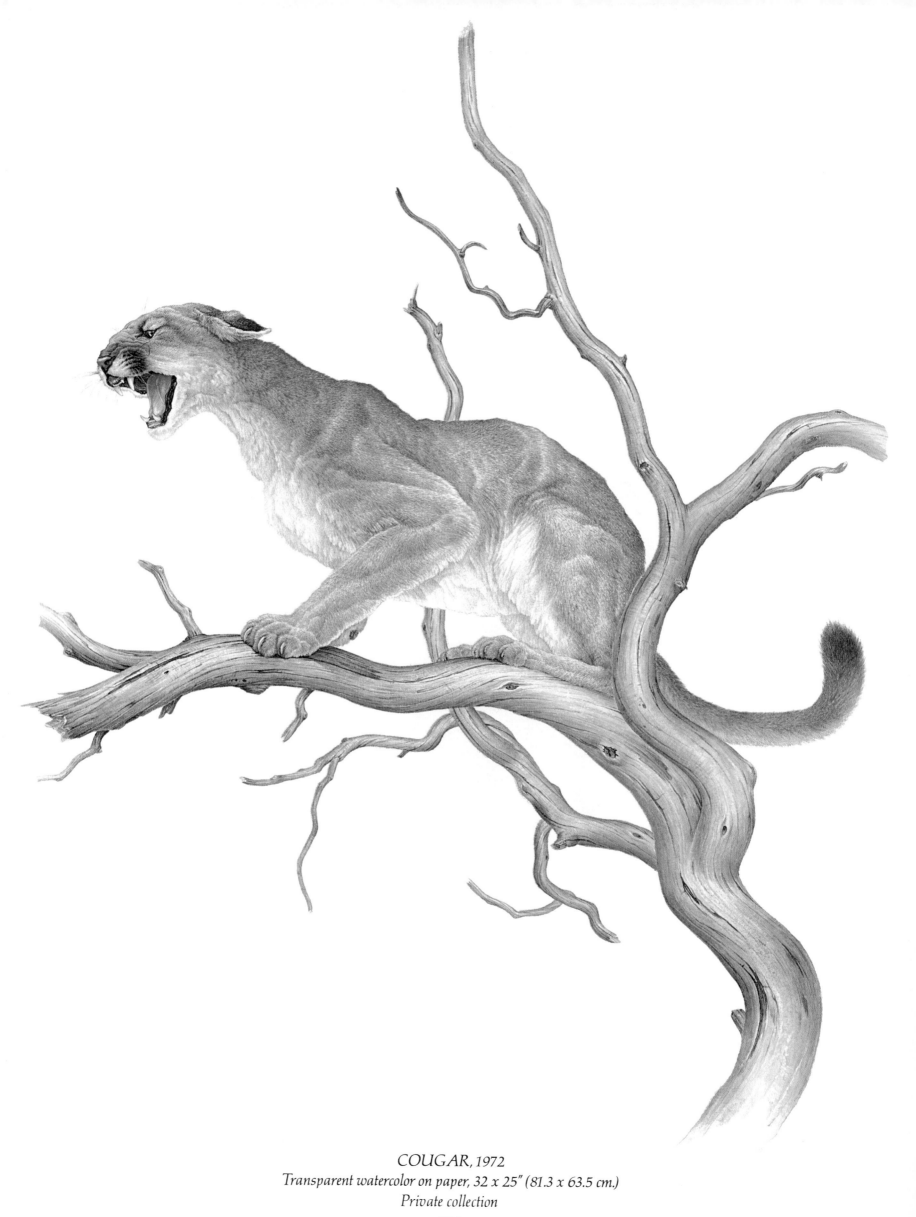

COUGAR, 1972
Transparent watercolor on paper, 32 x 25" (81.3 x 63.5 cm.)
Private collection
133

Top: QUAKER MEETING, *1971*
Pencil on paper, 11 x 14⅛" (28 x 35.9 cm.)

Above: CUMMER AVENUE BRIDGE, *1974*
Pencil on paper, 9 x 12" (22.9 x 30.5 cm)
Private collection

Top: SALLY, 1971
Pencil on paper, 12 ⅛ x 17 ½" (30.8 x 44.5 cm.)
Private collection
Above: Reclining, 1971
Pencil on paper, 12 ⅛ x 18" (30.8 x 45.7 cm.)
Private collection

135

WINTER BERRIES, 1972
Transparent watercolor on paper, 11 x 8½" (28 x 21.6 cm.)
Private collection

MAPLE LEAVES, 1972
Transparent watercolor on paper, 14 x 10″ (35.6 x 25.4 cm.)
Private collection

V. Interval

s they do for most naturalists, owls have a special fascination for Loates. Their extreme variety of shape and size, their compelling demeanor are most attractive to bird painters. The ageless mystery these night-time predators possess has led to legend and religious wonder throughout history. They can be at once winsome, like the familiar, petit brown and white Saw-whet Owl, or objects of awe like the giant and elusive Snowy Owl.

Most of Loates' available creative energy of 1972 was spent doing nineteen dramatic black and white pencil drawings of owls. These graphic studies reveal the careful draftsmanship and understanding of form which underlie the artist's paintings in color. Drawings such as these expose the weaknesses of all but the most proficient and dedicated draftsmen. There is no room for empty, fancy flourishes of the brush or easy elimination of bad drawing with highly-colored washes.

"I never get enough of owls," admits Loates. "I have travelled miles just to get a glimpse of a reported specimen. Over a period of time, you compose your own list of localities where certain species may be found, but they remain among the most tricky of birds to track down. Each member of the family has its own strange characteristics, but they all share the same blinking stare which makes them so tempting to paint. They are certainly among the true characters of the bird world. They often remind me strangely of wild cats."

Included among the owls Loates depicted in his drawings of 1972 were the Great-horned, Great Gray, Snowy, Long-eared, Barn, Short-eared, Saw-whet, Boreal, Hawk, Ferruginous Pigmy, Eastern Screech, Burrowing, Flammulated, Whiskered, Spotted, Elf and Western Pigmy.

One of the strong points of Loates' talent that emerges in these watercolors is his exceptional feeling for specific textures and his ability to faithfully render them. The feather arrangements and patterns of the Great-horned owl, Barn Owl and Saw-whet Owl very dramatically, and the artist emphasizes these differences to just the right degree. A fault of many bird painters is a tendency to gloss over such fine textural detail and simply to concentrate on the overall confirmations of their subjects, an attitude which sacrifices fidelity for pictorial convenience. Another aspect of Loates' power as a wildlife artist is his control of chromatic subtleties and this may be seen particularly in these owl paintings, where he has managed to suggest a rich range of color variations in birds which, as a species, are among the least brilliant in plumage.

To assist in creating his impressive studies, Loates was fortunate enough to find

an owl sanctuary at St. Catharines, Ontario. This sanctuary is operated privately by Mr. and Mrs. Larry McKeever, who care for injured specimens at their large estate. From time to time, they have had virtually every species native to Canada in their care. Loates made a number of trips to the McKeever's bird sanctuary to draw their patients. He later described these visits as a "tremendous opportunity" to study various owls at close range.

During the 1970's, Loates enjoyed increased national and international recognition. In November, 1973, his work received wide exposure when the International Edition of *The Reader's Digest* featured his paintings illustrating a biographical article by Anker Odum. Readers in thirteen languages were introduced to the artist's interpretations of eight mammals, the Eastern Chipmunk, Moose, Timber Wolf, Red Squirrel, Skunk, Black Bear, Short-tailed Weasel and the Whitetail Deer.

Early the following year, Loates was elected to full membership in the prestigious Royal Canadian Academy of Fine Arts.

In March 1974, Glen Loates was honored by an exhibition at Cornell University's Department of Ornithology at Sapsucker Woods, three miles from the main campus. Sapsucker Woods is one of America's most eminent centres of ornithology. It is world renowned for both the variety of birds its woods attract and for the importance of its Cornell Laboratory of Ornithology. Most of the leading ornithologists of the United States have studied bird life on its grounds, and many of the world's leading wildlife painters have shown in its exhibition halls. When he was invited to exhibit at Cornell, Loates joined such famed predecessors as Louis Agassiz Fuertes, Peter Scott and Roger Tory Peterson.

The two month Sapsucker Woods exhibition had been arranged by Olin Sewall Pettingill Jr., then director of the Department of Ornithology, and the assistant director (now director) Douglas A. Lancaster. The show consisted of more than forty works. Its reception from the highly-critical, specialized audience at Sapsucker Woods was remarkably warm. Apart from personal praise from famous ornithologists and mammalogists, Loates received an outstanding critical review in the esteemed Cornell *Newsletter*, which said, in part:

"When one refers to the *exquisite* quality of a piece of art, the usual definition of that over-used adjective comes to mind: beautifully made or designed. Applying that descriptive term to the watercolors of Martin Glen Loates is almost a necessity in order to convey adequately the degree of appreciation that his work arouses. However, the word exquisite itself is derived from the Latin *exquisitus*, chosen, exquisite, from the past participle of *exquirere*, to search out. It is this shade, then, of the word exquisite that makes the adjective singularly appropriate in a more arcane sense to Loates' work. He has searched out and chosen the subtle gradation in color, the elegant rhythm in form and line, the elusive in mood."

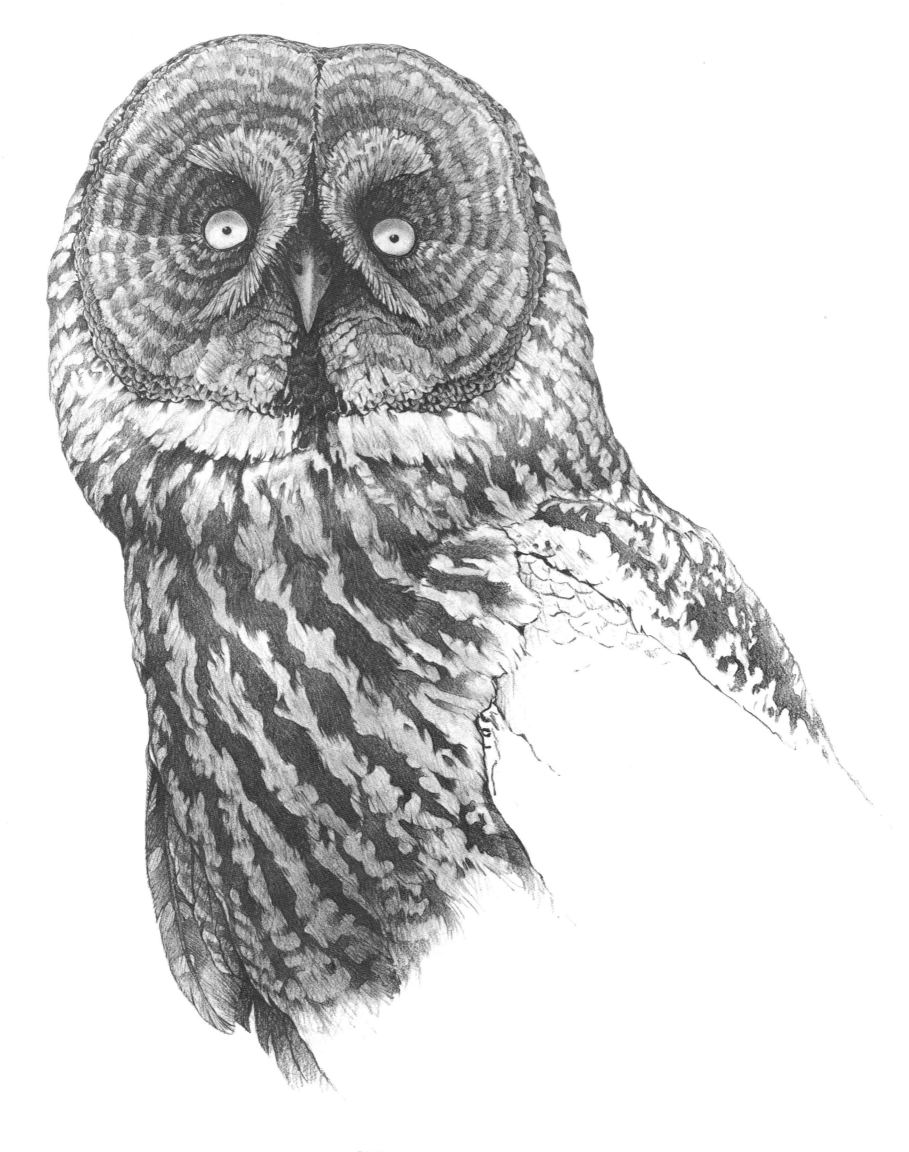

GREAT GRAY OWL, 1971
Pencil on paper, 24 x 18" (61 x 45.7 cm.)
Private collection

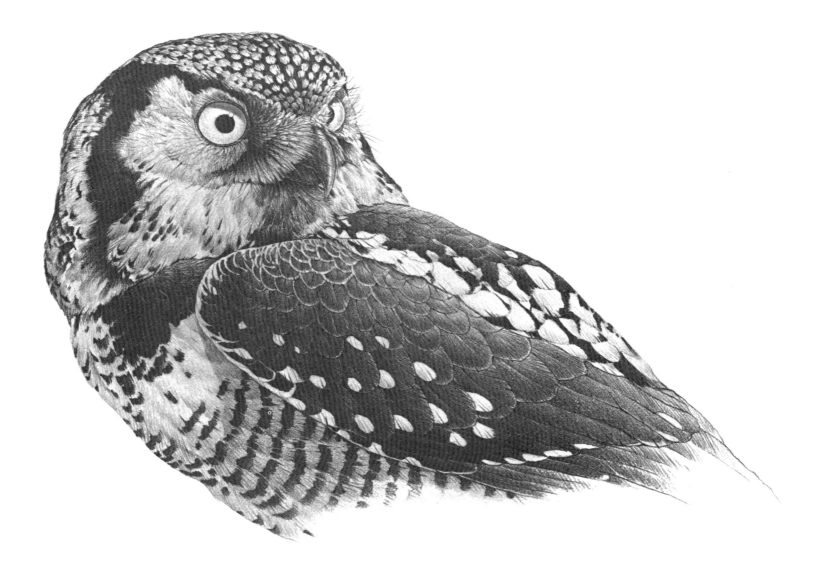

HAWK OWL, 1972
Pencil on paper, 14⅛ x 18" (35.9 x 45.7 cm.)
Private collection

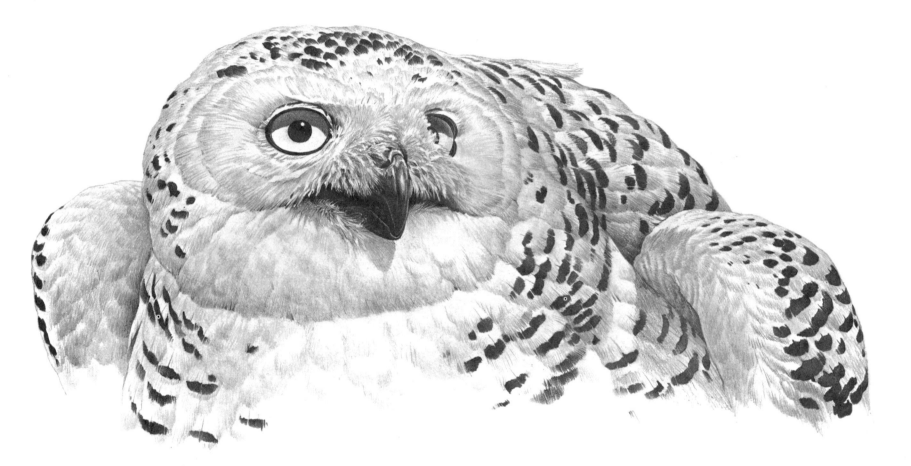

SNOWY OWL, 1972
Pencil on paper, 14 x 16¾" (35.6 x 42.6 cm.)
Private collection

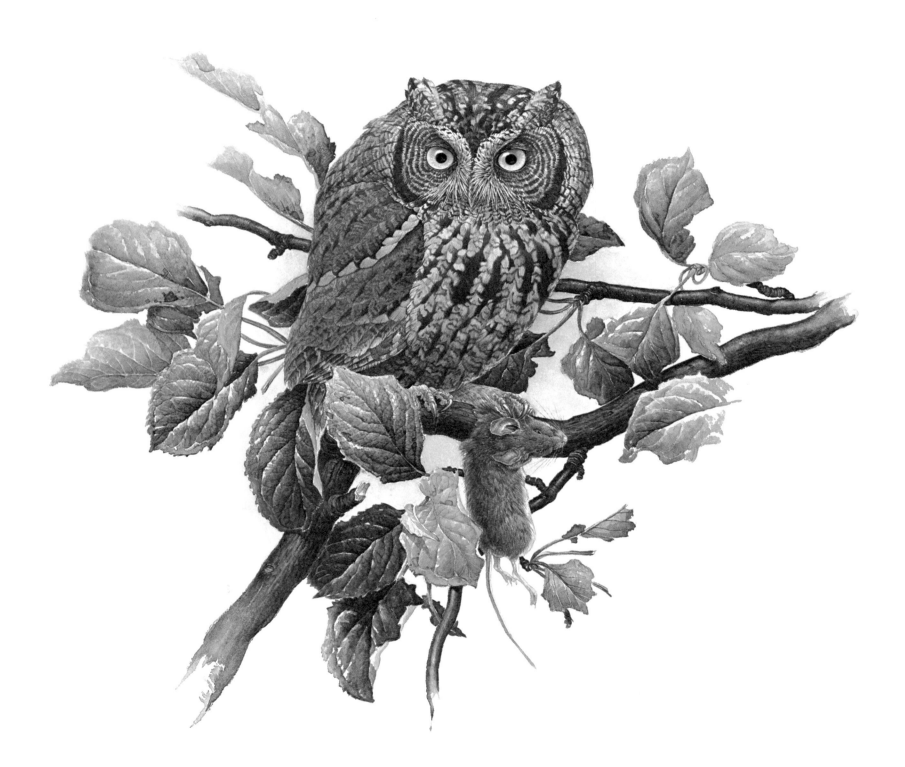

SCREECH OWL, 1973
Transparent watercolor on paper, 28 x 22½" (71.1 x 57.2 cm.)
Private collection

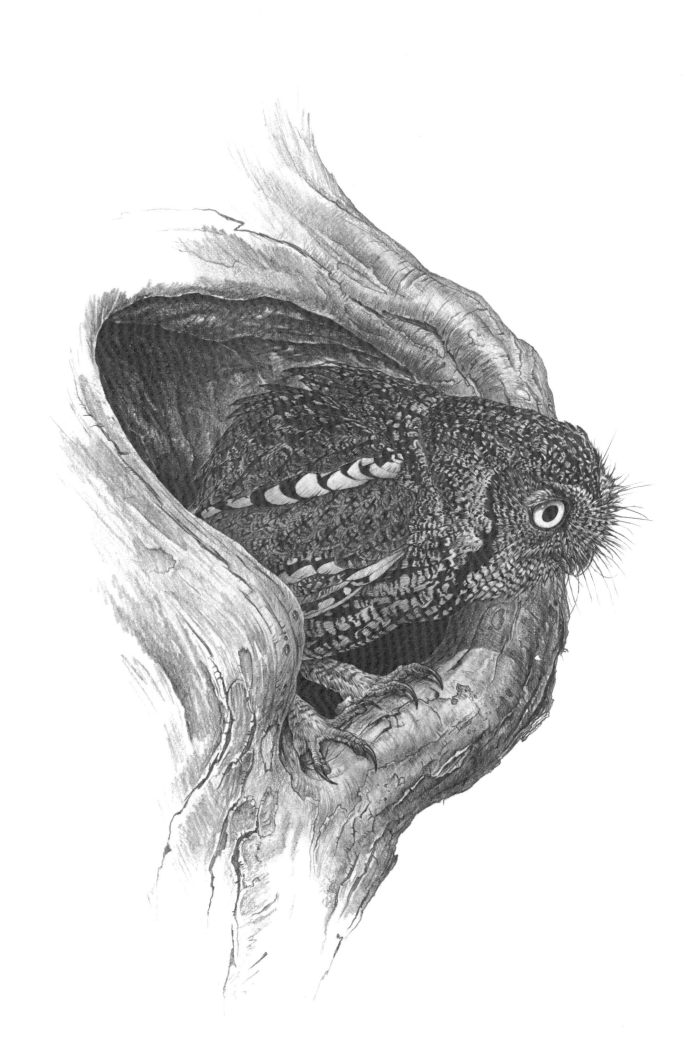

WHISKERED OWL, 1973
Pencil on paper, 16¾ x 14⅛" (42.6 x 35.9 cm.)
Private collection

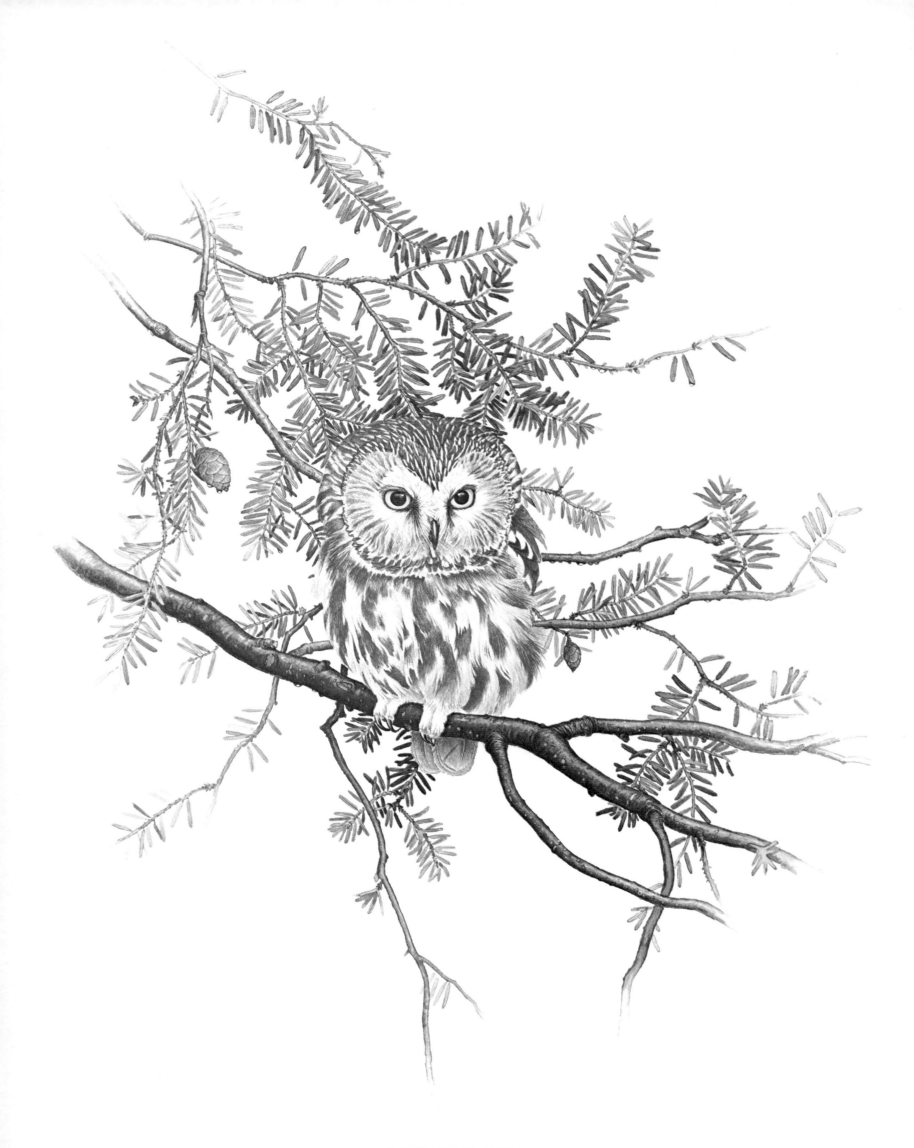

SAW-WHET OWL, 1973
Transparent watercolor on paper, 16 x 20" (40.7 x 50.8 cm.)
Private collection

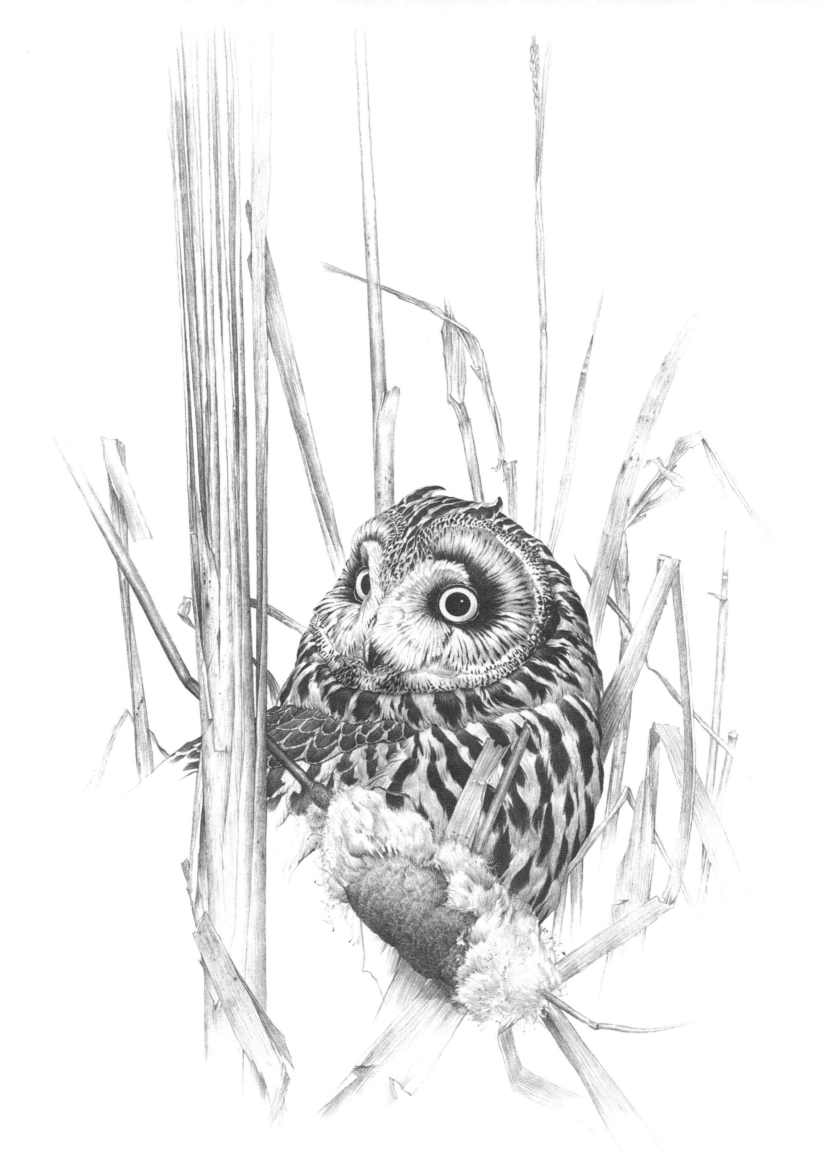

SHORT-EARED OWL, 1973
Pencil on paper, 23¼ x 18" (59 x 45.7 cm.)
Private collection

147

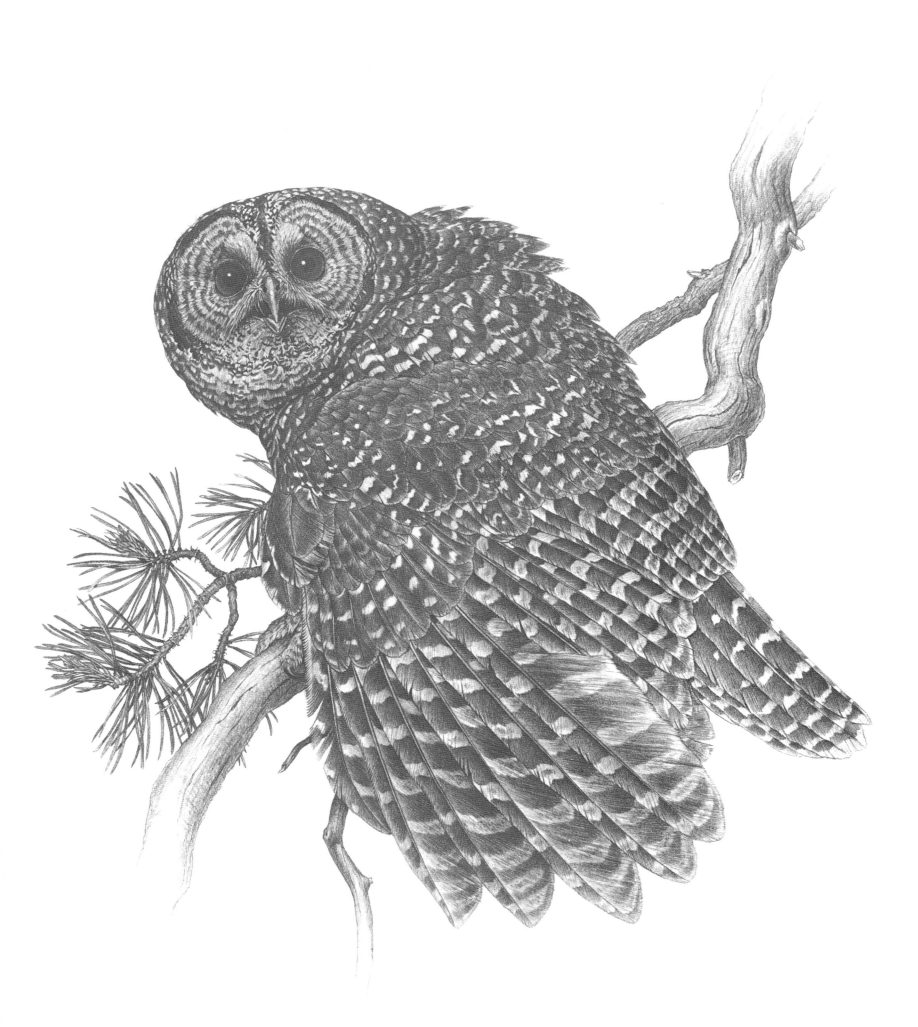

SPOTTED OWL, 1973
Pencil on paper, 23¾ x 18" (60.3 x 45.7 cm.)
Private collection

148

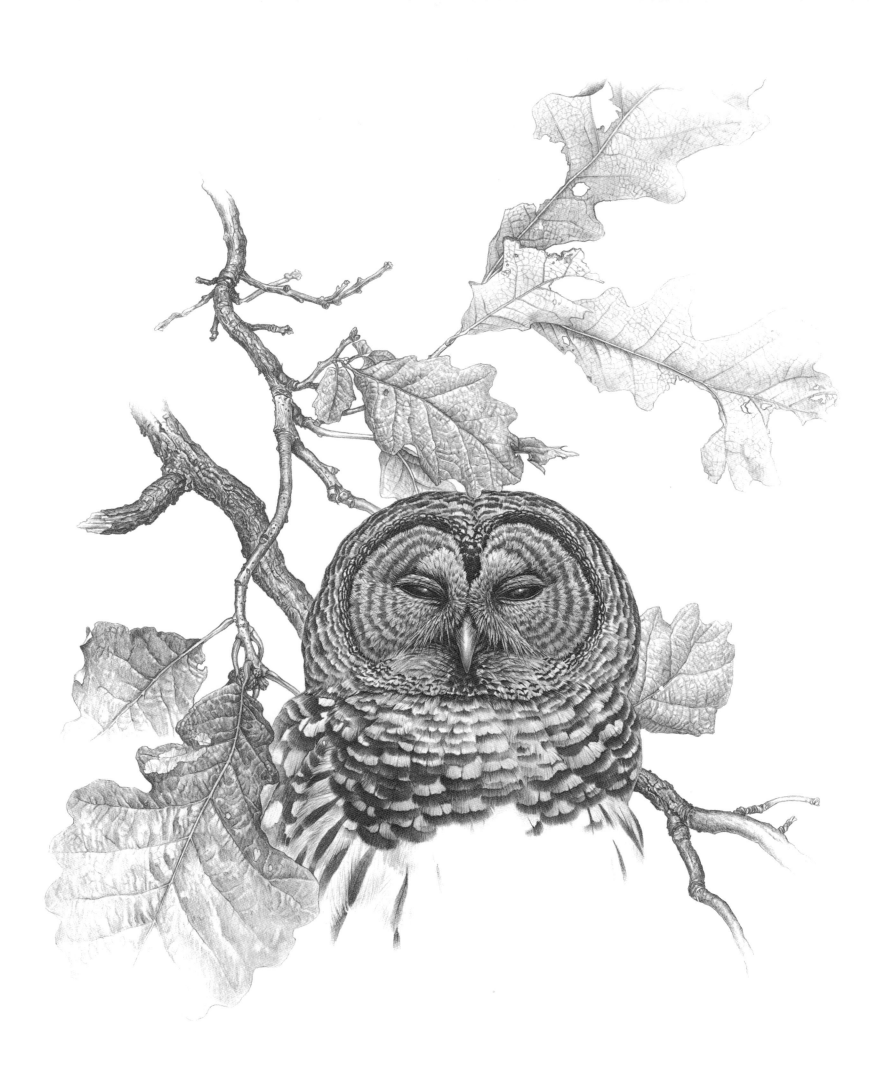

BARRED OWL, 1973
Pencil on paper, 23¾ x 18" (60.3 x 45.7 cm.)
Private collection

Barn Owl

eyes dark brown

owls pellet

BARN OWL FIELD SKETCH
Pencil on paper, 13¼ x 11¾″ (33.7 x 29.8 cm)
Private collection
150

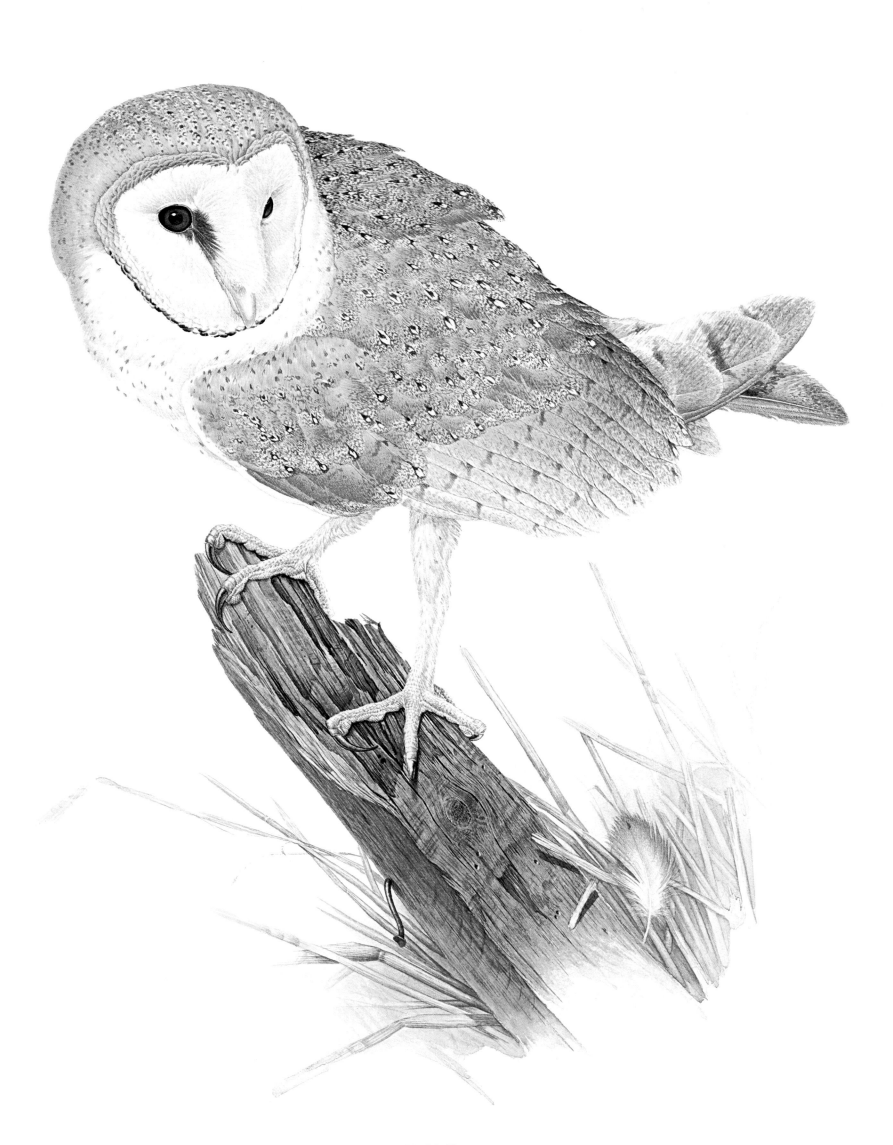

BARN OWL, 1973
Transparent watercolor on paper, 25¼ x 20″ (64.1 x 50.8 cm.)
Private collection

Great Horned Owl

retracted pupil

GREAT HORNED OWL FIELD SKETCH
Ink on paper, 10¾ x 10¼" (27.3 x 26 cm)
Private collection

GREAT HORNED OWL, 1974
Transparent watercolor on paper, 39¾ x 27" (101 x 68.6 cm.)
Private collection

Top: ELF OWL, 1973
Transparent watercolor on paper, 15½ x 12¾″ (39.4 x 32.4 cm.)
Private collection
Above: TUCSON, 1973
Transparent watercolor on paper, 6½ x 8″ (16.5 x 20.3 cm.)
154

CALLIOPE HUMMINGBIRD, 1974
Transparent watercolor on paper, 14 x 10¾″ (35.6 x 27.3 cm.)
Private collection

CEDAR WAXWING, 1974
Transparent watercolor and ink on tinted paper, 17½ x 14⅛" (44.5 x 35.9 cm.)

FALSE SOLOMON'S-SEAL & HERB-ROBERT STUDY, 1974
Transparent watercolor and ink on tinted paper, 25 x 18½″ (63.5 x 47 cm)

VI. Maturity

he years 1975 and 1976 were among Loates' most productive. Certainly, the overall quality of his art was the highest he had yet achieved. Achievement followed achievement, as he cemented his reputation as one of America's most brilliant, and personal, wildlife painters.

It is not necessary to analyze these eloquent nature studies one by one, although there is no repetition to be found in them. Every composition is a surprising revelation of the species depicted, each one caught in a moment of typical activity. It is Loates' marked ability to summarize the character of his subjects in one isolated image that makes his talent special. An instinctive understanding and wit underlie these portrayals.

Loates' most recent achievements may be best discussed by citing a few of his 1975 and 1976 compositions. The selection must of necessity be arbitrary, since the overall consistency of quality is high for those years. Unquestionably, however, his "Raccoon Family" and "Fox and Pheasant" represent the period at its best. They also show Loates' challenging attempts to illustrate confrontation between species in nature's constant tug-of-war for survival.

The "Raccoon Family" is unquestionably one of Loates' masterpieces. Technically it is a *tour de force* of controlled watercolor painting.

No part of the painting is without evidence of the artist's phenomenal skill with his medium. whether it be in the vegetation, water or the coats of the raccoons themselves. The problems of texture and drawing would cause most wildlife artists to shy away. Indeed, it is undoubtedly Loates' earlier insistence on painting landscape and plant life which has made it possible for him to so successfully integrate all of the elements in "The Raccoon Family." It is not only a memorable mammal painting but also a remarkable study of moss, fern and foliage. The crayfish prey and its underwater world are no less effectively presented. To anyone who knows the raccoon species, the antics of this family are portrayed with signal faithfulness and wit. Loates seems to have offered himself deliberate difficulties in draftsmanship in rendering the attitude of the Raccoon kit clambering the branch of an overhanging tree, but, as in the rest of the picture, he solves the problem with a disarming appearance of ease – the evidence of a craftsman completely in control of his medium.

Rivalling his Raccoons for its brilliance of presentation is Loates' "Fox and Pheasant" of 1975. Here he has chosen to capture a momentary encounter between mammal and bird that is extraordinarily difficult to record convincingly. Yet Loates not only persuades the viewer of the correctness of his facts, but does so with a composition that is stunning in its

pristine simplicity and execution. To attempt such a delicate piece of painting against pure white paper leaves no room for error in the artist's creative judgement. One slip, and the entire work is in ruin. To help achieve the fineness of brushwork such a work requires, Loates mainly restricts himself to the use of very small sable brushes on a Fabriano paper. It is not surprising, then, that each of his major paintings requires two to three months of research and execution.

Mention must also be made of such other superb paintings of 1975 and 1976 as "Black Bear Cubs," "Sea Otter," "Grey Squirrel," "Pine Marten Pursuing Squirrel," "Beaver Kits," "Bobcat Kitten," "Muskrat," "Least Weasel," "Ermine," "Blue Jays" and "Loon." That group alone represents enough achievement to place Loates among the best North American wildlife painters of his time.

LEAST WEASEL, 1976
Transparent watercolor on paper, 14¼ x 11½" (36.2 x 29.2 cm.)
Private collection

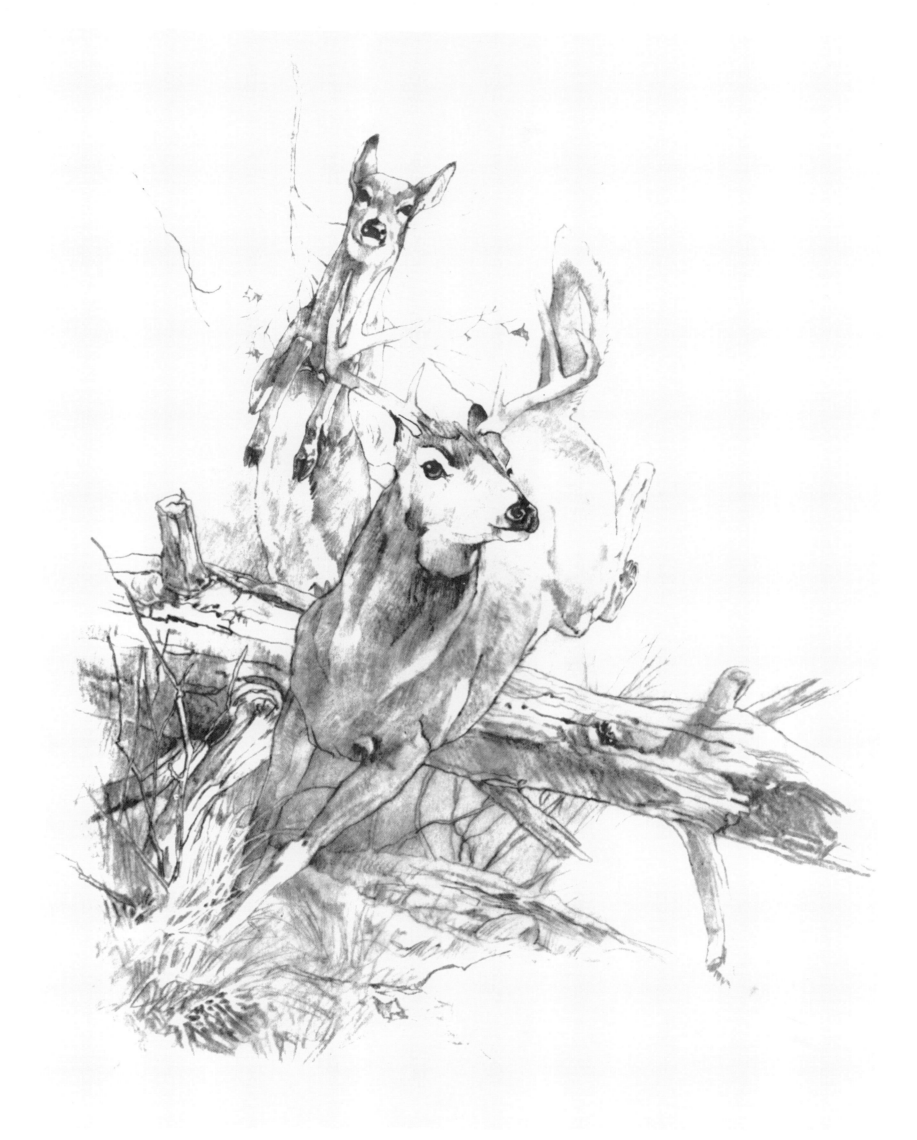

BUCK & DOE WORKING DRAWING, 1974
Pencil on paper, 17 x 12" (43.2 x 30.5 cm.)
Private collection

CHIPMUNK & WOODLAND BLUE BUTTERFLY, 1974
Transparent watercolor on paper, 16½ x 12¼" (42 x 31.1 cm.)
Private collection

COTTONTAIL BUNNY, 1975
Transparent watercolor on paper, 12½ x 9¼" (31.8 x 23.5 cm.)
Private collection

SEA OTTER, 1975
Transparent watercolor on paper, 24¾ x 18¾" (62.9 x 47.7 cm.)
Private collection

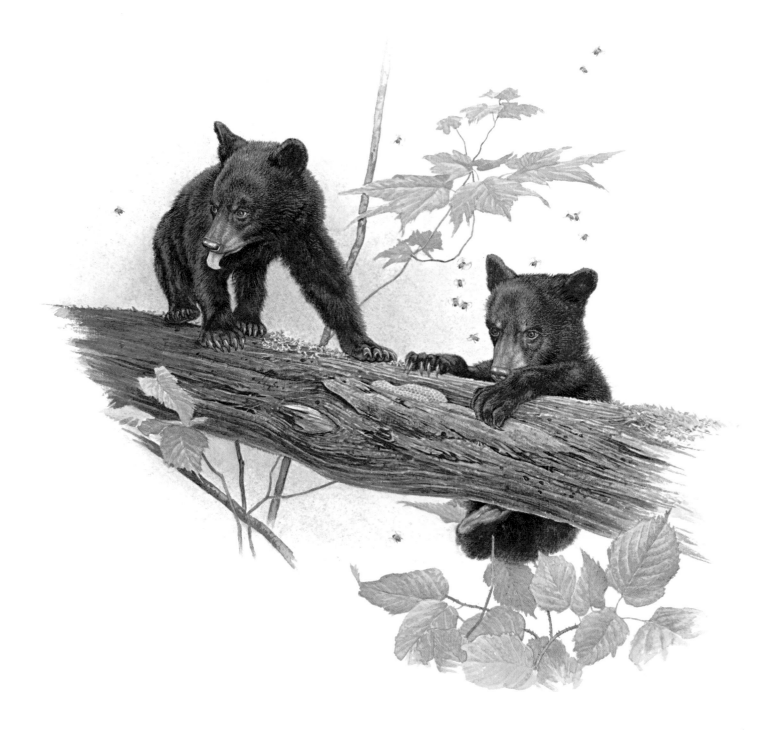

BLACK BEAR CUBS, 1975
Transparent watercolor on paper, 14 x 12½" (35.6 x 31.8 cm.)
Private collection

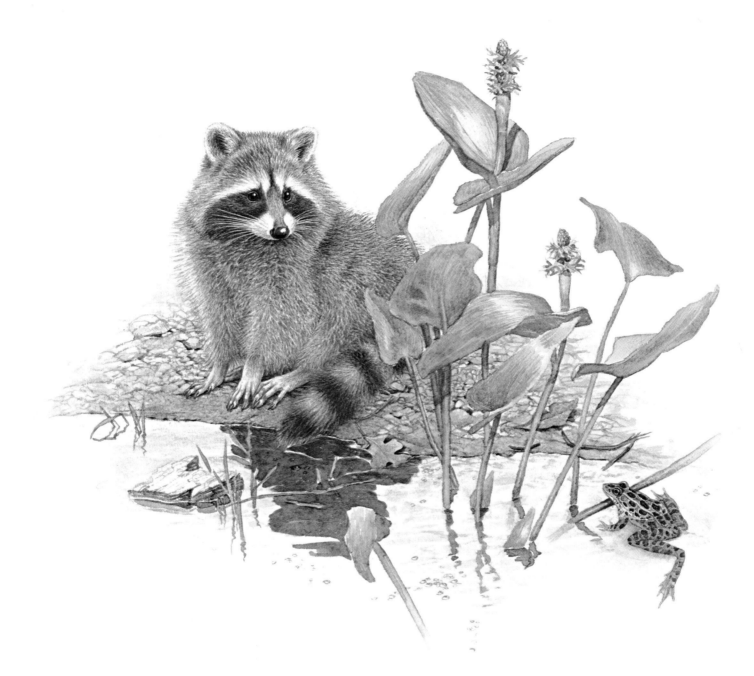

RACCOON YOUNG, 1975
Transparent watercolor on paper, 12½ x 11¼″ (31.8 x 28.5 cm.)
Private collection

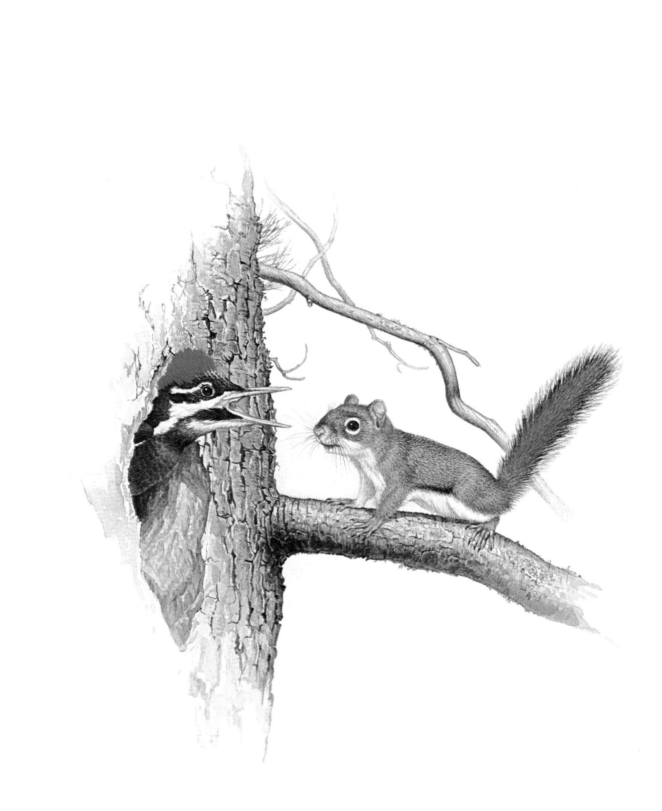

YOUNG RED SQUIRREL & PILEATED WOODPECKER, 1975
Transparent watercolor on paper, 12¼ x 10½" (31.1 x 26.7 cm.)
Private collection

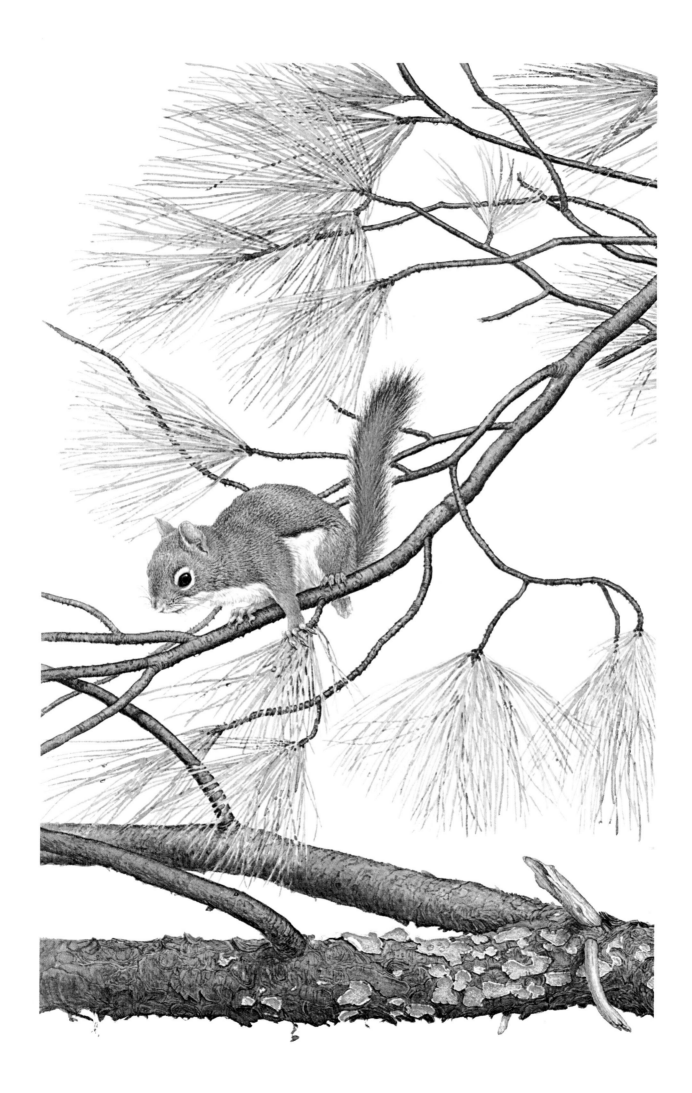

Detail from
PINE MARTEN PURSUING RED SQUIRREL, 1975

PINE MARTEN PURSUING RED SQUIRREL, 1975
Transparent watercolor on paper, 25½ x 20" (64.8 x 50.8cm.)
Private collection

RED FOX & RING-NECKED PHEASANT, 1975
Transparent watercolor on paper, 37¾ x 27" (95.9 x 68.6 cm.)
Private collection

FEATHERS, 1976
Transparent watercolor on paper, 30½ x 22½" (77.5 x 57.2 cm.)
Private collection

171

SQUIRREL FIELD SKETCH
Pencil on tinted paper, 14⅞ x 18" (37.8 x 45.7 cm.)
Private collection

172

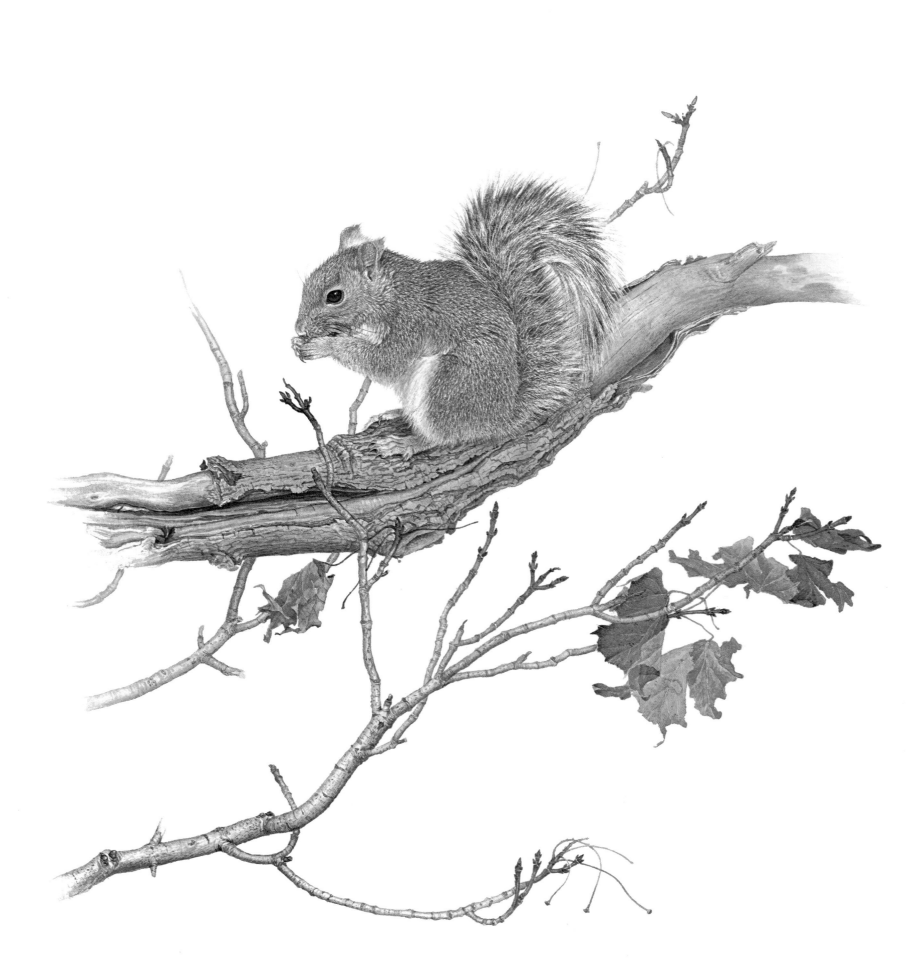

GRAY SQUIRREL, 1976
Transparent watercolor on paper, 16⅛ x 12½″ (41 x 31.8 cm.)
Private collection

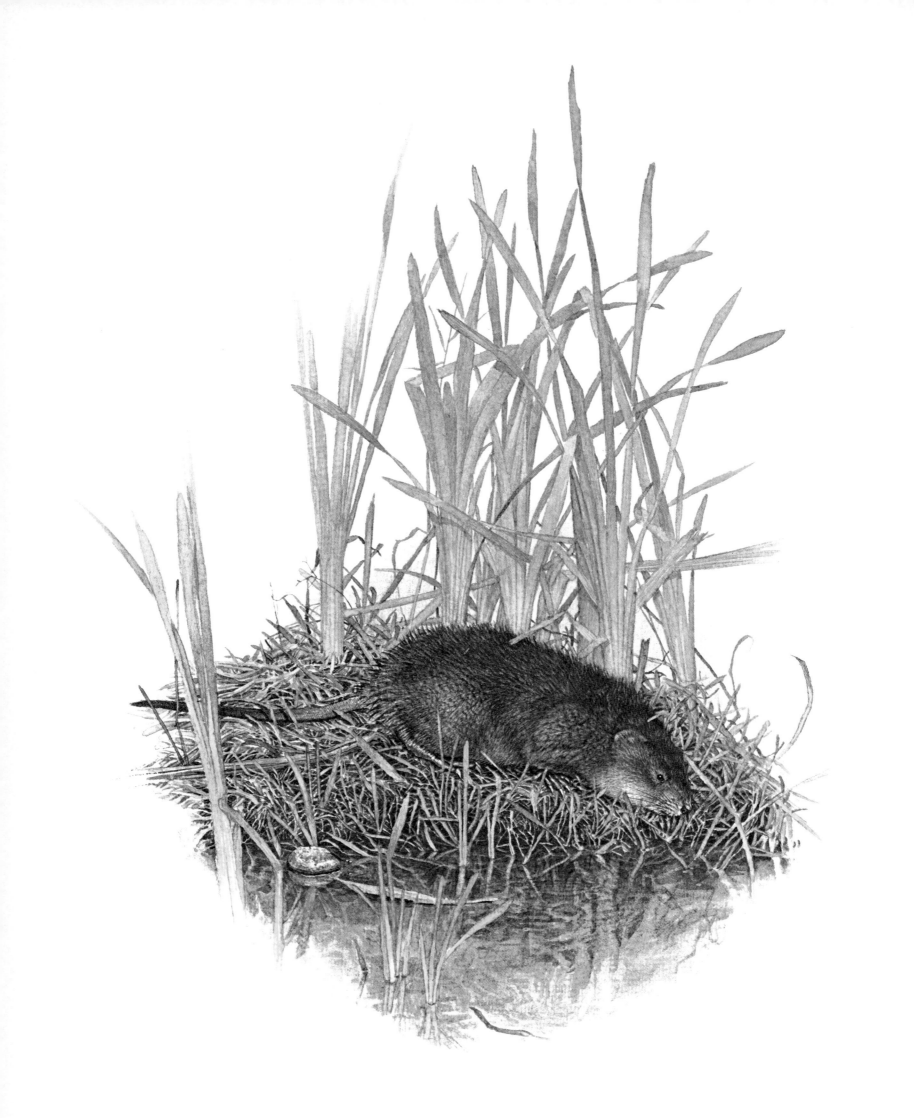

MUSKRAT, 1976
Transparent watercolor on paper, 12³⁄₈ x 10¹⁄₂″ (31.5 x 26.7 cm.)
Private collection

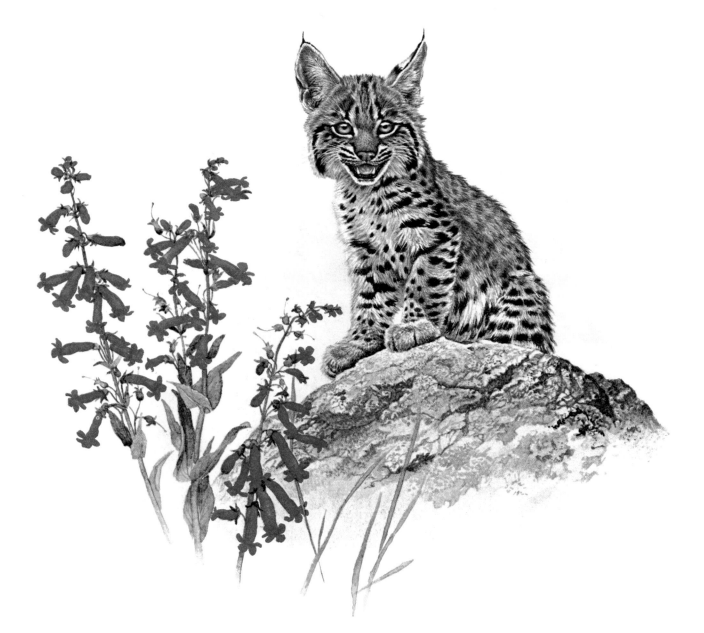

BOBCAT KITTEN, 1976
Transparent watercolor on paper, 12⅜ x 10½" (31.5 x 26.7 cm.)
Private collection

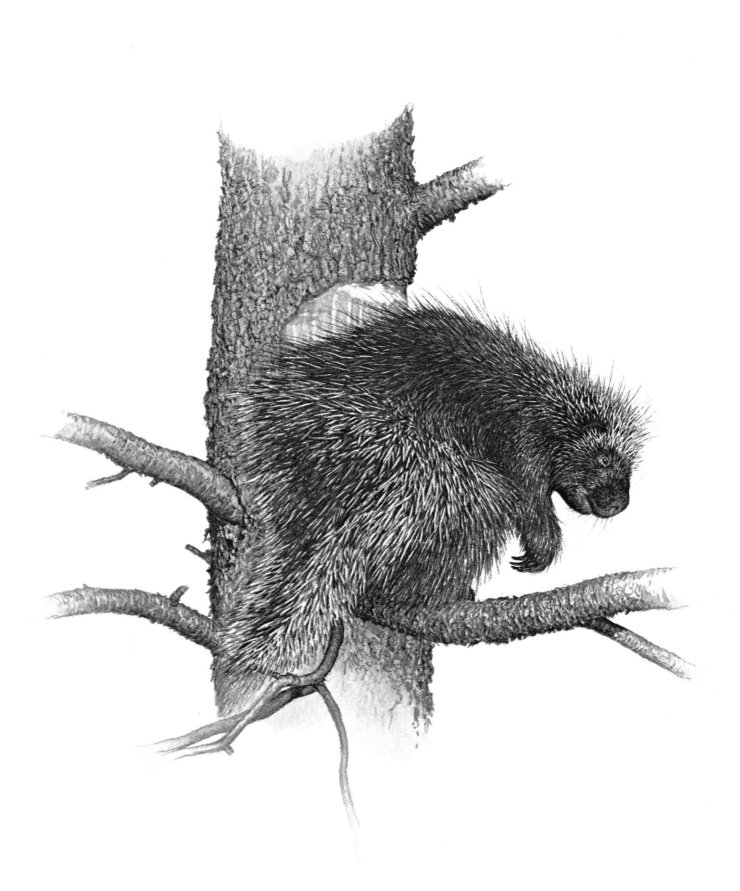

PORCUPINE, 1976
Transparent watercolor on paper, 12 x 10" (30.5 x 25.4 cm.)

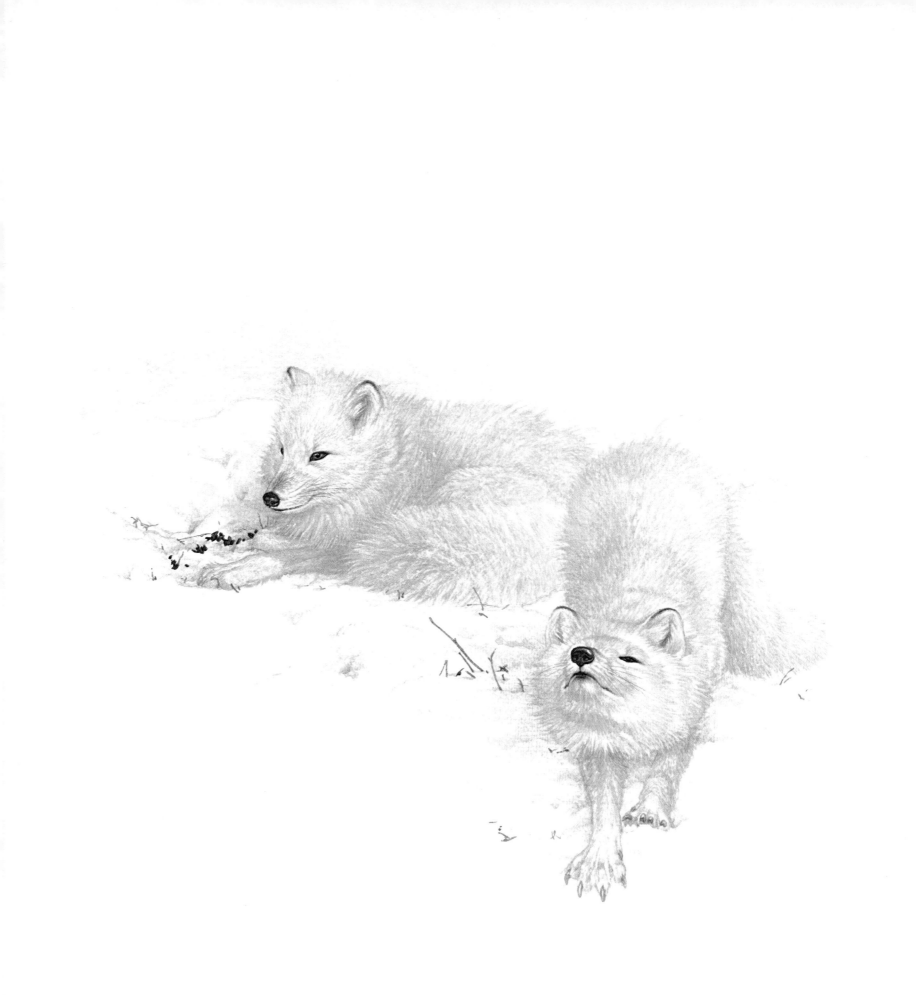

ARCTIC FOX, 1976
Transparent watercolor on paper, 18 x 14½" (45.7 x 36.9 cm.)
Private collection

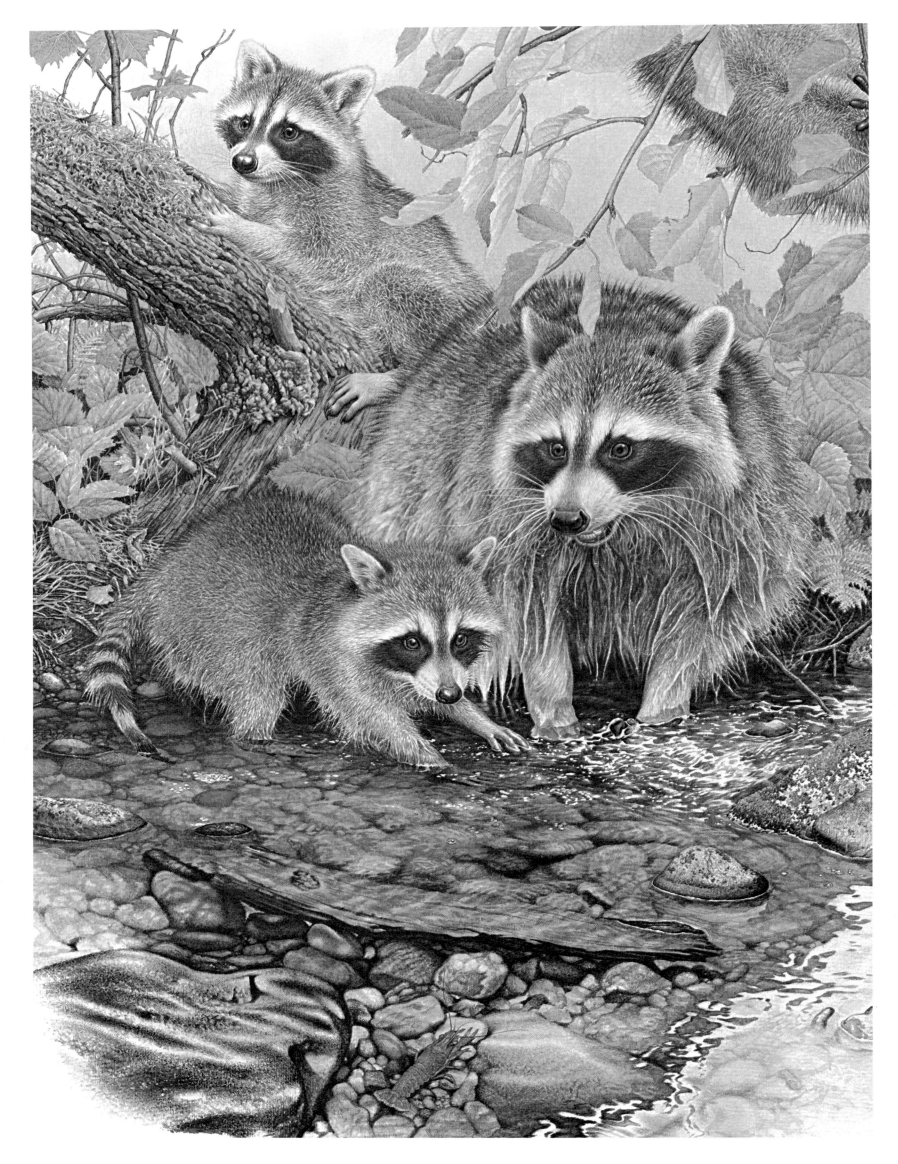

Detail from
RACCOON FAMILY, 1976

178

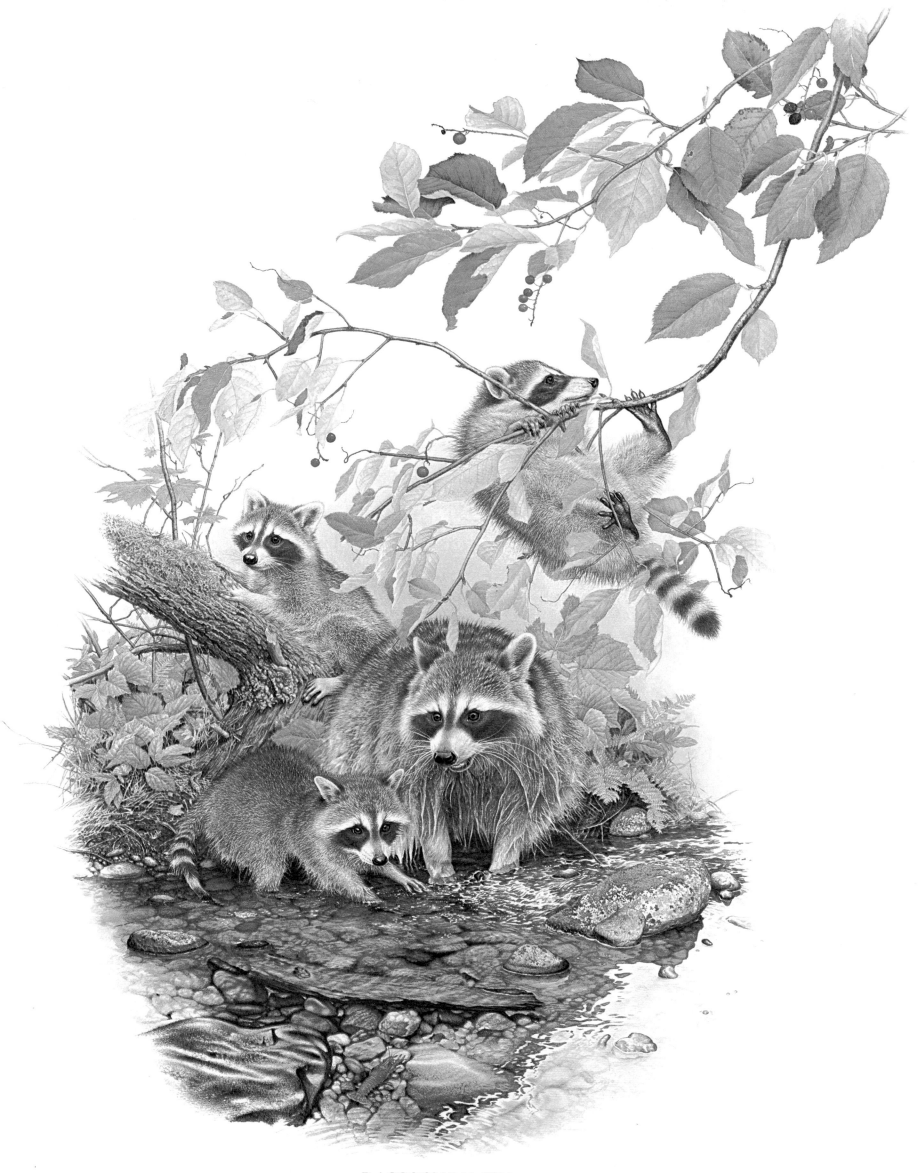

RACCOON FAMILY, 1976
Transparent watercolor on paper, 28 x 22" (71.1 x 55.9 cm.)

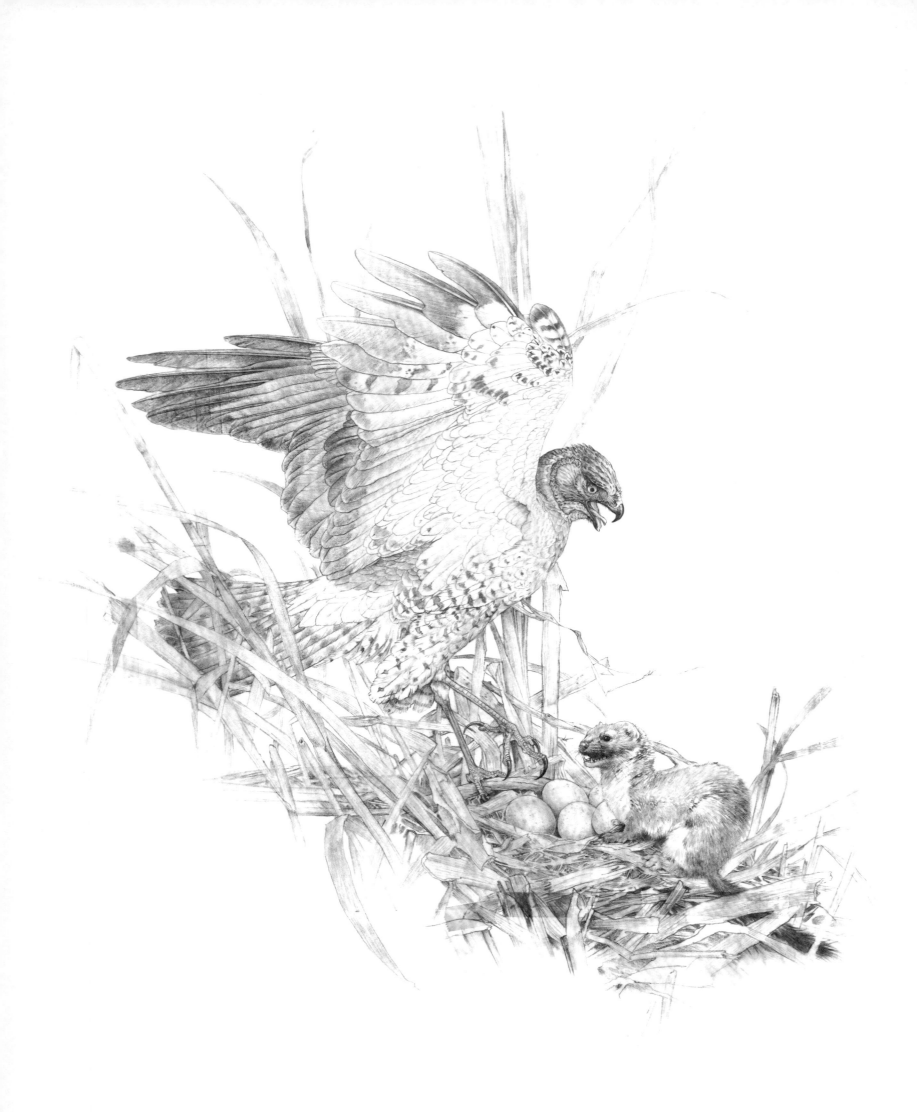

MARSH HAWK & LONGTAIL WEASEL WORKING DRAWING, 1976
Pencil on paper, 27½ x 22⅛″ (69.9 x 56.2 cm.)
Private collection

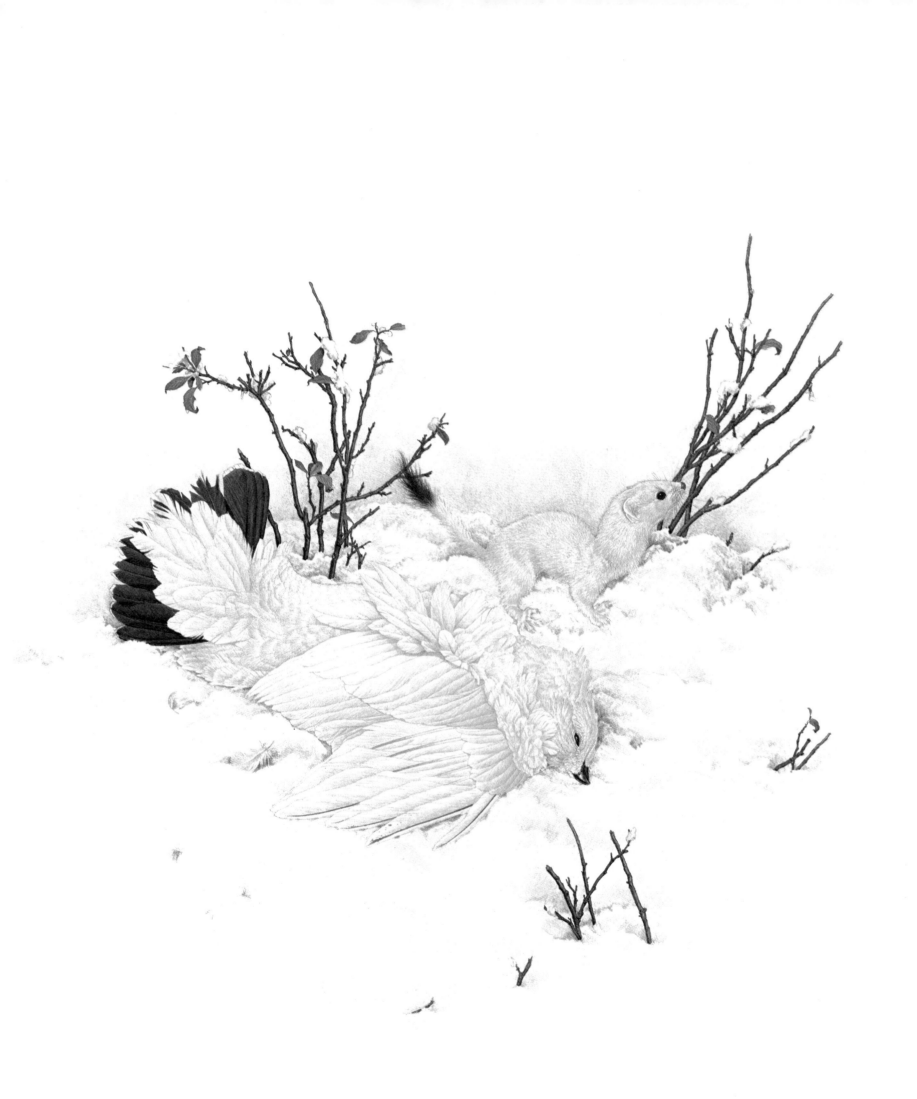

ERMINE & WILLOW PTARMIGAN, 1976
Transparent watercolor on paper, 26¼ x 22" (66.7 x 55.9 cm.)

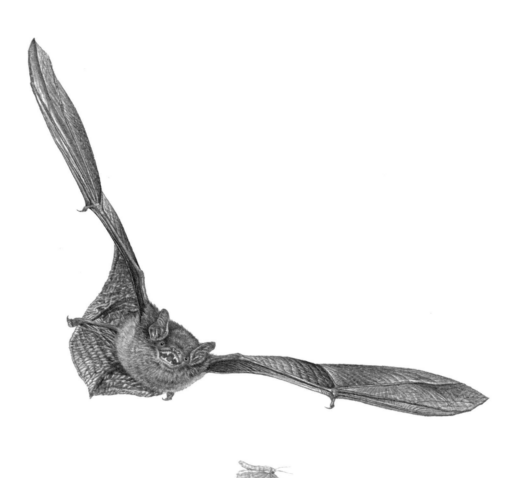

LITTLE BROWN BAT, 1976
Transparent watercolor on paper, 13 x 9⅞″ (33 x 25.1 cm.)

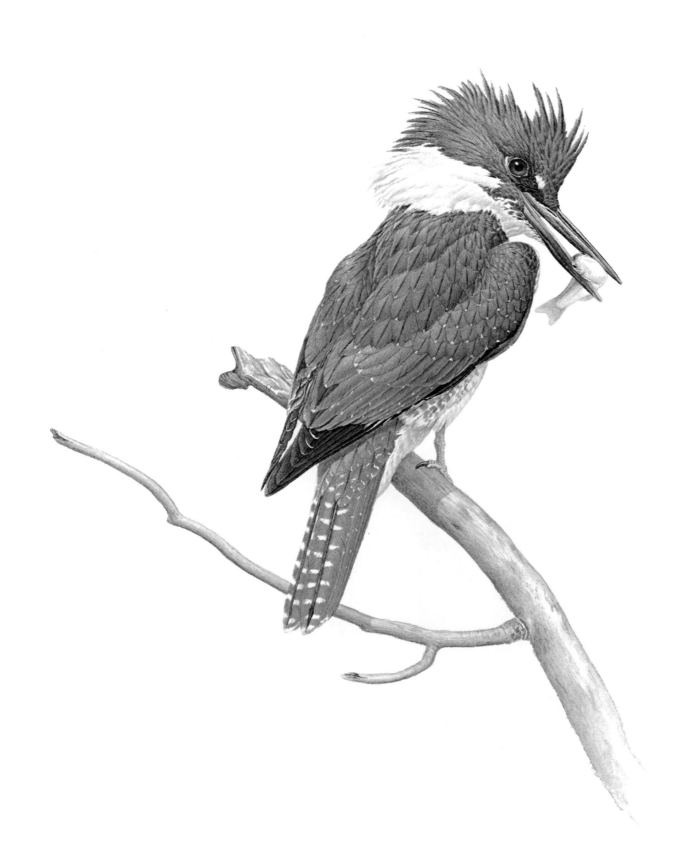

BELTED KINGFISHER, 1976
Transparent watercolor and ink on paper, 20⅜ x 15½" (51.8 x 39.4 cm.)
Private collection

LOON FIELD SKETCH
Transparent watercolor and pencil on paper, 20 x 26¼″ (50.8 x 66.7 cm.)
Private collection

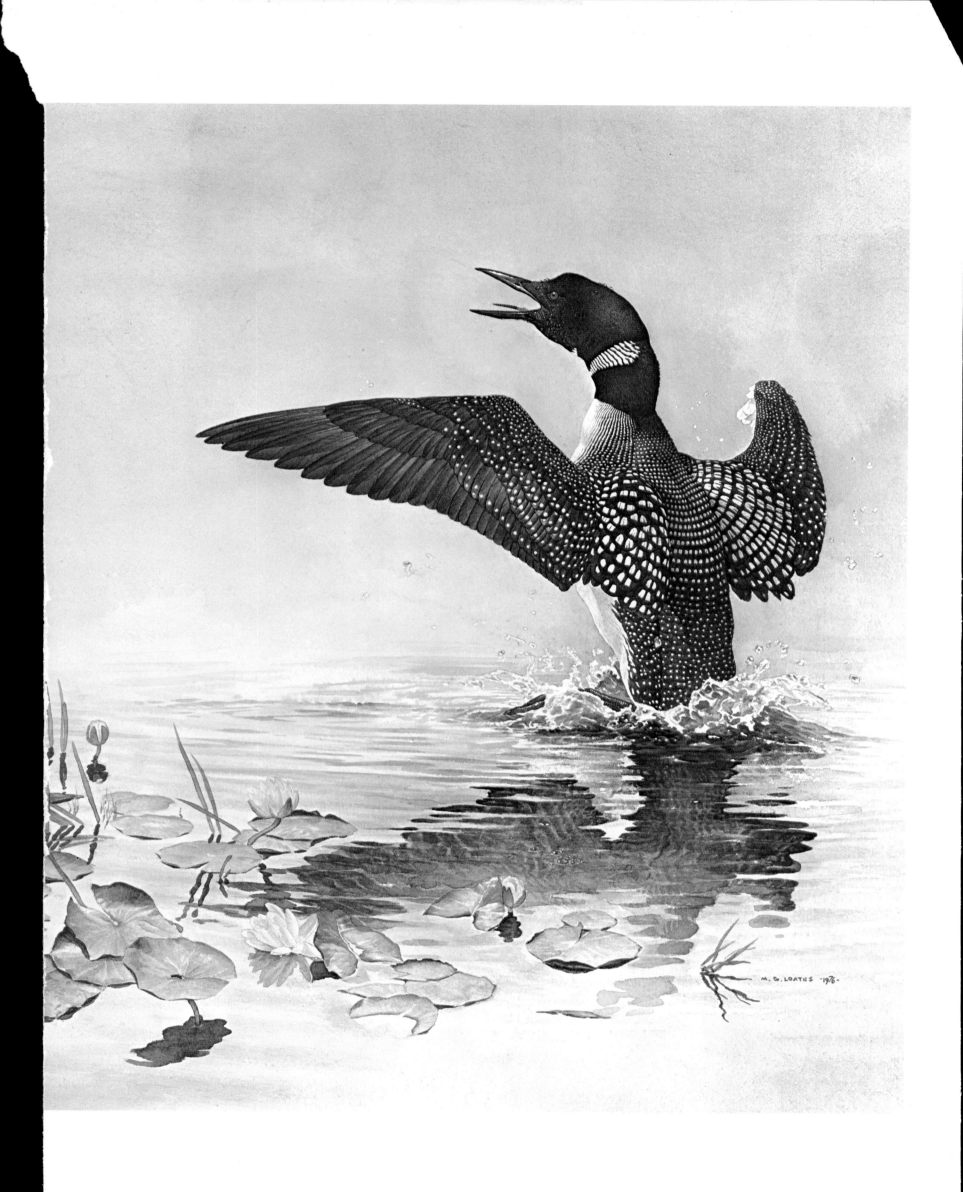

LOON, 1976
Transparent watercolor on paper, 14 x 24" (35.6 x 61 cm.)
Private collection

Artist's Statement

ll artists have their own reason for painting, but there is, I believe, a universal experience and understanding in the paintings of animals that everyone can share. I have a great love for the beauty of creation, and attempt with the resources at hand to convey this personal feeling in my work. In all of my paintings, then, I have tried to capture a moment in the life of each subject. If I can share with the viewer some enjoyment of my own experience with nature, I feel I will have accomplished more than I could have hoped for.

Every artist has been influenced by others before him, and I am no exception. Audubon, Fuertes, Thorburn, Rungius, Kuhn and Lansdowne have been my sources. All of the afore-mentioned artists work in their own style, creating very different moods and feelings in their paintings.

At a certain point in development, the artist breaks away from his mentors and creates his own style. This is what I feel I have now accomplished and will continue to expand. I have introduced more background into my recent work, while allowing the subject to stand out on its own, with the background remaining very detailed, as in the "Raccoon Family" and the "Pine Marten Pursuing Red Squirrel."

Perhaps this is a good time to mention the medium I use. I prefer working with watercolor paints on paper and cloth. I stretch the watercolor paper by soaking it and then taping it to a piece of board. The cloth is used for larger paintings and is also stretched, to a wood frame rather than board. The cloth is soaked with water and a thin layer of gesso is applied to the surface to prevent the paint from being absorbed into the cloth. This gesso coating also gives a much more brilliant effect to the colors. Washes are applied while the surface is still wet, allowing me to paint a soft vignette for the background. Before starting a painting, I complete the composition using the field notes I have collected. Some paintings take only a week while others may take several months to execute. Tubed watercolors and fine sable brushes are used to complete the painting. The subjects are not always life-size, for obvious reasons.

I start each picture by first painting the eye of a subject, then work towards completion, painting the background detail last. With botanical subjects, I paint the blossoms first.

The plant and background material are painted on the spot with watercolors. This work is then taken back to the studio along with some of the foliage for reference. I have on occasion used photographs as a reference only, taking a little here and there to create,

with the help of my own on-the-spot field sketches, a final work. As many as forty-five rough pencil sketches have been done of a single animal, in an attempt to capture all of its movements and anatomy. For the details of feathers and fur, I always use skins and pelts loaned to me by the Royal Ontario Museum.

The layman should be able to look at a good animal painting and feel surprised and excited, be convinced of its anatomical structure, and be able to gain a familiarity with its habitat, as well as a love for the subject itself.

Animal paintings should not be considered merely illustrations or studies; rather, they are truly creations of art.

The Studio.
Martin Glen Loates

Index to the Works

Dimensions are shown as height first then width.
Unless otherwise indicated all paintings are retained by the Artist.
*Indicates a Black & White plate.

American Woodcock, 64
Arctic Fox, 177

*Bald Eagle, 127
Baltimore Oriole, 131
Baltimore Oriole Field Sketch, 130
Baltimore Oriole Study, 31
Barn Owl, 151
*Barn Owl Field Sketch, 150
*Barn Swallow, 25
*Barred Owl, 149
Belted Kingfisher, 183
Big Horn Sheep
 Preliminary Watercolor, 122
Black Bear, 83
Black Bear Cubs, 165
Blue Jay, 1962, 39
Blue Jay, 1976, 13
Bobcat Kitten, 175
Bohemian Waxwing, 53
Brown Bear
 Preliminary Watercolor, 123
Brown Trout, 90
*Buck & Doe Working Drawing, 161

Calliope Hummingbird, 155
Canada Goose, 67
*Canada Goose Field Sketch, 66
Canada Lynx, 121
*Canada Lynx Study, 120
Cardinal, 132
Cecropia Moth, 98
Cecropia Moth Caterpillar, 97
Cedar Waxwing, 156
Chipmunk & Woodland Blue
 Butterfly, 162
Clown Fish With Sea Anemones, 45
Columbine & Ruby-Throated
 Hummingbird, 108
*Common Crow, 27
Common Housefly, 29
Cottontail Bunny, 163
Cottontail Rabbit, 87
Cottontail Rabbit Field Sketch, 86
Cougar, 133
*Cummer Avenue Bridge, 134

Day Lily, 107
Deer Mouse, 115
Dolphin, 45

Eastern Bluebird, 55
Eastern Chipmunk, 115
Eastern Meadowlark, 129
Elf Owl, 154
*Elk Field Sketch, 124
Elk Preliminary Watercolor, 125
English Sparrow, 68
Ermine & Willow Ptarmigan, 181

False Solomon's Seal &
 Herb-Robert Study, 157

Feathers, 171
Flying Squirrel, 116
Forget-Me-Not, 42
Fresh Water Clams, 44
Fringed Polygala, 51

Garter Snake & Grasshopper, 40
Goldfinch, 95
Gray Jay, 63
Gray Squirrel, 173
*Gray Squirrel Working Drawing, 172
Great Blue Heron, 37
*Great Gray Owl, 141
Great Horned Owl, 153
Great Horned Owl Field Sketch, 152
Grizzly Bear, 85
*Grizzly Bear Field Sketch, 84

Hawk, 23
*Hawk Owl, 142
Herb-Robert, 35
Hornet's Nest Study, 82

Indian Pipe, 70
Iris, 109

*Killdeer, 56
Kingfisher & Rainbow Trout, 58/59
Kokanee Salmon, 88

Lamprey Eel, 62
*Lamprey Eel Study, 62
Least Weasel, 160
Lion, 17
Little Brown Bat, 182
Loon, 185
Loon Field Skketch, 184
Luna Moth, 100

Mallard Duck, 65
Maple Leaves, 137
*Marsh Hawk & Longtail Weasel
 Working Drawing, 180
Meadowlark Field Sketch, 128
Meadow Vole, 114
Monarch Butterfly, 103
Moose, 79
Moose Field Sketch, 78
Morning-Glory, 105
Mosquito, 29
Mountain Goat, 81
Mountain Goat Field Sketch, 80
Mourning Cloak Butterfly, 104
Muskellunge Pursuing White
 Sucker, 61
Muskox Preliminary Watercolor, 119
Muskrat, 174

Northern Pike, 91
*Northern Shrike, 39

Orange Sulphur Butterfly, 102
Orange Sulphur Color
 Composition, 102

Parrot by A. A. Loates, 16
Pine Marten Pursuing
 Red Squirrel, 168/169
*Pine Study, 75
Polyphemus Moth, 101
Pond Leeches Feeding On
 Frogs-Eggs, 44
Porcupine, 176
Purple-Flowering Raspberry, 110

*Quaker Meeting, 134
Queen Anne's Lace, 51

Raccoon Family, 178/179
Raccoon Young, 166
Rainbow Trout, 89
*Raven, 71
*Reclining, 135
Red Admiral, 99
Red Fox, 112
Red Fox & Ring-Necked
 Pheasant, 170
*Ruffed Grouse, 126

*Sally, 135
Saw-Whet Owl, 146
Screech Owl, 144
Sea Otter, 164
*Short-Eared Owl, 147
Smallmouth Bass Pursuing
 Crayfish, 60
*Snapping Turtle, 25
*Snowy Owl, 143
*Sparrow Hawk, 27
Sperm Whale & Giant Squid, 46/47
*Spotted Owl, 148
Steller's Jay, 57
Striped Skunk, 113
*Swamp Sparrow, 38
*Squid, 29

*Tiger, 17
Timber Wolf
 Preliminary Watercolor, 118
Tucson, 154
Turk's-Cap Lily, 106

Vetch, 111
Virginia Ctenucha Moth, 99

Whiskered Owl, 145
Whitetail Deer, 77
White-Throated Sparrow, 69
Wild Ginger, 41
Winter Berries, 136
Woodchuck, 117
Woodland Violet Study, 43

Young Red Squirrel & Pileated
 Woodpecker, 167

189

Concept:
BERNARD LOATES

Editorial consultant:
MALCOLM LESTER

Design & Typography:
JOHN ORR
BERNARD LOATES

Initials:
JOHN CAPON

Portrait of the Artist:
HUNTLEY BROWN, R.C.A.

Special thanks to:
WALLACE MATHESON
GERRY HALPIN

Color separations:
FLINTLOCK PRODUCTIONS

Paper:
200(M) WARREN'S PATINA MATTE

Book Lithography:
ARTHURS-JONES

Bindery:
ANSTEY GRAPHICS